A Short Guide to Writing about Art

The Short Guide Series UNDER THE EDITORSHIP OF

Sylvan Barnet Marcia Stubbs

- A Short Guide to Writing about Literature by Sylvan Barnet
- A Short Guide to Writing about Biology by Jan A. Pechenik
- A Short Guide to Writing about Social Science by Lee Cuba
- A Short Guide to Writing about Film by Timothy Corrigan
- A Short Guide to Writing about Art by Sylvan Barnet
- A Short Guide to Writing about History by Richard Marius

A Short Guide to Writing about Art

Fourth Edition

SYLVAN BARNET

Tufts University

Acquisitions Editor: Patricia Rossi Project Editor: Brigitte Pelner

Design Supervisor and Cover Design: Wendy Ann Fredericks

Photo Researcher: Leslie Coopersmith

Production Administrator: Valerie A. Sawyer Compositor: Circle Graphics Typographers

Printer and Binder: R. R. Donnelley & Sons Company

Cover Printer: The Lehigh Press, Inc.

Cover Illustration: Edgar Degas, Woman Viewed from Behind. Collection of Mr. and Mrs. Paul Mellon, © 1992 National Gallery of Art, Washington, DC. Oil on canvas.

Color Photo: Helen Frankenthaler, *Mountains and Sea*, 1952. Oil on canvas 86 x 117". Collection of the artist, on loan to National Gallery of Art, Washington, DC.

For permission to use copyrighted material, grateful acknowledgment is made to the copyright holders on p. 201, which are hereby made part of this copyright page.

A Short Guide to Writing about Art, Fourth Edition

Copyright © 1993 by Sylvan Barnet

All rights reserved. Printed in the United States of America. No part of this book may be used or reproduced in any manner whatsoever without written permission, except in the case of brief quotations embodied in critical articles and reviews. For information address HarperCollins College Publishers, 10 East 53rd Street, New York, NY 10022.

Library of Congress Cataloging-in-Publication Data

Barnet, Sylvan.

A short guide to writing about art / Sylvan Barnet. — 4th ed.

p. cm. — (The Short guide series)
Includes bibliographical references and index.
ISBN 0-673-52293-8
1. Art criticism—Authorship. I. Title. II. Series.
N7476.B37 1993
808'.0667—dc20

92-26229 CIP

95 9 8 7 6 5

To the memory of my brother, Howard

Contents

Preface xiii

- 1 Writing about Art 1
 WHY WRITE? 1
 THE WRITER'S AUDIENCE 2
 THE FUNCTION OF CRITICAL WRITING 2
 A SAMPLE ESSAY 5
 Robert Herbert, "Millet's The Gleaners" 6
 SOME KINDS OF ESSAYS 9
 EXPRESSING OPINIONS 21
- 2 Analysis 23 ANALYTICAL THINKING: SEEING AND SAYING 23 SUBJECT MATTER AND CONTENT 27 GETTING IDEAS: ASKING QUESTIONS TO GET ANSWERS 29 Drawing and Painting 31 Sculpture 43 Architecture 52 Photography 59 Another Look at the Questions 68

FORMAL ANALYSIS VERSUS DESCRIPTION	71 79
STYLE AS THE SHAPER OF FORM 73	
PERSONAL STYLE AND PERIOD STYLE 75	
SAMPLE ESSAYS: TWO FORMAL ANALYSES	
Stephen Beer, "Formal Analysis: Prince Khunera as a Scribe" 79	
Joan Daremo, "Edvard Munch's The Scream" 83	

3 Writing a Comparison 86

THE USES OF COMPARISON 86

TWO WAYS OF ORGANIZING
A COMPARISON 90

SAMPLE ESSAYS: TWO COMPARISONS 95

L. R. Rogers, "Two Low Relief Carvings from the Fifteenth Century" 95

Rebecca Bedell, "John Singleton Copley's Early Development: From Mrs. Joseph Mann to Mrs. Ezekial Goldthwait" 99

- 4 In Brief: How to Write an Effective Essay 108
- 5 Style in Writing 116
 PRINCIPLES OF STYLE 116
 GET THE RIGHT WORD 117
 Denotation 117
 Connotation 117
 Concreteness 117
 Tone 118

Repetition 119
The Sound of Sense, the Sense of Sound 120
WRITE EFFECTIVE SENTENCES 120
Economy 120
Parallels 122
Subordination 123
WRITE UNIFIED AND COHERENT
PARAGRAPHS 125

WRITE UNIFIED AND COHERENT PARAGRAPHS 125
Unity 125
Coherence 133
Introductory Paragraphs 136
Concluding Paragraphs 137

6 Manuscript Form 139

BASIC MANUSCRIPT FORM 139

CORRECTIONS IN THE FINAL COPY 142

QUOTATIONS AND QUOTATION MARKS 143

ACKNOWLEDGING SOURCES 147
Borrowing Without Plagiarizing 147
Fair Use of Common Knowledge 150
"But How Else Can I Put It?" 151

FOOTNOTES AND ENDNOTES 152

Kinds of Notes 152

Footnote Numbers and Positions 152

Footnote Style 153

First Reference to a Book References to Introductions and to Reprinted Essays First Reference to a Journal First Reference to a Newspaper Unpaginated Material Secondhand References Subsequent References Footnoting Interviews, Lectures, Letters

BIBLIOGRAPHY 160

SOME CONVENTIONS OF LANGUAGE **USAGE** 164 The Apostrophe 164 Capitalization 165 The Dash 165 Foreign Words and Quotations in Foreign 166 Languages The Hyphen 166 Names 167 Sexist Language 167 Spelling 168 Titles 169 Underlining 170

The Research Paper

A NOTE ON ART-HISTORICAL RESEARCH AND ART CRITICISM 171 WHAT RESEARCH IS 176 PRIMARY AND SECONDARY MATERIALS 177 FROM SUBJECT TO THESIS 177 FINDING THE MATERIAL 179 The Library Catalog: Card or Computerized 179 Scanning Encyclopedias, Books, and Book Reviews 179 Indexes to Published Material 182 Other Guides 184

171

186

8 Essay Examinations 194
WHAT EXAMINATIONS ARE 194

READING AND TAKING NOTES

WRITING THE PAPER

WRITING ESSAY ANSWERS 196 LAST WORDS 199

Acknowledgments 201 Index 203

Preface

Another book for the student of art to read? I can only echo William James's report of the unwed mother's defense: "It's such a little baby." The title and the table of contents adequately reveal the subject of this book; if the chapters themselves fail to please and instruct, and if the questions listed on the inside front cover do not help to produce better essays, no preface will avail.

Still, a few additional words may be useful. Everyone knows that students today do not write as well as they used to. Probably they never did, but it is a truth universally acknowledged (among English teachers) that the cure is not harder work from instructors in composition courses; rather, the only cure is a demand, on the part of the entire faculty, that students in all classes write decently. But instructors outside of departments of English understandably say that they lack the time—and perhaps the skill—to teach writing in addition to, say, art.

This book may offer a remedy. Students who read it—and it is short enough to be read in addition to whatever readings the instructor regularly requires—should be able to improve their essays (1) partly by studying the principles explained (e.g., on tone, paragraphing, and manuscript form), (2) partly by studying the short models throughout the book, and, perhaps most important of all, (3) partly by finding that it will help them to generate ideas. As Robert Frost said, writing is a matter of having ideas, and this book tries to help students to have ideas by suggesting questions they may ask themselves as they contemplate works of art.

The book contains several essays by students, two by professors, and numerous paragraphs from published scholars such as Rudolf Arnheim, Albert Elsen, Mary D. Garrard, Anne Hollander, and Leo Steinberg. These discussions, as well as the numerous questions that are suggested, should help students to understand the sorts of things one says, and the ways one says them, when writing about art. After all, people do write about art, not only in the classroom but in learned journals, catalogs, and even in newspapers and magazines.

The first few pages of the book try to explain why one writes about art, but on this topic I would like to add one quotation. The late Harold Rosenberg said:

The art critic is the collaborator of the artist in developing the culture of visual works as a resource of human sensibility. His basic function is to extend the artist's act into the realms of meaningful discourse.

Art on the Edge (New York: Macmillan, 1975), p. 142

I am glad that I have this opportunity to thank James Cahill, Madeline Harrison Caviness, Ivan Galantic, Robert Herbert, Naomi Miller, and Elizabeth deSabato Swinton for showing me some of their examinations, topics for essays, and guidelines for writing papers. I have received invaluable help of another sort from those who read part or all of my manuscript. Howard Barnet, Peter Barnet, Morton Berman, William Burto, Ruth Butler, James Cahill, Charles Christensen, Fumiko Cranston, Joan Feinberg, Julius Held, Eugene J. Johnson, Susan Kuretsky, Jody Maxmin, Lawrence Nees, John Rosenfield, Marcia Stubbs, Gary Tinterow, and Stephen Urice called to my attention omissions, excesses, infelicities, and obscurities. I have not hesitated to adopt many of their suggestions verbatim. I am further indebted to Marcia Stubbs for letting me use some material that had appeared in a book we collaborated on, Barnet & Stubbs's Practical Guide to Writing.

A NOTE ON THE FOURTH EDITION

Many pages have been revised, most conspicuously in Chapter 1, where I have added a discussion of gender criticism (feminist, gay, and lesbian), and in Chapter 2, where I have added many questions

that students can ask themselves in order to generate responses to works of art. (Andy Warhol said that in America most people think that Art is a man's name.) Also new in Chapter 2 is a discussion concerning writing about nonobiective painting.

But there are other substantial changes, too. For instance, Chapter 3 now includes a comparison of two Buddhist images, and Chapter 4 ("In Brief: How to Write an Effective Essay") now includes material about peer review. Chapter 7, on the research paper, has of course been revised to take account of new research tools.

notably Bibliography of the History of Art (1991-).

Many of the people to whom in the first edition I expressed gratitude have continued to offer valuable suggestions. But I am now indebted to others, too, and I therefore want to express my thanks to Jane E. Aaron, Elizabeth ten Grotenhuis, Laura Kaufman, Kenneth J. Procter, Patricia Rogers, James M. Saslow, John M. Schnorrenberg, Ruth Thomas, and Jonathan Weinberg, all of whom have made valuable contributions to the fourth edition. (Saslow's generous contribution must be specified; he is the author of what at a casual glance might be thought to be my discussion of gay and lesbian art criticism.) These reviewers' comments helped me revise this edition: Professors Joseph Hutchinson, Department of Architecture at Texas A & M University; Jennifer Purtle, Department of Art History at Yale University; and Jack J. Spector, Department of Art History at Rutgers University. At HarperCollins, Judith Leet and Patricia Rossi expedited the publication of this new edition.

Sylvan Barnet

I saw the things which have been brought to the King from the new golden land: a sun all of gold a whole fathom broad, and a moon all of silver of the same size, also two rooms full of the armour of the people there, and all manner of wondrous weapons of theirs, harness and darts, wonderful shields, strange clothing, bedspreads, and all kinds of wonderful objects of various uses, much more beautiful to behold than prodigies. These things were all so precious that they have been valued at one hundred thousand gold florins. All the days of my life I have seen nothing that has gladdened my heart so much as these things, for I saw amongst them wonderful works of art, and I marvelled at the subtle *ingenia* of men in foreign lands. Indeed, I cannot express all that I thought there.

Albrecht Dürer, in a journal entry of 27 August 1520, writing about objects sent by Motecuhzoma to Cortés in 1519, and forwarded by Cortés to the Queen of Spain, Joan the Mad, and her son, Charles V.

All the arts live by words. Each work of art demands its response; and the urge that drives human beings to create—like the creations that result from this strange instinct—is inseparable from a form of "literature," whether written or not. . . . May not the prime motive of any work be the wish to give rise to discussion, if only between the mind and itself?

Paul Valéry (1871-1945)

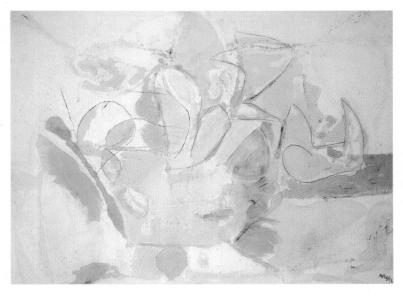

Helen Frankenthaler, *Mountains and Sea*, 1952. Oil on canvas, 86 x 117". Collection of the artist, on loan to National Gallery of Art, Washington, DC.

Writing about Art

WHY WRITE?

We write about art in order to clarify and to account for our responses to works that interest or excite or frustrate us. In putting words on paper we have to take a second and a third look at what is in front of us and at what is within us. And so writing is a way of learning. The last word is never said about complex thoughts and feelings—and works of art, as well as responses to them, embody complex thoughts and feelings-but when we write we hope to make at least a little progress in the difficult but rewarding job of talking about our responses. We learn, and then we hope to interest our reader because we are communicating our responses to material that for one reason or another is worth talking about.

But to respond sensitively to anything and then to communicate responses, we must have some understanding of the thing, and we must have some skill at converting responses into words. This book tries to help you to deepen your understanding of art—what art does and the ways in which it does it-and it also tries to help you transform your responses into words that will let your reader share your perceptions, your enthusiasms, and even your doubts. This sharing is, in effect, teaching. Students often think that they are writing for the teacher, but this is a misconception; when you write, you are the teacher. An essay on art is an attempt to help someone to see the work as you see it.

THE WRITER'S AUDIENCE

If you are not writing for the teacher, for whom are you writing? For yourself, of course, but also for an audience that you must imagine. All writers need to imagine some sort of audience high school students or lawyers or readers of *Time* or professors of art history—and the needs of one imagined audience are not the same as the needs of another. That is, writers must imagine their audience so that they can decide how much information to give and how much can be taken for granted.

In general, think of your audience as your classmates. If you keep your classmates in mind as your audience, you will not write, "Leonardo da Vinci, a famous Italian painter," because such a remark offensively implies that the reader does not know Leonardo's nationality or trade. You might, however, write, "Leonardo da Vinci, a Florentine by birth," because it's your hunch that your classmates do *not* know that Leonardo was born in Florence, as opposed to Rome or Venice. And you will write, "John Butler Yeats, the expatriate Irish painter who lived in New York," because you are pretty sure that only specialists know about Yeats. Similarly, you will not explain that the Virgin Mary was the mother of Jesus, but you probably will explain that St. Anne was the mother of Mary.

THE FUNCTION OF CRITICAL WRITING

In everyday language the most common meaning of criticism is "finding fault," and to be critical is to be censorious. But a critic can see excellences as well as faults. Because we turn to criticism with the hope that the critic has seen something we have missed, the most valuable criticism is not that which shakes its finger at faults but that which calls our attention to interesting matters going on in the work of art. In the following statement W. H. Auden suggests that criticism is most useful when it calls our attention to things worth attending to. He is talking about works of literature, but we can easily adapt his words to the visual arts.

What is the function of a critic? So far as I am concerned, he can do me one or more of the following services:

- Introduce me to authors or works of which I was hitherto unaware.
- 2. Convince me that I have undervalued an author or a work because I had not read them carefully enough.
- Show me relations between works of different ages and cultures which I could never have seen for myself because I do not know enough and never shall.
- Give a "reading" of a work which increases my understanding of it.
- 5. Throw light upon the process of artistic "Making."
- Throw light upon the relation of art to life, to science, economics, ethics, religion, etc.

The Dyer's Hand (New York: Random House, 1963), pp. 8-9

The emphasis on observing, showing, illuminating suggests that the function of critical writing is not very different from the common view of the function of literature or art. The novelist Joseph Conrad said that his aim was "before all, to make you see," and the painter Ben Shahn said that in his paintings he wanted to get right the difference between the way a cheap coat and an expensive coat hung.

Take Auden's second point, that a good critic can convince us—show us—that we have undervalued a work. Most readers can probably draw on their own experiences for confirmation. Still, an example may be useful. Rembrandt's self-portrait with his wife (p. 4), now in Dresden, strikes many viewers as one of his least, attractive pictures: The gaiety seems forced, the presentation a bit coarse and silly. Paul Zucker, for example, in Styles in Painting, finds it "over-hearty," and John Berger, in Ways of Seeing, says that "the painting as a whole remains an advertisement for the sitter's good fortune, prestige, and wealth. (In this case Rembrandt's own.) And like all such advertisements it is heartless." But some scholars have pointed out, first, that this picture may be a representation of the Prodigal Son, in Jesus' parable, behaving riotously, and, second, that it may be a profound representation of one aspect of Rembrandt's marriage. Here is Kenneth Clark on the subject:

Tuesday

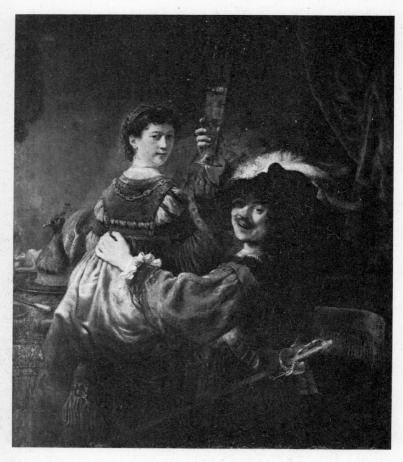

Rembrandt, Self-Portrait with Saskia, ca. 1635. Oil on canvas, $5'4'' \times 4'4''$. Gemäldegalerie, Dresden.

The part of jolly toper was not in his nature, and I agree with the theory that this is not intended as a portrait group at all, but as a representation of the Prodigal Son wasting his inheritance. A tallyboard, faintly discernible on the left, shows that the scene is taking place in an inn. Nowhere else has Rembrandt made himself look so deboshed, and Saskia is enduring her ordeal with complete detach-

ment—even a certain hauteur. But beyond the ostensible subject, the picture may express some psychological need in Rembrandt to reveal his discovery that he and his wife were two very different characters, and if she was going to insist on her higher social status, he would discover within himself a certain convivial coarseness.

An Introduction to Rembrandt (New York: Harper & Row, 1978), p. 73

After reading these words we may find that the appeal of the picture grows. Clark does not, of course, present an airtight case—one rarely can present such a case when writing about art—but notice that he does more than merely express an opinion or report a feeling. He offers evidence (the tally-board, and the observation that no other picture shows Rembrandt so "deboshed"), and the evidence is sufficiently strong to make us take another look at the picture. After looking again, we may come to feel that we have undervalued the picture.

A SAMPLE ESSAY

Kenneth Clark's paragraph, quoted a moment ago, comes from one of his two books on Rembrandt. Clark's audience was not limited to art historians, but it was, of course, limited to the sort of person who might read a book about Rembrandt. The following essay on Jean-François Millet's The Gleaners, written by Robert, Herbert, was originally a note in the catalog issued in conjunction with the art exposition at the Canadian World's Fair, Expo 67. Herbert's audience thus is somewhat wider and more general than Clark's. Given his audience, Herbert reasonably offers not a detailed study of one aspect of the painting, say, its composition; rather, he performs most of the services that on page 3 Auden says a critic can perform. In this brief essay, in fact, Herbert skillfully sets forth material that might have made half a dozen essays: Millet's life, the background of Millet's thought, Millet's political and social views, the composition of The Gleaners, Millet's depiction of peasants, Millet's connection with later painters. But the aim is always to make us see. In The Gleaners Millet tried to show us certain things, and now Robert Herbert tries to show us—tries to make us see—what Millet was doing and how he did it.

Millet's The Gleaners Robert Herbert

Jean-François Millet, born of well-to-do Norman peasants, bagan his artistic training in Cherbourg. In 1837 he moved to Paris where he lived until 1849, except for a few extended visits to Normandy. With the sounds of the Revolution of 1848 still rumbling, he moved to Barbizon on the edge of the Forest of Fontainebleau, already noted as a resort of landscape painters, and there he spent the rest of his life. One of the major painters of what came to be called the Barbizon School, Millet began to celebrate the labors of the peasant, granting him a heroic dignity which expressed the aspirations of 1848. Millet's identification with the new social ideals was a result not of overtly radical views, but of his instinctive humanitarianism and his rediscovery in actual peasant life of the eternal rural world of the Bible and of Virgil, his favorite reading since youth. By elevating to a new prominence the life of the common people, the revolutionary era released the stimulus which enabled him to continue this essential pursuit of his art and of his life.

The Gleaners, exhibited in the Salon of 1857, presents the very poorest of the peasants who are fated to bend their backs to gather with clubbed fingers the wisps of overlooked grain. That they seem so entirely wedded to the soil results from the perfect harmony of Millet's fatalistic view of man with the images which he created by a careful disposition of lines, colors, and shapes. The three women are alone in the bronzed stubble of the foreground, far removed from the bustling activity of the harvesters in the distance, the riches of whose labors have left behind a few gleanings. Millet has weighted his figures ponderously downward, the busy harvest scene is literally above them, and the high horizon line which the taller woman's cap just touches emphasizes their earth-bound role, suggesting that the sky is a barrier which presses down upon them, and not a source of release.

The humility of primeval labor is shown, too, in the creation of primitive archetypes rather than of individuals. Introspection such as that seen in Velázquez' Water Carrier of Seville, in which the three men are distinct individuals, is denied by suppressing the gleaners' features, and where the precise, fingered gestures of La Tour's Saint Jerome bring his intellectual work toward his sensate mind, Millet gives his women clublike hands which reach away from their bent bodies toward the earth.

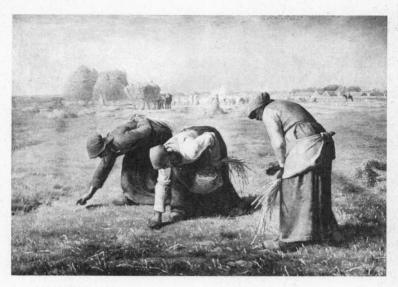

Jean-François Millet, *The Gleaners*, 1857. Oil on canvas, $32^{7/8}$ " \times $43^{1/4}$ ". The Musée d'Orsay, Paris.

It was, paradoxically, the urban-industrial revolution in the nine-teenth century which prompted a return to images of the pre-industrial, ageless labors of man. For all their differences, both Degas and Van Gogh were to share these concerns later, and even Gauguin was to find in the fishermen of the South Seas that humble being, untainted by the modern city, who is given such memorable form in Millet's *Gleaners*.

In this essay there is, of course, **evaluation**, or judgment, as well as analysis of what is going on in the painting. First, the writer judged Millet's picture to be worth talking about. Second, in his essay he explicitly praises some of its qualities ("perfect harmony," "memorable form"); but note that most of the evaluation is implicit in and subordinate to the **analysis** of what the writer sees. (For the moment we can define analysis as the separation of the whole into its

parts; the second chapter of this book is devoted to the topic.) The essayist sees things and calls them to our attention as worthy of note. He points out the earthbound nature of the women, the difference between their hands and those of Saint Jerome (in another picture that was in the exhibition), the influence of the Bible and of Virgil, and so forth. It is clear that he values the picture, and he states some of the reasons he values it; but he is not worried about whether Millet is a better artist than Velázquez, or whether this is Millet's best painting. He is content to help us see what is going on in the picture.

Or at least he seems to be content to help us see. In fact, of course, Herbert is advancing a **thesis**, an argument—in this case, that the picture celebrates the heroic dignity of the peasant. He tries to *persuade* us that what he sees is what is going on. And he sees with more than his eyes: Memories, emotions, and value systems help him to see, and his skill as a writer helps him to persuade us of the accuracy of his report. If he wants to convince us and to hold our interest, he has to do more than offer random perceptions; he has to present his perceptions coherently.

It is not enough for writers to see things and to report to readers what they have seen. Writers have to present their material in an orderly fashion, so that readers can take it in, and can follow a developing argument. In short, writers must organize their material. Let's look for a moment at the **organization**, or plan, of this essay. In his effort to help us see what is going on, the author keeps his eye on his subject.

- 1. The opening paragraph includes a few details (e.g., the fact that Millet was trained in Cherbourg) that are not strictly relevant to his main point (the vision embodied in the picture), but that must be included because the essay is not only a critical analysis of the picture but an informative headnote in a catalog of an exhibition of works by more than a hundred artists. Even in this preliminary biographical paragraph the writer moves quickly to the details closely related to the main business: Millet's peasant origin, his early association with landscape painters, his humanitarianism, and his reading of the Bible and Virgil.
- 2. The second paragraph takes a close look at some aspects of the picture (the women's hands, their position in the foreground, the harvesters above and behind them, the oppressive sky), and the third paragraph makes illuminating comparisons with two other

paintings in the exhibition. (A good description—one that catches the individuality of a particular work—almost always makes use of comparisons.)

3. The last paragraph, like most good concluding paragraphs, while recapitulating the main point (the depiction of ageless labors), enlarges the vision by including references to Millet's younger contemporaries who shared his vision. Notice that this new material does not leave us looking forward to another paragraph but neatly opens up, or enriches, the matter and then turns it back to Millet. (For additional remarks on introductory and concluding paragraphs, see pp. 136–138)

SOME KINDS OF ESSAYS

Most of this book will be devoted to writing about what we perceive when we look closely at a work of art, but it is worth noting that other kinds of writing can also help a reader to see (and therefore to understand better) a work of art. For example, one might discuss not a single picture but, say, a motif: Why does the laborer become a prominent subject in nineteenth-century European painting? Or how does the theme of leisure differ between eighteenth-century and nineteenth-century painting; that is, what classes are depicted, how aware of each other are the figures in a painting, what are the differences in the settings and activities—and why?

Such discussions of subject matter may be largely **social history**, and the esthetic qualities of the works of art may be of minor importance. Thus, a social historian's analysis of French "Orientalist" paintings—pictures of the Middle East by such artists as Delacroix and Gérôme—might concentrate on the ways in which these paintings depict not simply the Middle East, but also the European colonialist's view that the Middle East is a place of barbarism and corruption that is badly in need of European law and order and decency. (Marxist scholars especially see works of art as products that themselves do some sort of work. This work usually is the reenforcement of the ideology of the class that produced the works. In reading a discussion of this sort, one sometimes has the uneasy feeling that the writer began with a political thesis about society, and

then set about interpreting the pictures in accordance with the thesis.)

The social history of art has been much concerned not only with subject matter but also with examining the patrons of art in a given period: To what class did they belong, and what kinds of works did they want the artists to produce? Thus, Gary Schwartz, in Rembrandt: His Life, His Paintings, says that his intention is to study Rembrandt as "an artistic interpreter of the literary, cultural, and religious ideas of a fairly fixed group of patrons." Similarly, a study emphasizing the social context of art might try to answer the question, Why does portraiture in Italy in the later fifteenth century show an increased interest in capturing individual likenesses? (The answers are usually put in political and economic terms.)

The interest in patrons is only one aspect of the social historian's concern with the production of art. Obviously another question of interest is. Who are the artists in a given period? In Art News, January 1971, Linda Nochlin asked a fascinating sociological question: "Why Have There Been No Great Women Artists?" (The essay is reprinted in Nochlin's book, Women, Art, and Power and Other Essays [1988].) Nochlin rejects the idea that women lack artistic genius, and instead she finds her answer "in the nature of given social institutions." For instance, women did not have access to nude models (an important part of the training in the academies), and women, though tolerated as amateur painters, were rarely given official commissions. And, of course, women were expected to abandon their careers for love, marriage, and the family. Furthermore, during certain periods, women artists were generally confined to depicting a few subjects. In the age of Napoleon, for example, they usually painted scenes not of heroism but of humble, often sentimental domestic subjects such as a girl mourning the death of a pigeon.

Studies of this sort assume that works of art carry ideas, and that these ideas are shaped by specific historical, political, and social circumstances. The works are usually said to constitute ideologies of power, race, and gender. Architecture especially, being made for obvious uses (think of castles, cathedrals, banks, museums, schools, libraries, homes, malls), often is best discussed in terms of the society that produced it. Another assumption is that the person writing about art is not a disembodied or innocent eye, but inevitably is a

person with a point of view, for instance a white male, a Marxist or feminist, or whatever.

Feminist criticism begins with the fact that men and women are different. As Mary D. Garrard puts it:

The definitive assignment of sex roles in history has created fundamental differences between the sexes in their perception, experience and expectations of the world, differences that cannot help but be carried over into the creative process where they have sometimes left their tracks.

Artemisia Gentileschi: The Image of the Female Hero in Italian Baroque Art (Princeton, N.J.: Princeton University Press, 1989), p. 202

Feminist criticism has been especially interested in two topics—how women are portrayed in art, and, second, whether women (because of biology or socialization or both) create art and see art differently from men. The first topic is centered on subject matter: How do images of women (created chiefly by men) define "being female"? Are women depicted as individuals with their own identity, or chiefly as objects for men to consume?

The second topic, women as artists and as viewers of art, is closely related to the first. For instance, it is widely agreed that Renoir's pictures of women were created largely for the enjoyment of men, but how does a female respond to his pictures? Or take Picasso's Les Demoiselles d'Avignon (p. 22), a brothel scene. One critic has said,

Everything about the *Demoiselles*, and most of all the brothel situation it forces on the viewer, designates that viewer as male. To pretend . . . that women can play the customer—in *that* brothel in particular—or that as gendered subjects they can relate to the work on terms equal to men denies the intensity, force, and vehemence with which Picasso differentiated and privileged the male as viewer.

Is this assertion true? All viewers will, obviously, have to form their own answers.

Why, one can ask, do some heterosexual women take pleasure in some images of female nudity? Here are two of the many answers that have been offered. (1) These women, socialized by a patriarchal

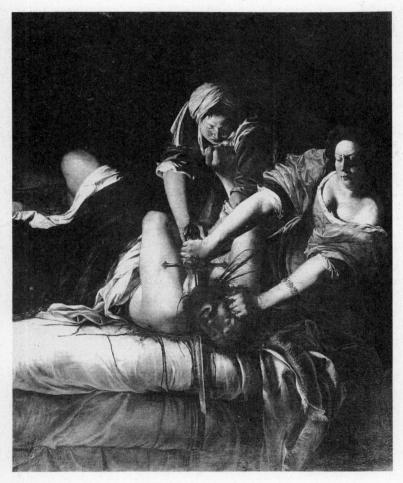

Artemisia Gentileschi, *Judith Slaying Holofernes*, ca. 1620. Canvas $6'6^1/3'' \times 5'4''$. Uffizi Gallery, Florence.

culture, may negate their own experience and identify with the heterosexual masculine voyeuristic gaze. (2) Some female viewers may narcissistically identify themselves with the female image depicted. (This second explanation is often used to account for images of female nudity found in advertising that is directed toward women.)

To turn to women as artists: Are the images created by women different from those created by men? In working in the "masculine" genre of the female nude, does a female artist (for instance Suzanne Valadon) produce images that significantly differ from the images produced by males working in the same artistic milieu?

Some writers have emphasized connections between events in the lives of women artists and their work. For instance, we know that Artemisia Gentileschi was raped by one of her father's apprentices. Some scholars have suggested that Gentileschi's depiction of Judith, the beautiful widow who according to the Bible saved the Hebrews by beheading Holofernes, an Assyrian general, was Gentileschi's way of taking revenge on men. Other writers, however, have pointed out that the subject was painted by men as well as by women, and still others have expressed uneasiness over the tendency to interpret the work of women in terms of their lives. Mary D. Garrard, in The New York Times, 22 September 1991, calls attention to the implications in some studies: "The art of women is defined in private and personal terms while the art of men is elevated to the level of 'universal' expression." A glance at certain writings about Frida Kahlo, the politically radical painter, supports Garrard's comment. Kahlo suffered greatly, both physically (she was partly paralyzed by a traffic accident) and mentally (her husband, the painter Diego Rivera, was notoriously unfaithful). Discussions of Kahlo's work usually emphasize the connection of the imagery with her suffering, and they tend to neglect the strong political (Marxist and nationalistic) content.

In thinking about distinctions between art produced by females and by males, one can of course go far beyond biographical matters. For instance, some writers have argued that the traditional distinction between "high" art (a painting by Renoir) and "low" art (a quilt by an anonymous woman) masquerades as a uni-

versal truth but is really a patriarchal concept designed to devalue female creativity.*

Gay and lesbian art criticism, like feminist criticism, operates from the principle that varieties of sexual orientation make important differences in how artists portray the world, love, and Eros, and in how viewers receive and interpret those images.† In fact, some critics combine feminist and gay approaches into a more comprehensive field now generally called *gender studies*, which attempts to link all aspects of cultural analysis concerning sexuality and gender. What these methodologies have in common is a root awareness that ideals and patterns of gender and sexual behavior are socially constructed, that they change from one time or culture to another, and that such analysis can help the viewer better to understand works of art by or about men and women, heterosexual and homosexual.

Like feminist art criticism, gay and lesbian criticism faces certain problems of definition and scope. Most broadly, it means both art about gay men and lesbians (or, more generally, homosexuality and bisexuality in all their various forms) and art by gay and lesbian artists. "Gay art" is not synonymous with erotic art or pornography. It can include, for example, genre scenes of gay life (Francis Bacon, David Hockney), portraits of famous individuals who were gay or lesbian (Berenice Abbott's photographs of the literary lesbians of Paris in the period between the two world wars), political art around social issues of special concern to lesbians and gay men (today, AIDS posters), and mythological or historical subjects (Jupiter and his cupbearer Ganymede, the lesbian poet Sappho).

Gay and lesbian art criticism looks at homosexuality both as subject matter/text and as a factor that may help to shape the work of the individual artist or creator. It asks about differences or parallels in

^{*}Examples of feminist criticism can now be found in almost all journals devoted to art, but they are especially evident in three journals: Women and Art, Woman's Art Journal, and Feminist Art Journal. For collections of feminist essays, see Feminism and Art History (1982), edited by Norma Broude and Mary D. Garrard, and Feminist Art Criticism (1988), edited by Arlene Raven, Cassandra L. Langer, and Joanna Frueh. For a survey of feminist art history, see T. Gouma-Peterson and P. Mathews, "The Feminist Critique of Art History," Art Bulletin 69 (1987): 326–357.

[†]This discussion of gay and lesbian criticism is by James M. Saslow, author of Ganymede in the Renaissance: Homosexuality in Art and Society (New Haven, Conn.: Yale University Press, 1986).

the ways that love, sexuality, gender, and daily life are depicted by heterosexuals and homosexuals; and it seeks to uncover distinctive expressions of the gay and lesbian experience that have, in the past, often been suppressed or misunderstood (for example, Greek vase paintings of homosexual courtship, Caravaggio's mythologized portraits of Roman boys, Rosa Bonheur's self-representation in male dress). It should be emphasized, however, that not all art by gay people (or by heterosexual men or women) can be reduced to biographical illustration.

In fact, while biography and psychology are important tools in understanding some art by gays and lesbians, gay art criticism is linked equally closely to both political and social history. Political because, throughout much of Western history at least, homosexual expression, when not silenced, has often been forced to operate indirectly, in a sort of code. Moreover, while heterosexuals have also represented scenes of homosexual life (for example, Brueghel's *Village Kermesse at Boboken*, with its male couple embracing at a carnival), their "outsider" images have often propagated negative attitudes that need to be placed in historical perspective.

In confronting images, it is important to avoid projecting one's own moral attitudes back onto earlier art. One should not assume, for example, that all cultures "naturally" condemn homosexuality; rather, one should try to discern what artists were trying to say within their own cultural framework. Gay art criticism is thus closely linked to social history, in that understanding of art about gay experience requires an understanding of attitudes about sex and

gender in various societies.

Much of what has just been said concerns iconography; in formal and visual terms, the issue of the gaze, adopted from feminist criticism, is important in gay and lesbian analysis as well. By "the gaze" I mean the act of looking itself, including both how it is established within works of art and what kind of outside viewer is implied. Students should ask such questions of pictures as, Who is doing the looking, and who or what is being looked at? Consider, for example, the different possible meanings of a male figure when he is painted or looked at by:

 a heterosexual male artist, for whom the sitter and his body are primarily an opportunity for scientific study, a traditional subject for drawing class, and the like; 2. a gay male artist, for whom the subject also has an erotic interest, and perhaps some significant biographical connection to the painter (e.g., Michelangelo's drawings of handsome young men and mythological boys);

3. a heterosexual woman, who, like a gay man, may also be erotically interested in the figure (the question of why there are no "academie" drawings by women before this century is a

related question for feminist history as well);

 a lesbian artist, who, like the heterosexual male, has no erotic interest in the sitter, but who might feel political or cultural solidarity (e.g., Romaine Brooks's portrait of Jean Cocteau).

A writer with an interest in **biography** might study the degree to which Picasso's style changed as he changed wives or mistresses, or as he changed literary friends—Apollinaire affecting Picasso's Cubism, Cocteau his Neoclassicism, and Breton his Surrealism. John Richardson's *A Life of Picasso*, in fact, is built on a remark by Picasso: "My work is like a diary. To understand it, you have to see how it mirrors my life."

Many of today's biographical studies can be called **psycho-analytic studies**. Such writings may seek to illuminate the works by relating them to early experiences. A psychoanalytic study of Winslow Homer argues that his works are related to crises in his life. For instance, *The Life Line* and *The Undertow*, two pictures that show men rescuing women, are said to reveal Homer's love for his mother and his desire to rescue her from death. (In reading psychoanalytic studies it is well to remember Freud's comment that "sometimes a

cigar is just a cigar.")

In some psychoanalytic studies, the works of art almost disappear. Thus, many pages have been written about why van Gogh cut off the lower part of his left ear and took it to a brothel, where he gave it to a prostitute with the request that she "keep this object carefully." (Among the theories are the following: (1) Van Gogh was frustrated by the engagement of his brother, Theo, and by his failure to establish a working relationship with Paul Gauguin. He first directed his aggression toward Gauguin, and then toward himself. (2) He identified himself with prostitutes as social outcasts. He had written that "the whore is like meat in a butcher shop," and so now he treated his body like a piece of meat. (3) He experienced auditory

hallucinations, and so he cut off a part of his ear, thinking it was diseased.)*

One kind of highly specialized study that keeps the image in view is iconography (Greek for "image writing"), that is, the identification of images with symbolic content or meaning. In Erwin/ Panofsky's words, iconography is concerned with "conventional subject matter," the iconographer showing us that certain forms are (for example) saints or gods or allegories. An iconographic study might point out that a painting by Rembrandt of a man holding a knife is not properly titled The Assassin, as it was once called, since it depicts St. Bartholomew, who, because he was skinned alive with a knife, is regularly depicted with a knife in his hand. (Saints often hold an attribute, that is, some object that serves to identify them. St. Peter, for example, holds keys.) But is every image of a man holding a knife St. Bartholomew? Of course not, and if, as in Rembrandt's painting, the figure wears contemporary clothing and has no halo, skepticism is warranted. Why can't the picture be of an assassin—or of a butcher or a cook or a surgeon? But a specialist in the thought (including the art) of the period might point out that the identification of this figure with St. Bartholomew is reasonable on two grounds. First, the picture, dated 1661, seems to belong to a series of pictures of similar size, showing half-length figures, all painted in 1661, and at least some of these surely depict apostles. For example, the man with another man at his right is Matthew, for if we look closely, we can see that the trace of a wing protrudes from behind the shoulder of the accompanying figure, and a winged man (or angel) is the attribute or symbol of Matthew. In another picture in this series a man leaning on a saw can reasonably be identified as Simon the Zealot, who was martyred by being sawn in half. Second, because the Protestant Dutch were keenly interested in the human ministry of Christ and the apostles, images of the apostles were popular in seventeenth-century Dutch art, and it is not surprising that Rembrandt's apostles look more like solid citizens of his day than like exotic biblical figures. In short, to make the proper identification of

^{*}On van Gogh, see William M. Runyan, Life Histories and Psychobiography (New York: Oxford University Press, 1982), pp. 38–41. For a survey of psychoanalytic scholarship and art, see Jack Spector, "The State of Psychoanalytic Research in Art History," Art Bulletin 70 (1988): 49–76.

an image, one must understand how the image relates to its contemporary context.

Iconology (Greek for "image study") is the interpretation, especially through literary, religious, and philosophical texts, of the image for evidence of the cultural attitudes that produced what can be called the meaning or content of the work. For instance, an image of a man chained to a rock, with an eagle feeding on his liver, can be identified as Prometheus, the Titan who stole fire from the gods and gave it to mortals. Iconology tells us that as early as the fifth century B.C. the Greeks gave this image a particular interpretation: Prometheus gave mortals not merely a natural element, fire, but divine wisdom. That is, the fire was seen as symbolic of a particular quality of the gods. But from reading certain texts we learn that early Christians gave the image a somewhat different content: They saw in Prometheus's gift an image of Christ rescuing mortals from their wretched sinful condition, and in Prometheus's enchainment they saw an image of Christ's crucifixion. Here we might say that the story becomes allegorical, that is, we get a system of equivalents: Prometheus = Christ; mortals lacking fire = sinners; the rock = the cross. The late eighteenth century saw in the image yet a different content: Prometheus was the inspired artist whose creative imagination is symbolized by heavenly fire. In the nineteenth century, Prometheus often was seen as the alienated artist, the exceptional human being who gives a precious gift to mortals but whose nature condemns him to isolation and suffering.

Similarly, to glance at another image, iconology can teach us the significance of changes in pictures of the Annunciation, in which the angel Gabriel confronts Mary. These changes reveal cultural changes. Early paintings show a majestic Gabriel and a submissive Virgin. Gabriel, crowned and holding a scepter, is the emblem of sovereignty. But from the fifteenth century onward the Virgin is shown as the Queen of the Angels, and Gabriel, kneeling and thus no longer dominant, carries a lily or a scepter tipped with a lily, emblem of the Virgin's purity. In this example, then, iconology—the study of iconography—calls to our attention evidence of a great change in religious belief.

The identification of images with symbolic content is not, of course, limited to images in Western art. Here is a brief passage discussing a veranda post (p. 20) for a palace, carved by an African

sculptor, Olowe, whom John Pemberton III calls "perhaps the greatest Yoruba carver of the twentieth century." (Olowe of Ise died in 1938.) The post shows a seated king wearing a conical beaded crown that is topped by a bird whose beak reaches halfway down the crown. Beneath the king are a kneeling woman and a palace servant, and behind the king is the senior queen. Pemberton says:

When the crown . . . is placed upon his head by the senior queen, his destiny (ori) is linked to all who have worn the crown before him. The great bird on the crown refers to "the mothers," a collective term for female ancestors, female deities and for older living women, whose power over the reproductive capacities of all women is held in awe by Yoruba men. Referring to the cluster of birds on his great crown, the Orangun-Ila said: "Without 'the mothers,' I could not rule." Thus, the bird on the Ogoga's crown and the senior queen, whose breasts frame the crown, represent one and the same power—the hidden, covert, reproductive power of women, upon which the overt power of Yoruba kings ultimately depends. . . .

John Pemberton III, "The Carvers of the Northeast," in Yoruba: Nine Centuries of African Art and Thought, ed. Allen Wardwell (New York: Center for African Art, 1989), p. 206

(Until fairly recently, discussions of African art rarely went beyond speaking of its "brute force," its "extreme simplifications," and its influence on Picasso and other European artists.)

Iconographic studies are highly specialized, requiring a good deal of knowledge of history, philosophy, and mythology. Historical studies, too, require research, often in humbler written documents. For instance, Schwartz's examination of Rembrandt in the context of patronage required him to study seventeenth-century wills, tax regulations, and records of birth, marriage, and burial. Probably, however, your instructor will begin by assigning something rather different, asking you—at least for the first assignment—to get on paper a sense of what you see in a work in front of you. This kind of essay, formal analysis, is the subject of the next chapter.

Writing an essay of any kind ought not to be an activity doggedly engaged in to please the instructor; it ought to be a stimulating, if taxing, activity that educates you and your reader. The job is twofold—seeing and saying—because these two activities finally are inseparable, for if you don't say it effectively, the reader won't see

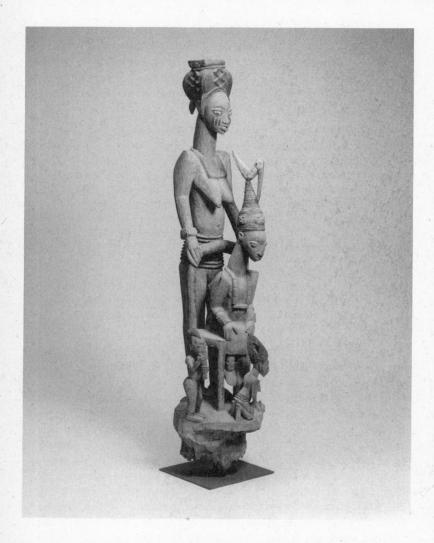

The central veranda post carved by Olowe of Ise for the palace of the Ogoga of Ikere, 1910–1914. Wood, pigment, 61". The Art Institute of Chicago Major Acquisitions Centennial Fund.

what you have seen, and perhaps you haven't seen it clearly either. What you say, in short, is a sort of device for helping the reader and yourself to see clearly.

EXPRESSING OPINIONS

The study of art is not a science, but neither is it the expression of random feelings loosely attached to works of art. You can—must—come up with statements that seem true to the work itself, statements that almost seem self-evident (like Clark's words about Rembrandt) when the reader of the essay turns to look again at the object.

Of course works of art evoke emotions—not only nudes, but also, for example, the sprawled corpse of a rabbit in a still life by Chardin, or even the jagged edges or curved lines in a nonobjective painting. It is usually advisable, however, to reveal your feeling not by continually saying "I feel" and "this moves me," but by calling attention to qualities in the object that shape your feelings. Thus, if you are writing about Picasso's Les Demoiselles d'Avignon (p. 22), instead of saying, "My first feeling is one of violence and unrest," it is probably better to call attention (as John Golding does, in Cubism) to "the savagery of the two figures at the right-hand side of the painting, which is accentuated by the lack of expression in the faces of the other figures." Golding does this in order to support his assertion that "the first impression made by the Demoiselles . . . is one of violence and unrest." The point, then, is not to repress or to disguise one's personal response but to account for it, and to suggest that it is not eccentric and private. Golding can safely assume that his response is tied to the object, and he can also safely assume that we share his initial response because he cites evidence that compels us to feel as he does-or at least evidence that explains why we feel this way. Here, as in most effective criticism, we get what has been called "persuasive description."

Understandably, instructors would rather be alerted to the evidence in the work of art than be informed about the writer's feelings, but to say that a writer does not keep repeating "I feel" is not to say that "I" cannot be used. Nothing is wrong with occasionally using "I," and noticeable avoidances of it—"it is seen that," "this

K

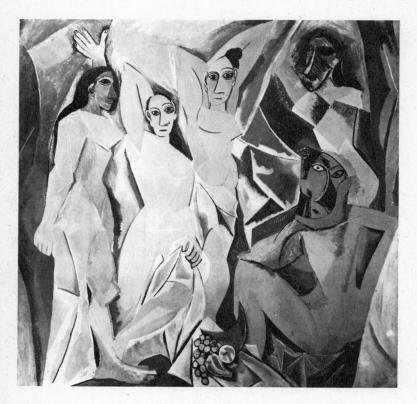

Pablo Picasso, Les Demoiselles d'Avignon, 1907. Oil on canvas, 8' × 7'8". Collection. The Museum of Modern Art, New York. (Acquired through the Lillie P. Bliss Bequest)

writer," "we," and the like—suggest an offensive sham modesty; still, too much talk of "I" can make a writer sound like an egomaniac.

Finally, it must be admitted that the preceding paragraph—indeed all of the preceding material—makes it sound as if writing about art is a decorous business. In fact, however, it is often a loud, contentious business, filled with strong statements about the decline of culture, revolution, pornography (or a liberating sexuality), the destruction of the skyline, fraud, new ways of seeing, and so forth. This energetic conversation has been going on for a long time, and it is now your turn to say something.

2 Analysis

ANALYTICAL THINKING: SEEING AND SAYING

An analysis is, literally, a separating into parts in order to understand the whole. You might, for example, analyze Michelangelo's marble statue *David* (p. 24) by considering

its sources (in the Bible, in Hellenistic sculpture, in Donatello's bronze *David*, and in the ideas of the age—e.g., David as a civic hero and David as the embodiment of Fortitude)

its material (marble lends itself to certain postures but not to others, and marble has an effect—in texture and color—that granite or bronze or wood does not have)

its pose (which gives it its outline, its masses, and its enclosed spaces or lack of them)

its facial expression

its nudity (a nude Adam is easily understandable, but why a nude David?)

its size (here, in this over-life-size figure, man as hero) its original site

and anything else you think the sculpture consists of—or does not consist of, for Michelangelo, unlike his predecessor Donatello, does not include the head of the slain Goliath, and thus Michelangelo's image is not explicitly that of a conquering hero. Or you might confine your attention to any one of these elements.

Analysis, of course, is not a process used only in talking about art. It is commonly applied in thinking about almost any complex

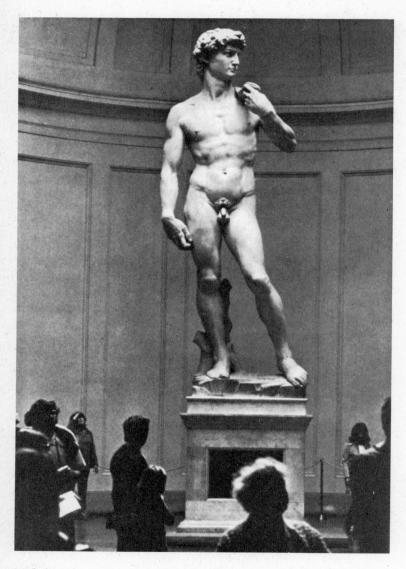

Michelangelo, *David*, 1501–1504. Marble, 13'5". Accademia, Florence. (Photograph courtesy of H. W. Janson)

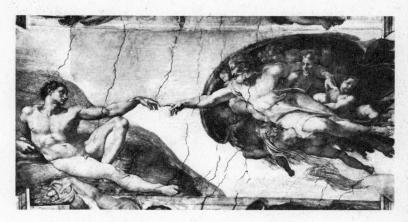

Michelangelo, *The Creation of Adam*, 1508–1512. Fresco, 9'2" × 18'8". Sistine Chapel, Vatican City. (The Vatican Museums)

matter. Martina Navratilova plays a deadly game of tennis. What makes it so good? How does her backhand contribute? What does her serve do to her opponents? The relevance of such questions is clear. Similarly, it makes sense, if you are writing about art, to try to see the components of the work.

Here is a very short analysis of one aspect of one of Michelangelo's paintings, *The Creation of Adam* (1508–1512), on the ceiling of the Sistine Chapel. The writer's *thesis*, or point that underlies his analysis, is, first, that the lines of a pattern say something, communicate something to the viewer, and, second, that the viewer does not merely *see* the pattern but experiences it, participate in it.

The "story" of Michelangelo's Creation of Adam, on the ceiling of the Sistine Chapel in Rome, is understood by every reader of the book of Genesis. But even the story is modified in a way that makes it more comprehensible and impressive to the eye. The Creator, instead of breathing a living soul into the body of clay—a motif not easily translatable into an expressive pattern—reaches out toward the arm of Adam as though an animating spark, leaping from fingertip to fingertip, were transmitted from the maker to the creature. The bridge of the arm visually connects two separate worlds: the self-contained compactness of the mantle that encloses God and is given forward motion by the diagonal of his body; and the incomplete, flat slice of

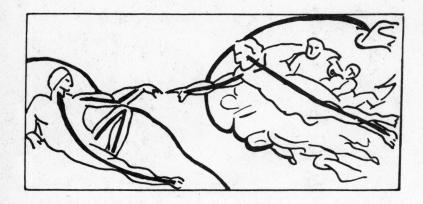

the earth, whose passivity is expressed in the backward slant of its contour. There is passivity also in the concave curve over which the body of Adam is molded. It is lying on the ground and enabled partly to rise by the attractive power of the approaching creator. The desire and potential capacity to get up and walk are indicated as a subordinate theme in the left leg, which also serves as a support of Adam's arm, unable to maintain itself freely like the energy-charged arm of God.

Our analysis shows that the ultimate theme of the image, the idea of creation, is conveyed by what strikes the eye first and continues to organize the composition as we examine its details. The structural skeleton reveals the dynamic theme of the story. And since the pattern of transmitted, life-giving energy is not simply recorded by the sense of vision but presumably arouses in the mind a corresponding configuration of forces, the observer's reaction is more than a mere taking cognizance of an external object. The forces that characterize the meaning of the story come alive in the observer and produce the kind of stirring participation that distinguishes artistic experience from the detached acceptance of information.

Rudolf Arnheim, Art and Visual Perception, New Version (Berkeley and Los Angeles: University of California Press, 1974), pp. 458-460

Notice that Arnheim does not discuss color, or the Renaissance background, or the place of the work in its site or in Michelangelo's development, though any or all of these are fit topics also. He has chosen to analyze the effect of only one element, but his paragraphs are an analysis, an attempt to record perceptions and to reflect on them.

SUBJECT MATTER AND CONTENT

Before we go on to analyze some of the ways in which art communicates, we can take a moment to distinguish between the subject matter of a work and the content or meaning. (Later in this chapter, on pp. 73–79, we will see that the content or meaning is expressed through the style or form, but it is best to postpone discussion of those difficult terms for as long as possible.)

Something has already been said (p. 18) about iconology, the study of artistic images and the cultural thoughts and attitudes that they reflect. Two pictures of the same subject matter—for instance, the Crucifixion—can express different meanings: One picture can show Christ's painful death (head drooping to one side, eyes closed, brows and mouth contorted, arms pulled into a V by the weight of the body, body twisted into an S shape); the other can show Christ's conquest of death (eyes open, face composed, arms horizontal, body relatively straight and self-possessed). The subject matter in both is the same—the Crucifixion—but the meaning or content (painful death versus the conquest of death) is utterly different. (The first kind of image, Christ Triumphant, was common in the twelfth and early thirteenth centuries; the second, Suffering Christ, emphasizing the mortal aspect of Jesus, was common in the later thirteenth and the fourteenth centuries.)

Or, to turn to another genre, if we look at some nineteenth-century landscapes we may see (aided by Barbara Novak's Nature and Culture: American Landscape and Painting 1825–1875) that the subject matter of skies streaked with red and yellow embodies a content that can be described, at least roughly, as the grandeur of God. Perhaps Paul Klee was trying to turn our attention from subject matter to content when he said, "Art does not reproduce the visible; rather, it makes visible," or (in a somewhat freer translation), "Art does not reproduce what we see; rather, it makes us see."

The content, one might say, is the subject matter transformed or re-created or infused by intellect and feeling with meaning—in short, the content is a meaning made visible. This is what Henri Matisse was getting at when he said that drawing is "not an exercise of particular dexterity but above all a means of expressing intimate feelings and moods."

Even abstract and nonobjective works of art probably make visible the artist's inner experiences and thus have a subject matter that conveys a meaning. Consider Picasso's words: "There is no abstract art. You must always start with something. Afterward you can remove all traces of reality. There is no danger then, anyway, because the idea of the object will have left an indelible mark. It is what started the artist off, excited his ideas, and stirred up his emotions. Ideas and emotions will in the end be prisoners in his work." This seems entirely reasonable. A bit less reasonable, but still only an exaggeration rather than an utter falsehood, is Wassily Kandinsky's remark: "The impact of an acute triangle on a sphere generates as much emotional impact as the meeting of God and Adam in Michelangelo's Creation." In this exaggeration Kandinsky touches on the truth that a painting conveys more than the objects that it represents. Still, lest we go too far in searching for a content in or behind or under the subject matter, we should recall a story. In the 1920s the poet Paul Eluard was eloquently talking to Joan Miró about what Eluard took to be a solar symbol in one of Miró's paintings. After a decent interval Miró replied, "That's not a solar symbol. It is a potato."

Speaking metaphorically, we can say that the meaning or content of a work of art is conveyed in the *language* of the art. For example, a picture with short, choppy, angular lines will "say" something different from a picture with gentle curves, even though the subject matter (let's say a woman sitting at a table) is approximately the same. When Klee spoke of "going for a walk with a line," he had in mind a line's ability (so to speak) to move quickly or slowly, assertively or tentatively. Of course many of the words we use in talking about lines—or shapes or colors—are metaphoric. If, for instance, we say that a line is "agitated" or "nervous" or "tentative" or "bold" we are not implying that the line is literally alive and endowed with feelings. We are really talking about the way in which we perceive the line, or, more precisely, we are setting forth our inference about what the artist intended or in fact produced, but such talk is entirely legitimate.

Are the lines of a drawing thick or thin, broken or unbroken? A soft pencil drawing on pale gray paper will say something different from a pen drawing made with a relatively stiff reed nib on bright white paper; at the very least, the medium and the subdued contrast of the one are quieter than those of the other. Similarly, a painting with a rough surface built up with vigorous or agitated brush strokes will not say the same thing—will not have the same meaning—as a painting with a smooth, polished surface that gives no evidence of the brush. If nothing else, the painting that gives evidence of brush strokes announces the presence of the painter, whereas the polished surface seems to eliminate the painter from the painting.

For obvious examples, compare a work by an Action painter of the late 1940s and the 1950s such as Jackson Pollock (as you can see from the illustration on page 199, the marks on the canvas almost let us see the painter in the act of brushing or dribbling or spattering the pigment) with a work by a Pop artist such as Andy Warhol or Robert Indiana. Whereas Pollock executed apparently free, spontaneous, self-expressive, nonfigurative pictures, Pop artists tended to favor commonplace images (e.g., Warhol's Campbell's soup cans) and impersonal media such as the serigraph. Their works call to mind not the individual artist but anonymous commercial art and the machine, and these commercial, mechanical associations are part of the meaning of the works. Such works express what Warhol said in 1968: "The reason I'm painting this way is because I want to be a machine."

In short, to get at the content or meaning of a work we have to interpret the subject matter, the material and the form (size, shape, texture, color, etc.), the sociohistorical content, and perhaps the artist's intentions.

GETTING IDEAS: ASKING QUESTIONS TO GET ANSWERS

The painter Ad Reinhardt once said that "Looking is not as simple as it looks." What are some of the basic things to look for in trying to acquire an understanding of the languages of art, that is, in trying to understand what a work of art expresses? Matisse has a comment on how all of the parts of a work contribute to the whole: "Expression, to my way of thinking, does not consist of the passion

mirrored upon a human face or betrayed by a violent gesture. The whole arrangement of my picture is expressive. The place occupied by figures or objects, the empty spaces around them, the proportions, everything plays a part."

One can begin a discussion of this complex business of expression in the arts almost anywhere, but let's begin with some basic questions that can be asked of almost any work of art—whether a

painting or a drawing or a sculpture or even a building.

What is my first response to the work? Later you may modify or even reject this response, but begin by trying to study it. Jot down your responses—even your free associations. Do you find the work puzzling, boring, pretty, ugly, offensive, sexy, or what? The act of jotting down a response may help you to deepen the response, or to move beyond it to a different response.

When and where was the work made? Does it reveal the qualities that your textbook attributes to the culture? (Don't assume that it does; works of art have a way of eluding easy generalizations.)

Where would the work originally have been seen? Perhaps in a church or a palace, or a bourgeois home, or (if the work is an African mask) worn by a costumed dancer, but surely not in a museum (unless it is a contemporary work) or in a textbook. For Picasso, "The picture-hook is the ruination of a painting. . . . As soon as [a painting] is bought and hung on a wall, it takes on quite a different significance, and the painting is done for."

What purpose did the work serve? To stimulate devotion? To enhance family pride? To teach? To delight? Does the work present a likeness, or express a feeling, or illustrate a mystery?

In what condition has the work survived? Is it exactly as it left the artist's hands, or has it been damaged, repaired, or in some way altered? What evidence of change do I see?

What is the title? Does it help to illuminate the work? Sometimes it is useful to ask yourself, What would I call the work? Picasso called one of his early self-portraits Yo Picasso (i.e., "I Picasso"), rather than, say, Portrait of the Artist, and indeed his title goes well with the depicted self-confidence. Charles Demuth called his picture of a grain elevator in his hometown of Lancaster, Pennsylvania, My Egypt, a title that nicely evokes both the grandeur of the object (the

silo shafts and their cap resemble an Egyptian temple) and a sense of irony (Demuth, longing to be in New York or Paris, was "in exile" in Lancaster). But note that many titles were not given to the work by the artist, and some are positively misleading. Rembrandt's Night Watch was given that name at the end of the eighteenth century, when the painting had darkened; it is really a daytime scene. And we have already noticed, on page 3, that one's response to a Rembrandt painting may differ, depending on whether it is titled Self-Portrait with Saskia or The Prodigal Son. Finally, one should recall that some painters have changed the titles of their works; Edvard Munch first called a picture Woman Kissing the Neck of a Man, but later he accepted as its title the suggestion of a friend, The Vampire.

If you ask yourself such questions, answers (at least tentative answers) will come to mind. In short, you will have some ideas, material that you will draw on and will shape when you are called on to write. Here are some additional questions to ask, first on drawing and painting, then on sculpture, architecture, and photography.

Drawing and Painting

What is the **subject matter**? What (if anything) is happening? If the picture is a **figure painting**, what is the relation of the viewer's **gaze** (and the artist's) to the gaze of the figure(s)? It has been argued, for instance, that in his pictures of his family and friends, Degas gives his subjects a level stare, effectively placing them on the same social level as the viewer; in his pictures of working women (laundresses, dancers), he adopts a high viewpoint, literally looking down on his subjects; in his pictures of prostitutes, he looks either from below or from above, that is, as a spy or a voyeur might do.

Baudelaire said that a **portrait** is "a model complicated by an artist." A portrait, one can say, is not simply a representation; it is also a presentation. In a given portrait, how much of the figure does the artist show, and how much of the available space does the artist cause the figure to occupy? What effects are thus gained? What do the clothes, furnishings, accessories (swords, dogs, clocks, and so forth), background, and angle of the head or the posture of the head and body (as well as the facial expression, of course) contribute to our sense of the personality (intense, or cool, or inviting, or whatever) of the figure portrayed?

Does a given artist present a strong sense of a social class (as Frans Hals does in his portraits), or a strong sense of an independent inner life (as Rembrandt does)? Is the view frontal, three-quarter, or profile? (It is usually held that a three-quarter view affords the artist the greatest opportunity to reveal personality.)

Consider again the figure's gaze. Is the figure related to the viewer, perhaps by a glance or a gesture? If the figure seems posed, do you agree with some theoreticians that posing is a subordination of the self to the gaze of another, and the offering of the self (perhaps

provocatively, perhaps shamefully) to the viewer?

If frontal, does the figure seem to face us in a godlike way, seeing all? If three-quarter, does it suggest motion, a figure engaged in a social world? If profile, is the emphasis decorative or psychological? (Generally speaking, a frontal or especially a three-quarter view lends itself to the rendering of a dynamic personality, perhaps even interacting in an imagined social context, whereas a profile does not—or if a profile does reveal a personality it is that of an aloof, almost unnaturally self-possessed sitter.) If the picture is a double portrait, does the artist reveal what it is that ties the two figures together? Do the figures look at each other? If not, what is implied in this lack of eye contact?

It is sometimes said that every portrait is a self-portrait; does this portrait seem to reveal the artist in some way? Does the portrait, in fact, reveal anything at all? Looking at John Singer Sargent's portrait entitled *General Sir Ian Hamilton*, the critic Roger Fry said, "I cannot see the man for the likeness." Sargent, by the way, said that he

saw an animal in every sitter.

(For a student's discussion of two portraits by Copley, see pages 99–107. For a professional art historian's discussion of Van Dyck's

portrait of Charles I, see pages 130-132.)

If the picture is a **still life**, does it suggest opulence, or does it suggest humble domesticity and the benefits of moderation? Does it imply transience, perhaps by a clock or a burnt-out candle, or even merely by the perishable nature of the objects (food, flowers) displayed? Other common symbols of *vanitas* (Latin for "emptiness," i.e., the emptiness of earthly possessions and accomplishments) are an overturned cup or bowl and a skull. If the picture shows a piece of bread and a glass of wine flanking a vase of flowers, can the bread and wine perhaps be eucharistic symbols, the picture as a whole repre-

senting life everlasting achieved through grace? Is there a contrast (and a consequent evocation of pathos) between the inertness and sprawl of a dead animal and its vibrant color or texture? Does the work perhaps even suggest, as some of Chardin's pictures of dead rabbits do, something close to a reminder of the Crucifixion? Or is all of this allegorizing irrelevant?

In a landscape, what is the relation between human beings and nature? Are the figures at ease in nature (e.g., aristocrats lounging complacently beneath the mighty oaks that symbolize their ancient power and grandeur), or are they dwarfed by it? Are they earthbound, beneath the horizon, or (because the viewpoint is low) do they stand out against the horizon and perhaps seem in touch with the heavens, or at least with open air? What does the picture tell us about the society for which it was created? Does it reveal an aristocrat's view of industrious peasants toiling happily in an ordered society? Do the natural objects in the landscape (e.g., billowy clouds, or dark clouds, or gnarled trees, or airy trees) somehow reflect the emotions of the figures? Even if the landscape, like many seventeenth-century Dutch paintings, seems highly realistic, is it also expressive of political or spiritual forces? Does the painting emphasize the play of light and the insubstantiality of objects in beautiful spaces, as is usual in the work of Claude Lorrain, Turner, and Monet, or does it emphasize the volume—of hills and trees for example—as is usual in the work of Poussin and van Gogh?

Does the origin of the picture help to interpret it? For instance, a Chinese landscape may bear an inscription explaining that the picture was a farewell gift to an official who was setting out for a remote post. In this case, the figures in the foreground (clear and detailed) may represent the present, and the misty depths may represent the uncertainty of the future. Or a Chinese landscape may have an inscription informing us that it shows someone's retirement villa. In this case the stream, the wall, and the screen of trees that separate the viewer from the cottage help to suggest the purity of the retiree's mind.

Are the **contour lines** (outlines of shapes) strong and hard, isolating each object? Or are they irregular, indistinct, fusing the objects or figures with the surrounding space? Do the lines seem (for instance in an Asian ink painting) calligraphic, that is, of varied

thicknesses that suggest liveliness or vitality, or are the lines uniform and suggestive of painstaking care?

What does the **medium** (the substance on which the artist acted) contribute? If a drawing has been made with a wet medium (e.g., ink applied with a pen, or washes applied with a brush), what has the degree of absorbency of the paper contributed? Are the lines of uniform width, or do they sometimes swell and sometimes diminish, either abruptly or gradually? (Quills and steel pens are more flexible than reed pens.) If the drawing has been made with a dry medium (e.g., silverpoint, charcoal, chalk, or pencil), what has the smoothness or roughness of the paper contributed? (When crayon is rubbed over textured paper, bits of paper show through, suffusing the dark with light, giving vibrancy.) In any case, a drawing executed with a dry medium, such as graphite, will differ from a drawing executed with a wet medium, where the motion of the instrument must be interrupted in order to replenish the ink or paint.

If the work is a painting, is it in tempera (pigment dissolved in egg, the chief medium of European painting into the later fifteenth century), which usually has a somewhat flat, dry appearance? Because the brush strokes do not fuse, tempera tends to produce forms with sharp edges—or, we might say, because it emphasizes contours it tends to produce colored drawings. Or is the painting done with oil paint, which (because the brush strokes fuse) is better suited than tempera to give an effect of muted light and blurred edges? Thin layers of translucent colored oil glazes can be applied so that light passing through these layers reflects from the opaque ground colors, producing a soft, radiant effect; or oil paint can be put on heavily (impasto), giving a rich, juicy appearance. Impasto can be applied so thickly that it stands out from the surface and catches the light. Oil paint is thus sometimes considered more painterly than tempera, or, to reverse the matter, tempera is sometimes considered to lend itself to a more linear treatment.

Chinese, Korean, and Japanese ink painting, too, illustrates the contribution of the media. A painting on silk is usually very different from a painting on paper. Because raw silk absorbs ink and pigments, diluting the strength of the line and the color, silk is usually sized (covered with a glaze or filler), making it less absorbent, indeed, slick. If the brush moves rapidly on the sized surface, it may not leave an unbroken line, so a painter working on silk usually

proceeds slowly, meticulously creating the image. If the painter wants spontaneous, dynamic, or blurred brushwork, he or she usually works not on silk but on paper.

Caution: Reproductions in books usually fail to convey the texture of brush strokes. If you must work from reproductions, try to find a book that includes details (small parts of the picture), preferably enlarged.

Is the **color** (if any) imitative of appearances, or expressive, or both? (Why is the flesh of the Buddha gold? Why did Picasso use white, grays, and blacks for *Guernica*, when in fact the Spaniards bombarded the Basque town on a sunny day?)

The material value of a pigment—that is to say, its cost—may also be significant. For instance, Velázquez's lavish use of expensive ultramarine blue in his *Coronation of the Virgin* in itself signifies the importance of the subject. Ultramarine—"beyond the sea"—made of imported ground lapis lazuli, was more expensive than gold; its costliness is one reason why, like gold, it was used for some holy figures in medieval religious paintings, where common earth pigments were used for nondivine figures.

Vincent van Gogh, speaking of his own work, said he sought "to express the feelings of two lovers by a marriage of two complementary colors, their mixture and their oppositions, the mysterious vibrations of tones in each other's proximity . . . to express the thought behind a brow by the radiance of a bright tone against a dark ground." As this quotation may indicate, comments on the expressive value of color often seem highly subjective and perhaps unconvincing. One scholar, commenting on the yellowish green liquid in a bulbous bottle at the right of Manet's Bar aux Folies-Bergère, suggested that the color of the drink—probably absinthe—is oppressive. A later scholar pointed out that the distinctive shape of the bottle indicates that the drink is crème de menthe, not absinthe, and therefore he finds the color not at all disturbing.

Caution: It is often said that warm colors (red, yellow, orange) produce a sense of excitement, whereas cool colors (blue, green) have a calming effect, but experiments have proved inconclusive; the response to color—despite clichés about seeing red or feeling blue—is highly personal, highly cultural, highly varied. Still, a few things can be said, or at least a few terms can be defined. Hue gives the color its name—red, orange, yellow, green, blue, violet. Value (also called

lightness or darkness, brightness or intensity) refers to relative lightness or darkness of a hue. When white is added, the value becomes "higher"; when black is added, the value becomes "lower." The highest value is white; the lowest is black. Saturation (also called hue intensity) is the strength of a hue—one red is redder than another; one yellow is paler than another. A vivid hue is of high saturation; a pale hue is of low saturation. But note that much in a color's appearance depends on context. Juxtaposed against green, red will appear redder than if juxtaposed against orange. A gray patch surrounded by white will seem darker than gray surrounded by black.

When we are armed with these terms, we can say, for example, that in his South Seas paintings Paul Gauguin used *complementary colors* (orange and blue, yellow and violet, red and green, i.e., hues that when mixed absorb almost all white light, producing a blackish hue) at their highest values, but it is harder to say what this adds up to. (Gauguin himself said that his use of complementary colors was "analogous to Oriental chants sung in a shrill voice," but one may question whether the analogy is helpful.)

For several reasons our nerve may fail when we try to talk about the effect of color. For example,

- 1. light and moisture cause some pigments to change over the years;
- 2. the colors of a medieval altarpiece illuminated by flickering candlelight or by light entering from the yellowish translucent (not transparent) glass or colored glass of a church cannot have been perceived as the colors that we perceive in a museum, and, similarly, a painting by van Gogh done in bright daylight cannot have looked to van Gogh as it looks to us on a museum wall.

The moral? Be cautious in talking about the effect of color. Keep in mind the remark of the contemporary painter Frank Stella: "Structural analysis is a matter of describing the way the picture is organized. Color analysis would seem to be saying what you think the color does. And it seems to me that you are more likely to get an area of common agreement in the former."

What is the effect of **light** in the picture? Does it produce sharp contrasts, brightly illuminating some parts and throwing others into darkness, or does it, by means of gentle gradations, unify most or all of the parts? Does the light seem theatrical or natural, disturbing or comforting? Is light used to create symbolic highlights?

Do the objects or figures share the **space** evenly, or does one overpower another, taking most of the space or the light? What is the focus of the composition? The **composition**—the ordering of the parts into a whole by line, color, and shape—is sometimes grasped at an initial glance and at other times only after close study. Is the composition symmetrical (and perhaps therefore monumental, or quiet, or rigid and oppressive)? Is it diagonally recessive (and perhaps therefore dramatic or even melodramatic)?

Are figures harmoniously related, perhaps by a similar stance or shared action, or are they opposed, perhaps by diagonals thrusting at each other? Speaking generally, diagonals may suggest motion or animation or instability, except when they form a triangle resting on its base, which is a highly stable form. Horizontal lines suggest tranquility or stability—think of plains, or of reclining figures. Vertical lines—tree trunks thrusting straight up, or people standing, or upright lances as in Velázquez's Surrender of Breda-may suggest a more vigorous stability. Circular lines are often associated with motion and sometimes—perhaps especially by men—with the female body and with fertility. It is even likely that Picasso's Still-Life on a Pedestal Table, with its rounded forms, is, as he is reported to have called it, a "clandestine" portrait of one of his mistresses. These simple formulas, however, must be applied cautiously, for they are not always appropriate. Probably it is fair to say, nevertheless, that when a context is so established, for instance by means of the title of a picture, these lines may be perceived to bear these suggestions if the suggestions are appropriate.

Caution: The sequence of eye movements with which we look at a picture has little to do with the compositional pattern. That is, the eye does not in fact move in a circle when it perceives a circular pattern. The mind, not the eye, makes the relationships. It is therefore inadvisable to say things like "The eye follows the arrow and arrives finally at the target."

Does the artist convey **depth**, that is, **recession in space**? If so, how? If not, why not? (Sometimes space is flattened—for example, to convey a sense of otherworldliness or eternity.) Among the chief ways of indicating depth are

- 1. overlapping (the nearer object overlaps the farther);
- 2. foreshortening (as in the recruiting poster, I Want You, where Uncle Sam's index finger, pointing at the viewer, is represented chiefly by its tip, and, indeed, the forearm is represented chiefly by a cuff and an elbow);
- 3. contour hatching, that is, lines or brush strokes that follow the shape of the object depicted, as though a net were placed tightly over the object;
- 4. shading or modeling, that is, representation of body shadows;
- 5. representation of cast shadows;
- 6. relative position from the ground line (objects higher in the picture are conceived of as further away than those lower);
- 7. perspective (parallel lines seem to converge in the distance, and a distant object will appear smaller than a near object of the same size.* Some cultures, however, use a principle of hierarchic scale. In such a system a king, for instance, is depicted as bigger than a slave not because he is nearer but because he is more important; similarly, the Virgin in a nativity scene may be larger than the shepherds even though she is behind them);
- 8. aerial—or atmospheric—perspective (remote objects may seem—depending on the atmospheric conditions—slightly more bluish than similar near objects, and they may appear less intense in color and less sharply defined than nearer objects. (Note that aerial perspective does not have anything to do with a bird's-eye view).

Does the picture present a series of planes, each parallel to the picture surface, or does it, through some of the means just enumerated, present an uninterrupted extension of one plane into depth?

What is the effect of the **shape** and **size** of the work? Because, for example, most still lifes use a horizontal format, a vertical still life

^{*}In the Renaissance, perspective was used chiefly to create a coherent space and to locate objects within that space, but later artists have sometimes made perspective expressive. Giorgio de Chirico, for example, often gives a distorted perspective that unnerves the viewer. Or consider van Gogh's Bedroom at Arles. Although van Gogh said that the picture conveyed "rest," viewers find the swift recession disturbing. Indeed, the perspective in this picture is impossible: If one continues the diagonal of the right-hand wall by extending the dark line at the base, one sees that the bed's rear right foot would be jammed into the wall.

may seem relatively monumental. Note too that a larger-than-life portrait will produce an effect (probably it will seem heroic) different from one 10 inches high. If you are working from a reproduction be sure, therefore, to ascertain the size of the original.

What is the **scale**, that is, the relative size? A face that fills a canvas will produce a different effect from a face of the same size that is drawn on a much larger canvas; probably the former will seem more expansive or more energetic, even more aggressive.

A Note on Nonobjective Painting. We have already noticed (p. 28) Wassily Kandinsky's comment that "The impact of an acute triangle on a sphere generates as much emotional impact as the meeting of God and Adam in Michelangelo's Creation." Kandinsky (1866-1944), particularly in his paintings and writings of 1910-1914, has at least as good a title as anyone else to being the founder of twentieth-century nonobjective art. Nonobjective art, unlike figurative art, depends entirely on the emotional significance of color, form, and texture and not on representational forms. (The term nonobjective art includes abstract expressionism—a term especially associated with the work of New York painters in the 1950s and 1960s, such as Jackson Pollock and Mark Rothko, who, deeply influenced by Kandinsky, sought to allow the unconscious to express itself. Nonobjective art is considered synonymous with pure abstract art, but it is not synonymous with "abstract art," since in most of what is generally called abstract art, forms are recognizable, though simplified.)

In several rather mystical writings, but especially in *Concerning the Spiritual in Art* (1910), Kandinsky advanced theories that exerted a great influence on American art after World War II. For Kandinsky, colors were something to be felt and heard. When he set out to paint, he wrote, he "let himself go. . . . Not worrying about houses or trees, I spread strips and dots of paint on the canvas with my palette knife and let them sing out as loudly as I could."

What do pictures "sing"? Like music, pictures (Kandinsky believed) communicate emotional insights into the universe. They reveal the spiritual world that is ordinarily obscured by the physical world:

Every work of art comes into being in the way that the universe came into being—as a result of catastrophes in which all the instruments

play out of tune until finally there sings out what we call "the music of the spheres."

As someone who is or soon will be writing about art, you may be interested in hearing Kandinsky's view of the ideal critic. "The ideal critic," he said, is "the one who would seek to *feel* how this or that form has an inner effect, and would then impart expressively his whole experience to the public."

Nonobjective painting is by no means all of a piece; it includes, to glance at only a few examples, not only the lyrical, highly fluid forms of Kandinsky and of Jackson Pollock (1912-1956) but also the pronounced vertical and horizontal compositions of Piet Mondrian (1872-1944), and the bold, rough slashes of black on white of Franz Kline (1910-1962), although Kline's titles sometimes invite the viewer to see the slashes as representations of the elevated railway of Kline's earlier years in New York City. Nonobjective painting is, in fact, not so much a style as a philosophy of art: In their works, and in their writings and their comments, many nonobjective painters emphasized the importance of the unconscious and of chance. Their aim in general was to convey feelings with little or no representation of external forms; the work on the canvas conveyed not images of things visible in the world, but intuitions of spiritual realities. Notice that this is not to say that subject matter is unimportant in nonobjective art. On the contrary, the artists often insisted that their works were concerned with what really was real-the essence behind appearances—and that their works were not merely pretty decorations. This point is emphasized in an article, in 1943, by Mark Rothko (1903-1970) and Adolph Gottlieb (1903-1974). After asserting that "Art is an adventure into an unknown world," they say,

There is no such thing as good painting about nothing. We assert that the subject is crucial, and only that subject-matter is valid which is tragic and timeless. That is why we profess a spiritual kinship with primitive and archaic art.

The titles of nonobjective pictures occasionally suggest a profound content (e.g., Pollock's *Guardians of the Secret*, Rothko's *Vessels of Magic*), occasionally a more ordinary one (Pollock's *Blue Poles*), and occasionally something in between (Pollock's *Autumn Rhythm*), but one can judge a picture by its title only about as well as one can judge a book by its cover (that is, sometimes well, sometimes not at all).

Here are two additional quotations concerning nonobjective art, both by the Dutch artist Piet Mondrian:

The first aim in a painting should be universal expression. What is needed in a picture to realize this is an equivalence of vertical and horizontal expressions.

The balanced ratio is the purest representation of universality, of harmony, and of the sense of unity, which are the unique attributes of the human mind.

In writing about the work of a nonobjective painter, you may get some help from his or her writings, though of course you may come to feel that the painting does not in fact do what the painter says he or she wants to do. (A good source for statements by artists is *Theories of Modern Art* [1968], ed. Herschel B. Chipp.)

The following comment by a critic, however, does not draw on the painter's writing; rather, the author looks at a painting by Helen Frankenthaler (see frontispiece) and, drawing on his experience as a viewer, puts it in a context of other works. The title of the painting, *Mountains and Sea*, allows a viewer to discern a few recognizable forms, but most of the shapes in the picture are not imitative of external nature, and the writer consequently is not greatly concerned with imitations. The passage occurs in the context of a discussion of the reaction against what the writer calls "the moralizing *fortissimo*" of certain Abstract Expressionists. (Because Jackson Pollock is mentioned by way of comparison, if you are unfamiliar with his work you might first want to look at page 199, for a sample.)

The reaction at first took the form of airy, spattered, lyrically colored and light-surfaced abstract painting whose take-off point was Jackson Pollock's "all-over" paintings from 1949. In them, line was no longer outline. It did not mark contours or define edges; it was not touchable, like the cut line along the edge of a Matisse pomegranate; it was almost a function of atmosphere. The artist who did most to grasp and develop this aspect of Pollock's work was Helen Frankenthaler (b. 1928), and she did it with one exquisite painting, Mountains and Sea, 1952. It is large, about seven feet by ten, but its effect is that of a watercolour: rapid blots and veil-like washes of pink, blue, and diluted malachite green, dashed down as though the canvas were a page in a sketchbook. Its most obvious affinity is with the luminous, broken-

formed landscape that rises from Cézanne's late watercolours; and the raw canvas soaked up the watery pigment just as rag paper absorbs a watercolour wash. Landscape, imagined as Arcadia, remained the governing idea in Frankenthaler's work, and her titles often invoked the idea of Paradise or Eden.

Robert Hughes, *The Shock of the New* (New York: Knopf, 1981), p. 154

Finally, one additional comment about a very different nonobjective painting, a severely geometric picture by Frank Stella (b. 1936). The picture, one of Stella's Protractor series, is 10 feet tall and 20 feet wide. Robert Rosenblum writes:

Confronted with a characteristic example, *Tahkt-i-Sulayman I*, the eye and the mind are at first simply dumbfounded by the sheer multiplicity of springing rhythms, fluorescent Day-Glo colors, and endlessly shifting planes—all the more so, because the basic components (circles and semicircles; flat bands of unmodulated color) and the basic design (here a clear bilateral symmetry) are so lucid. But again, as always in Stella's work, the seeming economy of vocabulary is coun-

Frank Stella, *Tahkt-i-Sulayman I*, 1967. Fluorescent acrylic on canvas, $10' \times 20'$. Collection, Mr. Robert Rowan.

tered by the elusive complexities of the result. At first glance, the overriding pattern is of such insistent symmetrical clarity that we feel we can seize predictable principles of organization and bring to rest this visual frenzy. But Stella permits no such static resolution, for the overall symmetries of the design are contradicted by both the interlace patterns and the colors, which constantly assert their independence from any simple-minded scheme. In a surprising way, this tangle of gyrating energies, released and recaptured, provides a 1960s rulerand-compass equivalent of the finest Pollocks, even in terms of its engulfing scale (here 20 feet wide), which imposes itself in an almost physical way upon the spectator's world. In this case, the springing vaults of the arcs, some reaching as high as four feet above one's head. turn the painting into something that verges on the architectural, a work that might rest on the floor and be subject to natural physical laws of load and support. Seen on this immense scale, the thrusts and counterthrusts, the taut and perfect spanning of great spaces, the razor-sharp interlocking of points of stress all contrive to plunge the observer into a dizzying tour-de-force of aesthetic engineering.

> Frank Stella (Baltimore: Penguin, 1971), pp. 48-49

What brief advice can be given about responding to nonobjective painting? Perhaps only this (and here is something of a repetition of what has already been said about representational drawings and paintings): As you look at the work, begin with your responses to the

dynamic interplay of colors, shapes, lines, textures (of pigments and of the ground on which the pigments are applied), size of the work (often large), and

shape of the work (most are rectangular or square, but especially in the 1960s many are triangular, circular, chevron-shaped, diamond-shaped, and so on).

Consider also the title.

Finally, remember that making a comparison is one of the most effective ways of seeing things. How does this work differ from that work, and what is the effect of the difference?

Sculpture

For what **purpose** was this object made? To edify the faithful? To commemorate heroism? The purpose of the Vietnam Veterans

Memorial, dedicated in 1982, was radically changed in 1984, as both the admirers and the foes of the original memorial admit, by the addition of a 50-foot flagpole and an 8-foot sculpture of three soldiers. Maya Lin's original design called only for a pair of 200-foot black granite walls that join to make a wide V, embracing a gently sloping plot of ground. On the walls, which rise from ground level to a height of 10 feet at the vertex, are inscribed the names of the 57,939 Americans who died in Vietnam. Opponents of this design argued that it commemorated the dead but ignored the veterans who survived, and was silent about the justice of the cause. The monument said nothing about heroism, these detractors claimed, in contrast to the Marine Corps Memorial across the Potomac River, which consists of a statue of marines raising the American flag on Iwo Jima. (One might reply that the Vietnam Memorial, which records the names of those who died, focuses on individuals, whereas the Marine Corps Memorial focuses on the collective heroism of one branch of the armed services.) The politically conservative National Review

Maya Lin, The Vietnam Veterans Memorial, 1982. (UPI/Bettmann Newsphotos)

argued in an editorial that Lin's memorial implied an antiwar stance in its black color and in its V-shaped walls ("the antiwar signal, the V protest made with the fingers"). One respondent wrote that the V should be perceived as "the chevron of the PFC who bore the brunt in the fighting of the war." Other defenders of the original design argued that the site itself—"sacred ground between the Washington Monument and the Lincoln Memorial"—adequately testified to the cause.

The Federal Fine Arts Commission, which has authority over the design and location of federal monuments, came up with a compromise: The flagpole and the sculpture of the three soldiers were added to the original design, but they were placed near an entrance to the memorial, whereas their proponents wanted the soldiers to form a centerpiece within the triangular plot of land embraced by the walls, and the flagpole to stand at the apex of the V. Advocates of the original design remain unhappy, arguing that it has become a mere backdrop to the figurative sculpture, and that the new composite monument replaces dignity, poignancy, and a symbol of loss with simplistic patriotism or, more bluntly, with a symbol of war. In any case, one cannot doubt that the two factions envisioned different purposes, and the purposes shaped the memorial that each proposed.

What are the **sources** or previous models? How does this piece differ from them?

What is expressed through the representation? What, for instance, does the highly ordered, symmetrical form of *King Chefren* (p. 48) suggest about the man? If the sculpture is a head, to what extent is it a portrait, a face revealing a particular appearance and personality at a moment in time? What is the relationship of naturalism to abstraction? If the sculpture represents a deity, what ideas of divinity are expressed? If a human being as a deity (e.g., Alexander the Great as Herakles, or King Chefren as the son of an Egyptian deity), how are the two qualities portrayed?

If the work is a **portrait**, some of the questions already suggested for painted portraits (pp. 31–32) may be relevant. Consider especially if the work presents a strong sense of an individual or, on the other hand, of a type. Paradoxically, a work may do both: Roman portraits from the first to the middle of the third century are (for the most part) highly realistic images of the faces of older men, the

conservative nobility who had spent a lifetime in public office. Their grim, wrinkled faces are highly individualized, and yet these signs of age and care indicate a rather uniform type, supposedly devoted and realistic public servants who scorn the godlike posturing and feigned spontaneity of such flashy young politicians as Caesar and Pompey. That is, although the model might not in fact have been wrinkled, it apparently was a convention for a portrait bust to show signs of wear and tear, such as wrinkles, thereby indicating that the subject was a hard-working, mature leader. In other societies such signs of mortality may be removed from leaders. For instance, African portrait sculpture of leaders tends to present idealized images. Thus, in Ife bronzes from the twelfth century, rulers show a commanding stance and a fullness of body, whereas captives (shown in order to say something not about themselves but about their conqueror) may be represented with bulging eyes, wrinkled flesh, and bones evident beneath the skin. In keeping with the tradition of idealizing, commemorative images of elders usually show them in the prime of life.

What does the **pose** imply? Effort? Rest? Arrested motion? Authority? In the Lincoln Memorial, Lincoln sits; in the Jefferson Memorial, Jefferson stands, one foot slightly advanced. Lincoln's pose, as well as his face, suggests weariness, while Jefferson's pose, as well as his faintly smiling face, suggests confidence and action. How relevant to a given sculpture is Rodin's comment that "The body always expresses the spirit for which it is the shell"? If the work is a bust, does it imply a stance or does it seem to float freely?

How forceful or how tenuous is the expression of three-dimen-

sionality?

Are certain bodily features or forms distorted? If so, why? (In most African equestrian sculpture, the rider—usually a chief or an ancestor—dwarfs the horse, in order to indicate the rider's high

status.)

To what extent is the **drapery** independent of the body? Does it express or diminish the **volumes** (enclosed spaces, e.g., breasts, knees) that it covers? Does it draw attention to specific points of focus, such as the head or hands? Does it indicate bodily motion or does it provide an independent harmony? What does it contribute to whatever the work expresses? If the piece is a wall or niche sculpture, does the pattern of the drapery help to integrate the work into the façade of the architecture?

What do the **medium** and the **techniques** by which the piece was shaped contribute? Clay is different from stone or wood, and stone or wood can be rough or they can be polished. Would the statue of Chefren (also called Khafre, Egyptian, third millenium B.C., p. 48) have the same effect if it were in clay instead of in highly polished diorite? Can one imagine Daniel Chester French's marble statue of Lincoln, in the Lincoln Memorial, done in stainless steel? What are the associations of the material, and, even more important, what is the effect of the tactile qualities, for example, polished wood versus terra cotta? Notice that the tactile qualities result not only from the medium but also from the **facture**, that is, the process of working on the medium with certain tools. An archaic Greek *kouros* ("youth") may have a soft, warm look not only because of the porous marble but because of traces left, even after the surface was smoothed with abrasives, of the sculptor's bronze punches and (probably) chisels.

Consider especially the distinction between carving and modeling, that is, between cutting away, to release the figure from the stone or wood, and, on the other hand, building up, to create the figure out of lumps of clay or wax. Rodin's Walking Man (p. 134), built up by modeling clay and then cast in bronze, recalls in every square inch of the light-catching surface a sense of the energy that is expressed by the figure. Can one imagine Michelangelo's David (p. 24), carved in marble, with a similar surface? Even assuming that a chisel could in fact imitate the effects of modeling, would the surface thus produced catch the light as Rodin's does? And would such a surface suit the pose and facial expression of David? Similarly, King Chefren was carved; the sculptor, so to speak, cut away from the block everything that did not look like Chefren, whereas Mercury (p. 49) was modeled—built up—in clay or wax, and then cast in bronze. The massiveness or stability of King Chefren partakes of the solidity of stone, whereas the elegant motion of Mercury suggests the pliability of clay, wax, and bronze.

What kinds of volumes are we looking at? Geometric (e.g., cubical, spherical) or irregular? Is the **silhouette** (outline) open or closed? (In Michelangelo's *David*, David's right side is said to be closed because his arm is extended downward and inward; his left side is said to be open because the upper arm moves outward and the lower arm is elevated toward the shoulder. Still, although the form of *David* is relatively closed, the open spaces—especially the space

Egyptian, King Chefren, ca. 2500 B.C. Diorite, 5'6". Egyptian Museum, Cairo. (Hirmer Fotoarchiv. Hirmer Verlag, München)

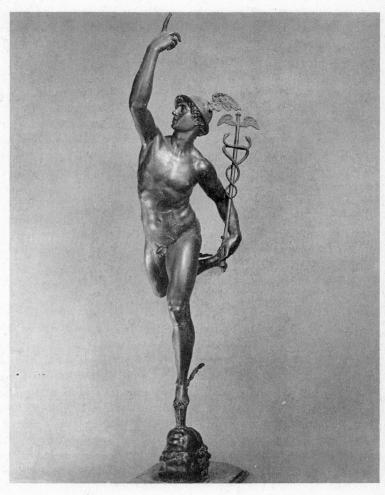

Giovanni da Bologna, *Mercury*. 1580. Bronze, 69". National Museum, Florence. (Alinari/Art Resource)

between the legs—emphasize the potential expansion or motion of the figure. See page 24.) What does the unpierced, thoroughly closed form of *King Chefren*, in contrast to the open form of Giovanni da Bologna's *Mercury*, imply about the subject?

What is the effect of **color**, either of the material or of paint? Is color used for realism or for symbolism? Why, for example, in the tomb of Urban VIII, did Giovanni Bernini use bronze for the sarcophagus (coffin), the pope, and Death, but white marble for the figures of Charity and Justice? The whiteness of classical sculpture is usually regarded as suggesting idealized form (though in fact the Greeks tinted the stone and painted in the eyes), but what is the effect of the whiteness of George Segal's plaster casts (p. 51) of ordinary figures in ordinary situations? Blankness?

What is the **size**? King Chefren and David are larger than life, Mercury (69 inches to the tip of his extended finger) somewhat smaller than life. What does the size contribute to the meaning or effect?

What was the original **site** or physical context (e.g., a pediment, a niche, or a public square)?

Is the **base** a part of the sculpture (e.g., rocks, or a tree trunk that helps to support the figure), and, if so, is it expressive as well as functional? George Grey Barnard's *Lincoln—the Man*, a bronze figure in a park in Cincinnati, stands not on the tall classical pedestal commonly used for public monuments but on a low boulder—a real one, not a bronze copy—emphasizing Lincoln's accessibility, his down-to-earthness. Almost at the other extreme, the flying *Mercury* (p. 49) stands tiptoe on a gust of wind, and at the very extreme, Marino Marini's *Juggler* is suspended above the base, emphasizing the subject's airy skill. Compare, too, the implications in the uneven base of Rodin's *L'Homme qui marche* (*Walking Man*; p. 134) with the implications (echoed in the throne and also in the figure) of the base of *King Chefren*. Finally, the pedestal of a statue of Lenin, in a railroad station in Leningrad, is an armored car carved out of stone.

Where is the best place (or where are the best places) to stand in order to experience the work? How close do you want to get? Why? What effect on you does the size of the piece have?

Caution: Photographs, of course, are an enormous aid; we can see details of a work that, even if we were in its presence, might be

George Segal, *The Bus Riders*. 1964. Plaster, metal, and vinyl, 69 × 40 × 76". Hirshhorn Museum and Sculpture Garden, Smithsonian Institution, Washington, D.C. (Gift of Joseph H. Hirshhorn, 1966)

invisible because the work is high above us on a wall or because it is shrouded in darkness. But one must remember:

- 1. because a photograph is two-dimensional, it gives little sense of a sculpture in the round;
- 2. a photograph may omit or falsify color, and it may obliterate distinctive textures;
- 3. the photographer's lighting may be misleading, playing up

- details that are meant to be subordinate or unduly emphasizing some volumes;
- 4. a photograph may not take account of the angle from which the work was supposed to be seen, as when we look at a photograph of Michelangelo's *Moses*, taken straight-on, though the work was supposed to be above the viewer;
- 5. generally, photographs do not afford a sense of scale; for example, one may see Michelangelo's *David* (about thirteen feet tall) as no bigger than a toy soldier, unless, as in the unusual photograph on page 24, human viewers are included.

Architecture

You may recall that Auden said (p. 3) that a critic can "throw light upon the relation of art to life, to science, economics, religion, etc." Works of architecture, since they are created for use, especially can be seen in the context of the society that produced them. As the architect Louis Sullivan said, "Once you learn to look upon architecture not merely as an art, more or less well or badly done, but as a social manifestation, the critical eye becomes clairvoyant, and obscure, unnoted phenomena become illumined."

The Roman architect Vitruvius suggested that buildings can be judged according to their *utilitas*, *firmitas*, and *venustas*, that is, according to their fitness for their purpose, their structural soundness, and their beauty; or, in Richard Krautheimer's version, their function, structure, and design. Much (though not all) of what follows is an amplification of these three topics.

What is the purpose of the building? Is this its original purpose? If not, what was it originally intended for?

Does the building appear today as it did when constructed? Has it been added to, renovated, restored, or otherwise changed in form?

What does the building say? "All architecture," wrote John Ruskin, "proposes an effect on the human mind, not merely a service to the human frame." One can distinguish between function as housing and function as getting across the patron's message. A nineteenth-century bank said, by means of its bulk, its bronze doors, and its barred windows, that your money was safe; and it also said,

since it had the façade of a Greek temple, that money was holy. A modern bank, full of glass and color, is more likely to say that money is fun. Some older libraries look like Romanesque churches, and the massive J. Edgar Hoover FBI building in Washington looks like—well, like the FBI. What, then, are the architectural traditions behind the building that contribute to the building's expressiveness? The Boston City Hall (p. 56), for all its modernity and (in its lower part) energetic vitality, is tied together in its upper stories by forceful bands of windows, similar in their effect to a classical building with columns. (Classical façades, with columns, pediments, and arches, are by no means out of date. One can see versions of them, often slightly jazzed up, as the entrances to malls and high-style retail shops that wish to suggest that their goods are both timeless and in excellent taste.)

Here is how Eugene J. Johnson sees (or hears) Mies van der Rohe's Seagram Building (1954–1957):

Austere, impersonal, and lavishly bronzed, it sums up the power, personality, and wealth of the modern corporation, whose public philanthropy is symbolized by the piazza in front, with its paired fountains—private land donated to the urban populace. If the piazza and twin fountains call to mind the Palazzo Farnese in Rome, so be it, particularly when one looks out from the Seagram lobby across an open space to the Renaissance-revival façade of McKim, Mead and White's Racquet Club which quotes the garden façade of Palazzo Farnese! Mies set up a brilliant conversation between two classicizing buildings, bringing the nineteenth and twentieth centuries together without compromise on either part. Mies was in many ways the great classicist of this century. One might say that one of his major successes lay in fusing the principles of the great classical tradition of Western architecture with the raw technology of the modern age.

Eugene J. Johnson, "United States of America," in *International Handbook of Contemporary Developments in Architecture*, ed. Warren Sanderson (Westport, Conn.: 1981), p. 506

Notice, by the way, how Johnson fuses description (for instance, "lavishly bronzed") with interpretive analysis (he sees in the bronze the suggestion of corporate power). Notice, too, how he connects the building with history (the debt of the piazza and twin fountains to the Palazzo Farnese), and how he connects it with its site (the "conversation" with a nearby building).

Like other buildings, museums (whether they resemble Greek temples and are entered only after a heavenward ascent of a great flight of steps, or whether they are insistently high-tech) and the exhibition spaces within museums make a statement. Here is an analysis of the statement made by a space exhibiting the work of a contemporary artist:

Because it is open at the front, like a box stage or even a chapel, the vestibule gallery of the retrospective exhibition of Frank Stella's work from 1970 to 1987 at the Museum of Modern Art communicates the sense that this is a special sort of space, set off from the mere public spaces of the museum.

Arthur C. Danto, Encounters and Reflections (New York: Farrar, Straus & Giroux, 1991), p. 144

What is the function of ornament, or of any architectural statuary in or on or near the building? To emphasize structure? To embellish a surface? To conceal the joins of a surface?

Do the forms and materials of the building relate to its neighborhood? What does the building contribute to the **site**? What does the site contribute to the building? How big is the building in relation to the neighborhood, and in relation to human beings; that is, what is the **scale**? The Cambridge City Hall (1889; p. 55), atop a slope above the street, crowns the site and announces—especially because it is in a Romanesque style—that it is a bastion of order, even of piety, giving moral significance to the neighborhood below. The Boston City Hall (1968), its lower part in brick, rises out of a brick plaza (p. 56)—the plaza flows into spaces between the concrete pillars that support the building—and seems to invite the crowds from the neighboring shops, outdoor cafés, and marketplace to come in for a look at government of the people by the people, and yet at the same time the building announces its importance.

Does form follow function? For better or for worse? For example, does the function of a room determine its shape? Are there rooms with geometric shapes irrelevant to their purposes? Louis Sullivan said, "Form ever follows function," but Philip Johnson replied, "Forms always follow forms and not function." Is the form symbolic, as it is, for instance, in Eero Saarinen's Trans World Airlines Terminal (p. 57) at Kennedy Airport, where the soaring roof suggests flight?

Cambridge City Hall, 1889. Photograph by G. M. Cushing. In Study of Architectural History in Cambridge, Report Two: Mid-Cambridge (Cambridge Historical Commission, 1967), p. 44.

What is the structural system? What materials are used in the structure? How do the materials contribute to the building's purpose and statement? The idea that marble—the material of the Parthenon—confers prestige dies hard: The Sam Rayburn House Office Building in Washington is clad in marble veneer (costing many millions of dollars) because marble is thought to suggest dignity and permanence. Marble in fact is highly versatile: White or black marble, common in expensive jewelry shops, can seem sleek or aloof; pink or creamy marble, in a boutique with goods for women, can seem soft and warm. Each building material has associations, or at least potential associations. Brick, for instance, often suggests warmth or unpretentiousness and handcraftsmanship. Wood is amazingly versatile. In its rough-bark state it suggests the great

City Hall Plaza Center, 1968. Photograph by Cervin Robinson. In *Architecture Boston* (Boston Society of Architects, 1976), p. 6.

Eero Saarinen, Trans World Airlines Terminal, 1956–1962. John F. Kennedy Airport.

outdoors; trimmed and painted it can be the clapboard and shingles of an earlier America; smooth and sleek and unpainted it can suggest Japanese elegance.

Do the exterior walls seem hard or soft, cold or warm? Is the sense of hardness or coldness appropriate? (Don't simply assume that metal must look cold. A metal surface that reflects images can be bright, lively, and playful. Curves and arches of metal can seem warm and "soft.") Does the material in the interior have affinities with that of the exterior? If so, for better or for worse? (Our experience of an interior brick wall may be very different from our experience of an exterior brick wall.)

Does the exterior stand as a massive sculpture, masking the spaces and the activities within, or does it express them? The exterior of the Boston City Hall (p. 56) emphatically announces that the building harbors a

variety of activities; in addition to containing offices it contains conference rooms, meeting halls, an exhibition gallery, a reference library, and other facilities. Are the spaces continuous? Or are they static, each volume capped with its own roof?

Does the interior arrangement of spaces say something—for example, is the mayor's office in the city hall on the top floor, indicating that he or she is above such humdrum activities as dog licensing, which is on the first floor?

In a given room, what is the function of the walls? To support the ceiling or the roof? To afford privacy and protection from weather? To provide a surface on which to hang shelves, blackboards, pictures? If glass, to provide a view in—or out?

What is the effect of the floor (wood, tile, brick, marble, carpet)? Notice especially the effect if you move from a room floored with one material (say, wood) to another (say, carpet).

Is the building inviting? The architect Louis Kahn said, "A building should be a . . . stable and harboring thing. If you can now [with structural steel] put columns as much as 100 feet apart you may lose more than you gain because the sense of enclosed space disappears." Is the public invited? The Cambridge City Hall has one public entrance, approached by a flight of steps; the Boston City Hall, its lower floor paved with the brick of the plaza, has many entrances, at ground level. What are the implications in this difference?

"There is no excellent Beauty that hath not some strangeness in the proportion." Thus Francis Bacon, in the early seventeenth century. Does the building evoke and then satisfy a sense of curiosity?

What is the role of color? To clarify form? To give sensuous pleasure? To symbolize meaning? (Something has already been said, on page 55, about the effects of the colors of marble.) Much of the criticism of the Vietnam Veterans Memorial centered on the color of the stone walls. One critic, asserting that "black is the universal color of shame [and] sorrow," called for a white memorial.

What part does the changing daylight play in the appearance of the exterior of the building? Does the interior make interesting use of natural light? And how light is the interior? (The Lincoln Memorial, open only at the front, is somber within, but the Jefferson Memorial,

admitting light from all sides, is airy and suggestive of Jefferson's rational—sunny, we might say—view of life.)

As the preceding discussion suggests, architectural criticism usually is based on three topics: (1) the building or monument as an envelope (its purpose, structural system, materials, sources of design, history, and design [articulation of the façade, including the arrangement of windows and doors, ornamentation, color]); (2) the interior (hierarchy of spaces, flow of traffic, connection with the exterior); and (3) the site (relationship of the building to the environment). A fourth topic is the architect's philosophy, and the place of the building in the history of the architect's work.

A few words about the organization of an essay on a building may be useful. Much will depend on your purpose, and on the building, but consider the possibility of using one of these three methods of organization:

- 1. You might discuss, in this order, utilitas, firmitas, and venustas, that is, function, structure, and design (see p. 52).
- 2. You might begin with a view of the building as seen at a considerable distance, then at a closer view, and then go on to work from the ground up, since the building supports itself this way.
 - 3. You might take, in this order, these topics:
 - a. the materials (smooth or rough, light or dark, etc.).
 - b. the general form, perceived as one walks around the building. (Are the shapes square, rectangular, or circular, or what? Are they simple or complex?)
 - c. the façades, beginning with the entrance. (Is the entrance dominant or recessive? How is each façade organized? Is there variety or regularity among the parts?
 - d. the relation to the site, including materials and scale.

Photography

First, a few prefatory words. No one today, we can hope, believes that photography is so mechanical a business that a photograph cannot be a work of art. This now discredited view was fostered, ironically, by Kodak: "You press the button, we do the rest." But let's begin with a different simplification, and divide photographers into two schools, **pictorialists** and **reporters**.

In the early days of photography, especially in the late nineteenth century, some photographers—we are calling them pictorialists—were not content simply to report images of the world around them. They posed their subjects into compositions resembling those of the Old Masters, and used "Rembrandt lighting," that is, a high side light. Or they photographed moonlit lakes, or rural subjects, watching out for Corot's landscapes and for Millet's peasants laboring in the fields. (The influence went both ways: Corot in the late 1840s seems to have imitated the daguerreotype, whose images of trees are rather blurry or gauzy because of the motion of the leaves during the long exposure. It's too simple to say that the photographers imitated the painters, and vice versa. The similarities are probably better accounted for by saying that the work of photographers and painters reveals a shared esthetic.) Moreover, the pictorialists reworked their pictures much as a painter might: They retouched, and they underdeveloped or overdeveloped the negative to produce a desired effect.

Although the most obvious pictorialists are those who, using a soft focus and printing on warm, matte paper, resemble mid-nineteenth-century painters and Impressionists, many later and utterly different photographers produced works that resemble the works of later schools of painting. For example, between 1915 and 1930 we get hard-edged photographs that seem Cubist, such as Paul Strand's photograph of a porch, taken with a tilted camera, or Strand's Abstract Patterns Made by Bowls. "Abstract" photographs—say, a closeup of a toadstool crossed by a blade of grass, or a detail of a stairway, where a viewer sees patterns of lines and dark and light shapes rather than recognizable forms—are strongly influenced by the esthetic standards that also influenced the painting of their day. Not surprisingly, the abstract photographers, reacting against the softness of the images of earlier photographers, tended to use a sharp focus, and they printed their pictures not on matte paper but on cold. hard paper.

It is worth noting, too, that some painters, such as Ben Shahn and Charles Sheeler, were also photographers. A photograph by Sheeler, of a cactus with big flat leaves standing on a cylinder in a corner, is virtually identical with one of his paintings; the photograph is no less indebted than the painting to the collages and constructions of Cubist-influenced painters and sculptors, for both

images seem almost to have been assembled out of cardboard. And, of course, Sheeler's fondness for monochromatic paintings whose surfaces scarcely seem painterly reveals his frequent reliance, in his paintings, on photographs of his subjects.

In recent decades—let's say from the middle 1970s—the chief pictorialists have engaged in manipulated photography and fabricated photography. A manipulated photograph has been altered. For example the photographer may draw on the negative, or on the photograph (William Wegman took a photo of his dog, and then added, in ink, the ears and whiskers of a cat); or the photographer may deliberately smudge the still-wet emulsions of a Polaroid print in order to give a somewhat surrealistic effect. A fabricated photograph shows an obviously invented circumstance, for instance a jungle made of a couple of plants, with a dog who has been turned into an elephant by means of a long sock put on to his snout (Wegman again).

Now let's turn to the *reporters*, the "straight" photographers, the supposedly objective people who give us the stuff of ordinary life, unposed. Kodak's early slogan, "You press the button, we do the rest," implies that photography is just a matter of recording what happens to be around. Kodak of course was just trying to sell cameras, but the great photographer Robert Capa professed to hold a similar view of photography. Talking about his photographs of the Spanish Civil War he said, "No tricks are necessary to take pictures in Spain. . . The pictures are there, and you just take them. The truth is the best picture, the best propaganda." Thinking of this sort has led to the **snapshot esthetic:** The images (usually of people) are taken at eye level in daylight, with the subject in the center of the frame, and with some unplanned "marginalia" that give the picture its spontaneity and complexity.

We seem to be turning from Beauty to Truth, or (if one wants to say that all art communicates truth) from Ideal Truth to the Truth of the Moment. But, it is evident, a photograph does not have to look like an Impressionist painting or a Rembrandt portrait or a Millet genre scene to be called pictorial. A scene of a woman at work in a mill may at first glance appear to be simply a document, a report valuable for the message that it records rather than for its inherent beauty; yet it, too, if it holds us, probably does so largely by its form. Even a newspaper photograph or an amateur's snapshot does not in fact record the object as it really is. It records what you would see if

you had only one eye and stood at a particular place at a particular time of day, and if what you saw was printed on a particular kind of

paper.

To take the most obvious points of mind over mechanism: The photographer selects the subject, the time at which to photograph it (hence the lighting), and the composition, for in taking a photograph one backs up a little, shifts to the left a bit, bends one's legs, waits for the right moment, and so forth. As Antonioni said, "Every camera position represents a moral decision." Granted, "pictorial" photographs are more obviously personal or subjective than are the photographs of reporters, but no photograph taken by a human being can be utterly "objective." Most of the reporters, then, can say with the photographer Minor White, "I don't take pictures, I make them."

Many of the questions on drawing and painting (pp. 31–43)—for example, those on line (edges may be hard or soft), composition, and even color—can be usefully asked of photographs too.

Here, however, are a few additional questions.

Does the picture yield all that it has to offer in a glance? Or does the picture sustain and perhaps increase its initial appeal with repeated viewings? Why? Because of the composition, or interesting forms, especially of light and dark? (More about composition in a moment.) Symbolism? Detail (e.g., a face that, whatever its character, is a fascinating map)? Revelation of character, not only through the face but through posture, gesture, and setting (including the angle of vision and the lighting)? Anecdote (or narrative)? Irony, or humor?

Does the photograph capture what Henri Cartier-Bresson calls the "decisive moment"? The term alludes not only to an action at its peak but also to the moment when all elements in the composition come together to reveal a formal—usually geometric—beauty. Cartier-Bresson writes, "I have a passion for geometry. My greatest joy is the surprise of facing a beautiful organization of forms." On the other hand, one can find pictures that appeal not because they have the order of geometry but, so to speak, the messy order of life.

Does the **angle of vision** (eye level, or slightly or greatly above or below eye level) say something?

Does **light** give meaning to the subject? Does light reveal a new aspect of a commonplace subject?

63

Is the **focus** expressive? Certain parts of the picture may be out of focus, to concentrate a viewer's attention on the focused parts, or to convey, perhaps, a dreamlike quality. If movement is blurred, is the blurring effective? (Incidentally, we do not in fact see swift activity as blurred. The use of blur to imply speed is a convention.)

Is the choice of **print size** expressive? The print of a photograph may be one inch square, or it may cover a wall.

What **process** was used? The differences among photographic processes can be very great. For instance, albumen prints are smooth, slightly glossy, clear in details, and rich in subtle gradations of tone. Platinum prints are matte, silvery-gray or bluish-gray, and without intense shadows or highlights. What does the process imply?

If you are more than a casual photographer, you may want to ask: How did the photographer get this effect? What kind of lens, or aperture setting, or filter, or film, did the photographer use, and why? Has the picture been cropped, and why?

Let's look now at a photograph (p. 64) by Dorothea Lange, an American photographer who made her reputation with photographs of migrant farmers in California during the depression that began in 1929. Lange's Migrant Mother, Nipomo, California (1936) is probably the best-known image of the period. A student made the following entry in a journal in which he regularly jotted down his thoughts about the material in an art course he was taking. (The student was given no information about the photograph other than its title.)

This woman seems to be thinking. In a way, the picture reminds me of a statue called The Thinker, of a seated man who is bent over, with his hand touching his forehead. But I wouldn't say that this photograph is really so much about thinking as it is about other things. I'd say that it is about several other things. First (but not really in any particular order), fear. The children must be afraid, since they have turned to their mother. Second, the pic—

Dorothea Lange, Migrant Mother, Nipomo, California. Gelatin-silver print, 1936. The Museum of Modern Art, New York.

ture is about love. The children press against their mother, sure of her love. The mother does not actually show her love—for instance, by kissing them, or even hugging them—but you feel she loves them. Third, the picture is about hopelessness. The mother doesn't seem to be able to offer any comfort. Probably they have very little food; maybe they are homeless. I'd say the picture is also about courage. Although the picture seems to me to show hopelessness, I also think the mother, even though she does not know how she will be able to help her children, shows great strength in her face. She also has a lot of dignity. She hasn't broken down in front of the children; she is going to do her best to get through the day and the next day and the next.

Another student wrote:

Is this picture sentimental? I remember from American Lit that good literature is not sentimental. (When we discussed the word, we concluded that "sentimental" meant "sickeningly sweet.") Some people might think that Lange's picture, showing a mother and two little children, is sentimental, but I don't think so. Although the children must be upset, and maybe they even are crying, the mother seems to be very strong. I feel that with a mother like this, the children are in very good hands. She is not "sickeningly sweet." She may be almost overcome with despair, but she doesn't seem to ask us to pity her.

A third student wrote:

Why does this picture bother me? It's like those pictures of the homeless in the newspapers and on TV. A photographer sees some man sleeping in a cardboard box, or a woman with shopping bags sitting in a doorway, and he takes their picture. I suppose the photographer could say that he is calling the public's attention to "the plight of the homeless," but I'm not convinced that he's doing anything more than making money by selling photographs. Homeless people have almost no privacy, and then some photographer comes along and invades even their doorways and cardboard houses. Sometimes the people are sleeping, or even if they are awake they may be in so much despair that they don't bother to tell the photographer to get lost. Or they may be mentally ill and don't know what's happening. In the case of this picture, the woman is not asleep, but she seems so preoccupied that she isn't aware of the photographer. Maybe she has just been told there is no work for her, or maybe she has been told she can't stay if she keeps the children. Should the photographer have intruded on this woman's sorrow? This picture may be art, but it bothers me.

All of these entries are thoughtful, interesting, and helpful—material that can be the basis of an essay—though of course even taken together they do not provide the last word. Here are a few additional points.

First, it happens that Lange has written about the picture. She said that she had spent the winter of 1935–1936 taking photographs of migrants, and now, in March, she was preparing to drive 500

miles to her home, when she noticed a sign that said, "Pea-Pickers Camp." Having already taken hundreds of pictures, she drove on for 20 miles, but something preyed on her mind, and she made a U-turn and visited the camp. Here is part of what she wrote.

I saw and approached the hungry and desperate mother, as if drawn by a magnet. I do not remember how I explained my presence or my camera to her, but I do remember she asked me no questions. I made five exposures, working closer and closer from the same direction. I did not ask her name or her history. She told me her age, that she was thirty-two. She said that they had been living on frozen vegetables from the surrounding fields, and birds that the children killed. She had just sold the tires from her car to buy food. There she sat in that lean-to tent with her children huddled around her, and seemed to know that my pictures might help her, and so she helped me. There was a sort of equality about it. . . . What I am trying to tell other photographers is that had I not been deeply involved in my undertaking on that field trip, I would not have had to turn back. What I am trying to say is that I believe this inner compulsion to be the vital ingredient in our work.

Dorothea Lange, "The Assignment I'll Never Forget," Popular Photography 46:2 (February 1960): 43

Lange does not say anything about posing the woman and her child, and we can assume that she had too much decency to ask a woman and children in these circumstances to arrange themselves into an interesting pictorial composition. Furthermore, it seems obvious that unlike, say, a figure in a wedding portrait, the woman is not striking a pose. She has not deliberately prepared herself for a picture that will represent her to the public. Nevertheless, the composition—the way things are put together—certainly contributes to the significance of the picture. Of course the subject matter, a mother with children, may suggest the traditional madonna and child of the Middle Ages and the Renaissance, but the resemblance is not just in the subject matter. Lange's photograph may remind us of paintings in which the madonna and the infant Jesus form a unified composition, their heads and limbs harmonizing and echoing each other. The photograph, with its near-balance—a child on each side, the mother's bare left arm balanced by the child's bare arm, the mother's hand at one side of her neck echoed by the child's hand at the other side—achieves a stability or a harmony that helps to make the painfulness of the subject acceptable. That is, although the subject may be painful, it is possible to take some pleasure in the way in which it is presented. That the faces of the children are turned away probably helps to make the subject acceptable. If we saw not only the woman's face but also the faces of two hungry children, we might feel that Lange was tugging too vigorously at our heartstrings.

Another Look at the Questions

In short, you can stimulate responses (and understanding) by asking yourself two kinds of questions:

- 1. What is this doing? Why is this figure here and not there? Why is the work in bronze rather than in marble? Or put it this way: What is the artist up to?
- 2. Why do I have this response? Why do I find this landscape oppressive, this child sentimental but that child fascinating? That is, how did the artist manipulate the materials in order to produce the strong feelings that I experience?

The first of these questions (What is this doing?) requires you to identify yourself with the artist, wondering, perhaps, whether pen is better than pencil for this drawing, or watercolor better than oil paint for this painting. One senses that Eugene J. Johnson may have put to himself questions of this sort before making the following points about Eero Saarinen's Terminal Building at Dulles International Airport (1958–1962):

Rising majestically out of the flat countryside, the broad, low structure echoes, in its strong horizontal roof supported by regularly spaced posts, the classical architecture of Washington, and perhaps even the great porch of George Washington's house at nearby Mount Vernon. Indeed, the whole terminal is a porch. Departing or arriving, the traveler experiences the building as a semi-enclosed space that lies between the enclosed space of the airplane or of the bus that brings the traveler to the terminal proper and the open Virginia landscape that waits outside.

International Handbook of Contemporary Developments in Architecture, ed. Warren Sanderson (Westport, Conn.: 1981), p. 509

Sometimes artists tell us what they are up to. Van Gogh, for example, in a letter to his brother, helps us to understand why he put a blue background behind the portrait of a blond artist: "Behind the

Doonesbury

BY GARRY TRUDEAU

Doonesbury, August 28, 1985. Copyright © 1985 G. B. Trudeau. Reprinted with permission of Universal Press Syndicate. All rights reserved.

head instead of painting the ordinary wall of the mean room, I paint infinity, a plain background of the richest, intensest blue that I can contrive, and by the simple combination of the bright head against the rich blue background, I get a mysterious effect, like a star in the depths of an azure sky." But, of course, you cannot rely on the artist's statement of intention; the intention may not be fulfilled in the work itself.

The second question (Why do I have this response?) requires you to trust your feelings. If you are amused or repelled or unnerved or soothed, assume that these responses are appropriate and follow them up—but not so rigidly that you exclude the possibility of other, even contradictory feelings. (The important complement to "Trust your feelings" is "Trust the work of art." The study of art ought to enlarge feelings, not merely confirm them.)

Questions like these are not childish; excellent scholars have left traces of them in their writings. Nikolaus Pevsner, for example, writes of Michelangelo's sculptures in the ducal tombs in the Medici Chapel:

The question has often been asked what made him keep the untreated stone below his reclining figures of *Day and Night* and *Morning* and *Evening*. The answer is that he wanted to let them appear in the act of coming to life out of a stony, subhuman preexistence. To shape the image of man entirely liberated from these dark forces must have seemed almost a sacrilege to the young and again the very old Michelangelo. Hence also his many unfinished works.

"The Architecture of Mannerism," The Mint, I (1946); in Readings in Art History, 2nd ed., ed. Harold Spencer (New York: Scribner's, 1976), II, 121

Here is another example; this time the writer asks a question but can't answer it. Kenneth Clark is talking about Rembrandt's Samson Betrayed by Delilah.

Incidentally, the Macbeth-like figure in the back must be one of the earliest representations in art of a kilt and plaid. How did Rembrandt come by it? Had he seen a drawing of a Highlander, or is it based on some engraving of a barbarian on Trajan's column?

An Introduction to Rembrandt (New York: Harper & Row, 1978), p. 54 Someday an art historian will turn up a convincing answer, and it will help us—even though only to a tiny degree—better to understand Rembrandt's art.

In fact, art-historical research is largely an attempt to explain certain results—let's say, the new style of painting that arose in Flanders in about 1420—by setting forth causes. That is, the historian asks, Why, and searches for explanations.

FORMAL ANALYSIS VERSUS DESCRIPTION

First, it should be understood that the word formal in "formal analysis" is not used as the opposite of informal, as in a formal dinner or a formal dance. Rather, a formal analysis is an analysis of the form the artist produces, that is, an analysis of the work of art, which is made up of such things as line, shape, color, texture. These things give the stone or canvas its form, its expression, its content, its meaning. Second, it should be mentioned that sometimes a distinction is made between formal analysis—an analysis of the configuration of the artistic object itself—and stylistic analysis—an analysis that can include discussion of similar features in related objects; but we need not preserve this distinction.

Is the term formal analysis merely a pretentious substitute for description? Not quite. A description deals with the relatively obvious, reporting what any eye might see: "A woman in a white dress sits at a table, reading a letter. Behind her, . . ." It can also comment on the execution of the work ("thick strokes of paint," "the highly polished surface"), but it does not offer inferences and it does not evaluate. A description tells us, for example, that the head of a certain portrait sculpture "faces front; the upper part of the nose and the rim of the right earlobe are missing. . . . The closely cropped beard and mustache are indicated by short random strokes of the chisel," and so forth.

These statements, from an entry in the catalog of an exhibition, are all true and they can be useful, but they scarcely reveal the thought, the reflectiveness, that we associate with analysis. When the entry in the catalog goes on, however, to say that "the surfaces

below the eyes and cheeks are sensitively modeled to suggest the soft, fleshly forms of age," we begin to feel that now indeed we are reading an analysis. Similarly, although the statement that "the surface is in excellent condition" is purely descriptive (despite the apparent value judgment in "excellent"), the statement that the "dominating block form" of the portrait contributes to "the impression of frozen tension" can reasonably be called analytic.

Much of any formal analysis will inevitably consist of description ("The pupils of the eyes are turned upward"), and accurate descriptive writing itself requires careful observation of the object and careful use of words. But an essay is a formal analysis rather than a description only if it seeks to show *how* the described object works. For example, "The pupils of the eyes are turned upward, suggesting a heaven-fixed gaze, or, more bluntly, suggesting that the figure is divinely inspired."

Another way of putting it is to say that analysis tries to answer the somewhat odd-sounding question, "How does the work mean?" Thus, the following paragraph is chiefly analytic rather than descriptive. The author has made the point that a Protestant church emphasizes neither the altar nor the pulpit; "as befits the universal priesthood of all believers," he says, a Protestant church is essentially an auditorium. He then goes on to analyze the ways in which a Gothic cathedral says or means something very different:

The focus of the space on the interior of a Gothic cathedral is . . . compulsive and unrelievedly concentrated. It falls, and falls exclusively, upon the sacrifice that is re-enacted by the mediating act of priest before the altar-table. So therefore, by design, the first light that strikes the eye, as one enters the cathedral, is the jeweled glow of the lancets in the apse, before which the altar-table stands. The pulsating rhythm of the arches in the nave arcade moves toward it; the string-course moldings converge in perspective recession upon it. Above, the groins of the apse radiate from it; the ribshafts which receive them and descend to the floor below return the eye inevitably to it. It is the single part of a Gothic space in which definiteness is certified. In any other place, for any part which the eye may reach, there is always an indefinite beyond, which remains to be explored. Here there is none. The altar-table is the common center in which all movement comes voluntarily to rest.

John F. A. Taylor, Design and Expression in the Visual Arts (New York: Dover, 1964), pp. 115-117

In this passage the writer is telling us, analytically, how the cathedral means.

Still another way of putting the matter is to say that an essay on art usually advances a thesis. It does not merely report what is evident, but it presents an interpretation. Thus, on page 4, Kenneth Clark advances the thesis (or, since his thesis is tentative, we can call it a hypothesis) that Rembrandt's Self-Portrait with Saskia "may express some psychological need in Rembrandt to reveal his discovery that he and his wife were two very different characters." On page 6 Robert Herbert advances the thesis that Millet's The Gleaners celebrates the heroic nature of the peasants, and on page 26 Arnheim advances the thesis that "the structural skeleton [of The Creation of Adam] reveals the dynamic theme of the story." The arguments may not be convincing, that is, they may not be adequately supported, but they are arguments, assertions of a thesis, not mere descriptions.

STYLE AS THE SHAPER OF FORM

This chapter has in large measure been talking about style, and it is now time to define this elusive word. The first thing to say about style is that the word is not used by most art historians to convey praise, as in "He has style." Rather, it is used neutrally, for everyone and everything made has a style-good, bad, or indifferent. The person who, as we say, "talks like a book" has a style (probably an annoying one), and the person who keeps saying "Uh, you know what I mean" has a style too (different, but equally annoying). Similarly, whether we wear jeans or painter's pants or gray flannel slacks, we have a style in our dress. We may claim to wear any old thing, but in fact we don't; there are clothes we wouldn't be caught dead in. The clothes we wear are expressive; they announce that we are police officers or bankers or tourists or college students-or at least they show what we want to be thought to be, as when in the sixties many young middle-class students wore tattered clothing, thus showing their allegiance to the poor and their enmity toward what was called the Establishment. It is not silly to think of our clothing as a sort of art that we make. Once we go beyond clothing as something that merely serves the needs of modesty and that provides

protection against heat and cold and rain, we get clothing whose style is expressive.

To turn now to our central topic, style in art, we can all instantly tell the difference between a picture by van Gogh and one by Norman Rockwell or Walt Disney, even though the subject matter of all three pictures may be the same, for instance, a seated woman. How can we tell? By the style, that is, by line, color, medium, and so forth-all of the things we talked about earlier in this chapter. Walt Disney's figures tend to be built up out of circles and ovals (think of Mickey Mouse), and the color shows no modeling or traces of brush strokes; Norman Rockwell's methods of depicting figures are different, and van Gogh's are different in yet other ways. Similarly, a Chinese landscape, painted with ink on silk or on paper, simply cannot look like a van Gogh landscape done with oil paint on canvas, partly because the materials prohibit such identity and partly because the Chinese painter's vision of landscape (usually lofty mountains) is not van Gogh's vision. Their works "say" different things. As the poet Wallace Stevens put it, "A change of style is a change of subject."

We recognize certain distinguishing characteristics (from large matters, such as choice of subject and composition, to small matters, such as kinds of brush strokes) that mark an artist, or a period, or a culture, and these constitute the style. Almost anyone can distinguish between a landscape painted by a Chinese and one painted by van Gogh. But it takes considerable familiarity with the styles of Chinese painting to be able to say, "This is a Chinese painting of the seventeenth century, in fact the late seventeenth century. It belongs to the Nanking School and is a work by Kung Hsien—not by a follower, and certainly not a copy, but the genuine article."

Style, then, is revealed in **form**; an artist creates form by applying certain techniques to certain materials, in order to embody a particular vision or content. In different ages people have seen things differently: the nude body as splendid, or the nude body as shameful; Jesus as majestic ruler, or Jesus as the sufferer on the cross; landscape as pleasant, domesticated countryside, or landscape as wild nature. So the chosen subject matter is not only part of the content, but is also part of that assemblage of distinguishing characteristics that constitutes a style.

All of the elements of style, finally, are expressive. Take ceramics as an example. The kind of clay, the degree of heat at which it is baked, the decoration or glaze (if any), the shape of the vessel, the thickness of its wall, all are elements of the potter's style, and all contribute to the expressive form. But every expressive form is not available in every age; certain visions, and certain technologies, are, in certain ages, unavailable. Porcelain, as opposed to pottery, requires a particular kind of clay and an extremely high temperature in the kiln, and these were simply not available to the earliest Japanese potters. In fact, even the potter's wheel was not available to them; they built their pots by coiling ropes of clay and then, sometimes, they smoothed the surface with a spatula. The result is a kind of thick-walled, low-fired ceramic that expresses energy and earthiness, far different from those delicate Chinese porcelains that express courtliness and the power of technology (or, we might say, of art).

PERSONAL STYLE AND PERIOD STYLE

Although each work that an artist produces is an individual work, it is evident that there must be family resemblances among the works, for not even the greatest artists can totally escape the limitations of their age and of their own vision. And so we can reasonably speak of van Gogh's style, or, in an effort to be more precise, of his early or late style, or of his style in still life and of his style in portraiture. We recognize that each work has individual traits, but we find some connections among works. No one questions the usefulness of talking about an artist's personal style—well, no one except Picasso, who denied that he had a style and who liked to believe that each work was a new answer to a new problem.

How useful is it, however, to speak not of the personal style of an individual artist but of the style of a century or so, that is, of a period style? The term, of course, has some validity, for the works of a period at least to some degree share certain features, for reasons of materials and technology, most obviously, but also perhaps because of a shared vision. One may see a resemblance, for instance, between the sculpture and the architecture of a given period. Let's take as an example Roman sculpture and architecture of the early fourth century, but first we must briefly consider what preceded it.

Roman portrait sculpture of the first two and a half centuries A.D. shows a personality *in time*, caught in the act of raising an eyebrow, or frowning, or looking at the viewer. The face, therefore, is not strictly symmetrical, and the hair, whose texture is suggested, usually seems slightly disordered or at least not highly disciplined. And if we take as an example of architecture Hadrian's palace at Tivoli, we find that its buildings are arranged rather freely, not with strict symmetry.

When, however, we turn to Roman sculpture and architecture at the end of the third century and the beginning of the fourth, we find something different. Roman portrait sculpture now shows faces removed from the world of time. The faces are more strictly symmetrical, the hair much more severely patterned, the eyes unnaturally large and staring, the whole face somewhat cubic and masklike rather than highly imitative of a natural form. The 8-foot-high head of Constantine the Great (A.D. 330) is an example of this later Roman style; nothing like it existed in the previous two and a half centuries. And this change in sculpture seems to be paralleled by a change in architecture, for Diocletian's palace at Spalato (A.D. 300–305, in

Palace of Diocletian, A.D. 300-305. Spalato (Split). Reconstruction by E. Hebrard. (Alinari/Art Resource)

Roman, Constantine the Great, ca. A.D. 330. Marble, 8'6". Palazzo dei Conservatori, Rome. (Hirmer Fotoarchiv. Hirmer Verlag, München)

Yugoslavia) is strictly symmetrical, a massive, seemingly impenetrable block.

And so it can be argued that in a given period we see a stylistic similarity—a period style—in different kinds of works of art. Moreover, one can argue that this massive, cubic, consolidated style reflects the spirit of the age, for Constantine, an absolute ruler, established a centralized bureaucracy and did much to unify the Roman Empire.

Yet, a word of caution is necessary in a discussion of period style. Most of us have a tendency to try to make order out of chaos, to see connections even where there may not be connections, and historians (including art historians) are not exceptions. For instance, the historian who tries to catch the spirit of the age of the Gothic period may tell us that it can be seen not only in its painting, sculpture, and architecture but also in its philosophy. The assumption (often unstated) is that all of the activities of a period *must* be related, or, to put it in other words, that there is a period style. Thus, it has been said that Gothic art is fond of innumerable subdivisions and multiplicity of forms and that we find these qualities not only in a cathedral but also in the writings of Thomas Aquinas.

But how far can we push this idea that a period manifests a spirit in all of its productions? The very term *Gothic period* is a historian's invention, an attempt to impose order. Having imposed this simplification, the historian then begins to feel a bit uneasy and distinguishes between Early Gothic and Late Gothic, then between Early English Gothic and Early French Gothic, and so on. Is there really an all-embracing style in a given period? One can be skeptical, and a simple analogy may be useful. A family often consists of radically different personalities: improvident husband, patient wife, one son an idler and the other a go-getter, one daughter wise in her choice of career and the other daughter unwise. And yet all may have come from the same culture. Or take the individual: A man may have wretched table manners, but he may also paint beautifully.

A Gothic painting, of course, resembles other Gothic paintings infinitely more than it resembles a painting by Rembrandt, and a Gothic painting may bear some resemblances to Gothic architecture. It may even in some ways resemble medieval law—but then again, it

may not. We do well when we try to see the hidden connections between things, but we do badly when we suppress the rich, individualizing details that give a work its value and we see only some forced and not very interesting similarity. It is useful to keep in mind Bishop Butler's words: "Everything is what it is, and not another thing."

SAMPLE ESSAYS: TWO FORMAL ANALYSES

The first analysis, by an undergraduate, includes a good deal of description and is conspicuously impersonal, but notice that even this apparently dispassionate assertion of facts is shaped by a *thesis:* The sculpture successfully combines a highly conventional symmetrical style, on the one hand, with mild asymmetry and a degree of realism on the other.

The second analysis, also by an undergraduate, is somewhat more personal (notice the opening sentence), but it, too, is chiefly a report on the object (how the form expresses content) rather than a report of casual impressions.

Stephen Beer

Formal Analysis: Prince Khunera as a Scribe

Prince Khunera as a Scribe, a free-standing Egyptian sculpture twelve inches tall, now in the Museum of Fine Arts, Boston, was found at Giza in a temple dedicated to the father of the prince, King Mycerinus. The limestone statue may have been a tribute to that Fourth Dynasty king. The prince, sitting cross-legged with a scribal tablet on his lap, rests his hands on his thighs. He wears only a short skirt or kilt.

¹Museum label.

The statue is in excellent condition although it is missing its right forearm and hand. Fragments of the left leg and the scribe's tablet also have been lost. The lack of any difference in the carving between the bare stomach and the kilt suggests that these two features were once differentiated by contrasting paint that has now faded, but the only traces of paint remaining on the figure are bits of black on the hair and eyes.

The statue is symmetrical, composed along a vertical axis which runs from the crown of the head into the base of the sculpture. The sculptor has relied on basic geometric forms in shaping the statue on either side of this axis.

Thus, the piece could be described as a circle (the head) within a triangle (the wig) which sits atop a square and two rectangles (the torso, the crossed legs, and the base). The reliance on basic geometric forms reveals itself even in details. For example, the forehead is depicted as a small triangle within the larger triangular form of the headdress.

On closer inspection, however, one observes that the rigidity of both this geometric and symmetric organization is relieved by the artist's sensitivity to detail and by his ability as a sculptor. None of the shapes of the work is a true geometric form. The full, rounded face is more of an oval than a circle, but actually it is neither. The silhouette of the upper part of the body is defined by softly undulating lines that represent the muscles of the arms and that modify the simplicity of a strictly square shape. Where the prince's naked torso meets his kilt,

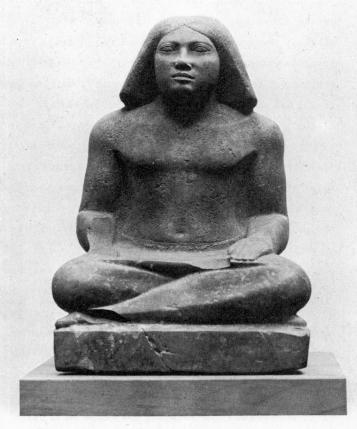

Egyptian, Seated Statue of Prince Khunera (or Khuenre) as a Scribe, Dynasty IV (2599–2571 B.C.). Yellow limestone, 12". Museum of Fine Arts, Boston. (Harvard-Boston Expedition)

just below the waist, the sculptor has suggested portliness by allowing the form of the stomach to swell slightly. Even the "circular" navel is flattened into an irregular shape by the suggested weight of the body. The contours of the base, a simple matter at first glance, actually are not exactly four-square but rather are slightly curvilinear. Nor is the symmetry on either side of the vertical axis perfect: Both the mouth and the nose are slightly askew; the right and left forearms originally struck different poses; and the left leg is given prominence over the right. These departures from symmetry and from geometry enliven the statue, giving it both an individuality and a personality.

Although most of the statue is carved in broad planes, the sculptor has paid particular attention to details in the head. There he attempted to render precisely and with apparent descriptive accuracy the details of the prince's face. The parts of the eye, for example—the eyebrow, eyelids, eyeballs, and sockets—are distinct. Elsewhere the artist has not worked in such probing detail. The breasts, for example, are rendered in large forms, the nipples being absent. The attention to the details of the face suggests that the artist attempted to render a lifelikeness of the prince himself.

The prince is represented in a scribe's pose but without a scribe's tools. The prince is not actually <u>doing</u> anything. He merely sits. The absence of any open spaces (for example, between the elbows and the waist) contributes to the figure's composure or self-containment. But

if he sits, he sits attentively: There is nothing static here. The slight upward tilt of the head and the suggestion of an upward gaze of the eyes give the impression that the alert prince is attending someone else, perhaps his father the king. The suggestion in the statue is one of imminent work rather than of work in process.

Thus, the statue, with its variations from geometric order, suggests the presence, in stone, of a particular man. The pose may be standard and the outer form may appear rigid at first, yet the sculptor has managed to depict an individual. The details of the face and the overfleshed belly reveal an intent to portray a person, not just a member of the scribal profession. Surely when freshly painted these elements of individuality within the confines of conventional forms and geometric structure were even more compelling.

Joan Daremo

Edvard Munch's The Scream

Is there a more unnerving work of art than Munch's lithograph of 1896? Even his painting of the same subject, two years earlier, by virtue of its color (rather than severely contrasting black and white spaces) seems less filled with anguish. This lithograph is almost unbearably agitated: Although the two little boats seem to rest easily on the water, our eyes cannot rest on them, for the thrusting diagonals pull the eyes to the left rear, yet the compelling picture of the central anguished

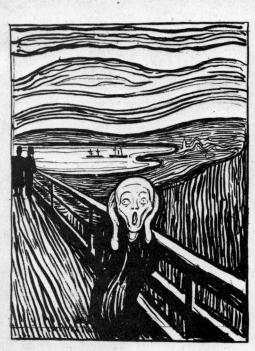

Edinol 1801

Ceschrei

Joh fühlte das grosse Geration Surch die Natur

Edvard Munch, *The Scream* (or *The Shriek*), 1896. Lithograph, printed in black, $20^5/8'' \times 15^{13}/16''$. Collection. The Museum of Modern Art, New York. (Matthew T. Mellon Fund)

figure pulls them forward again. Perhaps there is some calm in the heavens (although even in the sky the vigorous undulating horizontal lines are full of motion) as well as in the water, but the isolated figure in the center is surrounded by, and seems assaulted by, strongly conflicting lines—at the right, verticals that crash into horizontals, and at the left, the diagonals.

At the left, too, walking out of the picture and thus away from the chief figure, two figures stand near each other, forming, we might say, the society from which the central figure is excluded. But even these two figures are separated from each other by a narrow space (this is not a world in which someone can put an arm on another's shoulder) and, more important, by the fact that they are looking in different directions. These two stiff passersby apparently muse on the water, but the screaming wobbly figure, whose bones seem to have dissolved from terror, averts its eyes from (and closes it ears to) the seething surrounding world; it (the figure seems sexless, almost a skull, though some people perceive a female) faces nothing but us, or, rather, the empty space which we occupy, for its eyes are not focused together.

Writing a Comparison

THE USES OF COMPARISON

Analysis frequently involves comparing: Things are examined for their resemblances to and differences from other things. Strictly speaking, if one emphasizes the differences rather than the similarities, one is contrasting rather than comparing, but we need not preserve this distinction; we can call both processes *comparing*.

Although your instructor may ask you to write a comparison of two works of art, the *subject* of the essay is the *works*, or, more precisely, the subject is the thesis you are advancing, for example, that one work is later than the other, or is more successful. Comparison is simply an effective analytical *technique* to show some of the qualities of the works. For example, in a course in architecture you may compare two subway stations (considering the efficiency of the pedestrian patterns, the amenities, and the esthetic qualities), with the result that you may come to understand both of them more fully; but a comparison of a subway station with a dormitory, no matter how elegantly written the comparison is, can hardly teach the reader or the writer anything.

Art historians almost always use comparison in discussing authenticity: A work of uncertain attribution is compared with undoubtedly genuine works, on the assumption that if the uncertain work, when closely compared with genuine works, somehow is markedly different, perhaps in brush technique, it is probably not genuine (here we get to the thesis) despite superficial similarities of, say, subject matter and medium. (This assumption can be challenged—a given artist may have produced a work with unique characteristics—but it is nevertheless widely held.)

Similarly, in holding the assumption that certain qualities in a work indicate the period, the school, perhaps the artist and even the period within the artist's career, historians frequently make use of comparisons in trying to date a work.

Let's assume that there is no doubt about who painted a particular picture, and that the problem is the date of the work. By comparing this work with a picture that the artist is known to have done in, say, 1850, and with yet another that the artist is known to have done in 1870, one may be able to conjecture that the undated picture was done, say, midway between the dated works, or that it is close in time to one or to the other.

Here is a very brief example of this approach. The author is discussing Matteo di Giovanni's Madonna and Child with Saints Jerome and Catherine or Alexandria and Two Angels (National Gallery of Art, Washington).

This picture is the most sumptuous and among the best preserved of Matteo di Giovanni's early paintings of the Madonna and Child. It is usually dated to about 1470 (see Shapley 1979) and related to a panel, signed and dated 1470, in the Pinacoteca Nazionale, Siena (no. 286), showing the Madonna and Child Enthroned with Four Angels. However, it exhibits the naturalism and the exuberantly patterned and decorated fabrics and gold ground—in which the ornamental designs are almost obtrusively oversized—characteristic of Matteo's earliest works. Such details as the Child's strong grip on his mother's collar and the cov, wide-eved expressions of the singing angels-with their open mouths and bared teeth-in addition to the seemingly casual placement of the figures within the composition, suggest that this picture occupies a midway point between the altarpieces from 1462-63 in the cathedral of Pienza and the panel of 1470 in Siena. As such, it would be approximately contemporary with a triptych by Matteo in the Museo d'Arte Sacra, Asciano, in which the dominant influences of Matteo's youth-Domenico di Bartolo and the late works of Sasseta-although recognizable, have been superseded.

> Laurence B. Kanter, in Keith Christiansen, Laurence B. Kanter, and Carl Brandon Strehlke, *Painting in Renaissance Siena 1420–1500* (New York: Metropolitan Museum of Art, 1988), p. 272

Again the assumption (here, that contemporary works by an artist necessarily resemble each other closely) is widely held and it

88

Matteo di Giovanni, Madonna and Child with Saints Jerome and Catherine or Alexandria and Two Angels. National Gallery of Art, Washington.

often seems to produce reasonable results, but it can be challenged. Manet's Woman Writing can be dated fairly precisely because it is inscribed to John Leech, and we know that Manet first met Leech in 1862, and that Leech died in 1864. Yet Françoise Cachin, coauthor of a splendid catalog entitled Manet, admits in her discussion of Woman Writing that "This drawing, so spontaneous and free, would certainly have been assigned a date in the late 1870s were it not for the dedication." To complicate things still further, it should be added that although the evidence for the date of Manet's drawing is conclusive, even a date inscribed by the artist does not always provide trustworthy evidence. For example, Mondrian in the 1940s added dates to some of his earlier paintings, but he was occasionally mistaken and dated several of them incorrectly by a few years.

Edouard Manet, *Woman Writing*, brush and black ink $5^9/16^n \times 6^1/4^n$. Copyright © 1982 Sterling and Francine Clark Art Institute, Williamstown, Mass. Reproduced by permission.

The assumptions underlying the uses of comparison are that am expert can not only recognize the stylistic characteristics of an artist, but can also identify those that are permanent and can establish the chronology of those that are temporary. In practice these assumptions are usually based on yet another assumption: A given artist's early works are relatively immature; the artist then matures, and if there are some dated works, we can with some precision trace this development or evolution. Whatever the merits of these assumptions, comparison is a tool by which students of art often seek to establish authenticity and chronology.

TWO WAYS OF ORGANIZING A COMPARISON

We can call the two ways *splitting* and *lumping*. If you split, you more or less interweave the two things being compared, perhaps in alternating paragraphs, or even in alternating sentences. If you lump, you discuss one thing, and then the other. Here is a paragraph that, in miniature, illustrates splitting. The writer compares a Japanese statue of a Buddha with a Chinese statue of a bodhisattva (a slightly lower spiritual being, dedicated to saving humankind).

The Buddha sits erect and austere, in the lotus position (legs crossed, each foot with the sole upward on the opposing thigh), in full control of his body. In contrast, the bodhisattva sits in a languid, sensuous posture known as "royal ease," the head pensively tilted downward, one knee elevated, one leg hanging down. The carved folds of the Buddha's garments, in keeping with his erect posture, are severe, forming a highly disciplined pattern, whereas the bodhisattva's garments hang naturalistically. Both figures are spiritual but the Buddha is remote, constrained, and austere; the bodhisattva is accessible, relaxed, and compassionate.

In effect the structure is this:

The Buddha (posture)

The Bodhisattva (posture)

The Buddha (garments)

The bodhisattva (garments)

The Buddha and the bodhisattva (synthesis)

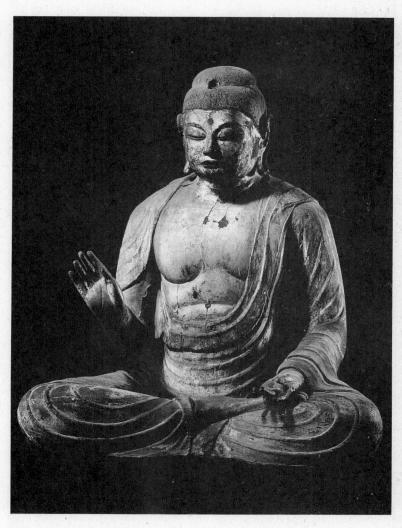

Sakyamuni Buddha (wood, 33½"; Japanese, late tenth century). Museum of Fine Arts, Boston.

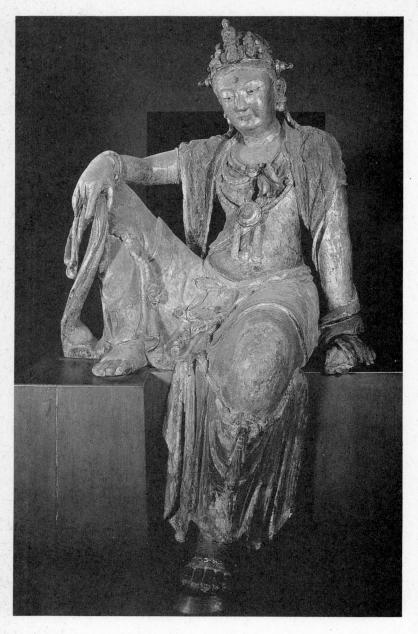

Bodhisattva Kuan Yin (wood, 56½"; Chinese, twelfth century). Museum of Fine Arts, Boston.

Here is an outline, paragraph by paragraph, of an essay built on splitting, comparing two fifteenth-century Italian low-relief carvings of the Madonna and Child, one by Desiderio da Settignano, the other by Agostino di Duccio (pp. 96–97). The essay itself is printed later in this chapter on pages (pp. 95–99).

The two were contemporaries, but their work is markedly different. Desiderio's Madonna has a "natural, homely humanity while Agostino's is elegantly aristocratic."

The differences are evident if we look at the hair; in Desiderio it is less clearly defined than in Agostino, who "treated the hair as a highly stylized pattern of regular lines." The drapery reveals a similar difference.

A comparison of the right forearms and hands of the two Virgins reveals a difference. Agostino . . . ; Desiderio. . . .

The outlines and modeling of the contours differ.

Conclusion: This is not to say that Agostino's relief is more carefully designed or that Desiderio's is more naturalistic—only that Desiderio's design is less obtrusive.

In a comparison it is usually advisable to begin by defining the main issue—here, although the works are of the same period, one depicts "homely humanity," the other depicts "aristocratic" figures. Then proceed with a comparative analysis, probably treating first the major aspects (e.g., composition, space, color) and next the finer points.

But a comparison need not employ this structure, and indeed an essay that uses splitting too rigidly is likely to produce a Ping-Pong effect. There is also the danger that the essay will not come into focus—the point will not be grasped—until the essayist stands back from the seven-layer cake and announces, in the concluding paragraph, that the odd layers taste better. In one's preparatory thinking one may want to make the comparisons in pairs (line in Desiderio, line in Agostino; hair in each; treatment of arms in each, etc.), but one must come to some conclusions about what these add up to before writing the final version.

The final version should not duplicate the thought processes; rather, since the point of a comparison is to make a point, it should be organized so as to make the point clearly and effectively. Lumping will often do the trick. After reflection one may believe that although

there are superficial similarities between X and Y, there are essential differences; in the finished essay, then, one probably will not wish to obscure the main point by jumping back and forth from one work to the other, working through a series of similarities and differences. It may be better to announce your thesis, then discuss X, and then Y. Some repetition in the second half of the essay (e.g., "In contrast to the rather nervous lines of X, the lines in Y are . . .") will serve to bind the two halves into a meaningful whole, making clear the degree of similarity or difference. The point of the essay is not to list pairs of similarities or differences but to illuminate a work, or works, by making thoughtful comparisons.

Although in a long essay one cannot postpone until, say, page 30 a discussion of the second half of the comparison, in an essay of, say, fewer than ten pages, there is nothing wrong with lumping, that is, with setting forth half of the comparison and then, in light of it, the second half. The essay will break into two unrelated parts if the second half makes no use of the first, or if it fails to modify the first half, but not if the second half looks back to the first half and calls attention to differences that the new material reveals.

Again, the point of a comparison is to call attention to the unique features of something by holding it up against something similar but significantly different. If the differences are great and apparent, a comparison is a waste of effort. (Blueberries are different from elephants. Blueberries do not have trunks. And elephants do not grow on bushes.) Indeed, a comparison between essentially and obviously unlike things can only obscure, for by making the comparison, the writer implies that there are significant similarities, and readers can only wonder why they do not see them. The essays that do break into two unrelated halves are essays that make uninstructive comparisons: The first half tells the reader about five qualities in El Greco; the second half tells the reader about five different qualities in Rembrandt. Notice in Bedell's essay (pp. 99–107) that the second half occasionally looks back to the first half.

SAMPLE ESSAYS: TWO COMPARISONS

The first of these essays, already glanced at on page 93, is reprinted from a book. It compares two objects more or less simultaneously. The second essay, by an undergraduate, discusses one

object first and then discusses the second. Thus, her essay lumps rather than splits. It does not break into two separate parts because at the start she looks forward to the second object, and in the second half of the essay she occasionally reminds us of the first object.

By the way, when you read the student's essay on Copley, don't let its excellence discourage you into thinking that you can't do as well. This essay, keep in mind, is the product of much writing and rewriting. As Bedell wrote, her ideas got better and better, for in her drafts she sometimes put down a point and then realized that it needed strengthening (e.g., with concrete details) or that—come to think of it—the point was wrong and ought to be deleted. She also derived some minor assistance—for facts, not for her fundamental thinking—from books, which she cites in her footnotes.

Two Low Relief Carvings from the Fifteenth Century L. R. Rogers

We turn now to two fifteenth-century Italian low relief carvings on the theme of the Madonna and Child. Desiderio da Settignano's all too short thirty-five years of life (1430-64) began and ended during the lifetime of Agostino di Duccio (1418-81). Yet although the two artists were contemporaries who almost certainly knew of each other's work, it would be difficult to find two artists who display a greater difference in the qualities of their lines. Desiderio's lines are full of minute changes of direction and breaks in continuity. They have a nervous delicacy, a gentleness, and quiet unassertiveness which is appropriate, in our example, to the character and mood expressed in a more directly psychological way in the faces of Mary and the Child. They are neither rhetorical nor merely decorative but describe the form and represent material qualities in a naturalistic manner. There is nothing arbitrary about them. For the most part they are not clear-cut lines; their depth and intensity varies and they have an irregular scratched rather than a sharp-edged quality. Many of them are little more than short incised "touches" with the chisel. Agostino's relief is also gentle and delicate but it is in every respect more self-consciously "designed," more contrived, than Desiderio's. Both Madonnas are human rather than divine but Desiderio's is a natural, homely humanity while Agostino's is elegantly aristocratic and artificial. If there is

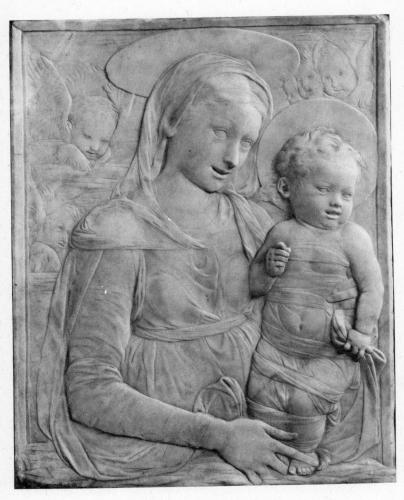

Desiderio da Settignano, *Virgin and Child*, 1455–1460. Marble, $23^{1}/4'' \times 17^{3}/4''$. Philadelphia Museum of Art. (Purchased by the Wilstach Committee)

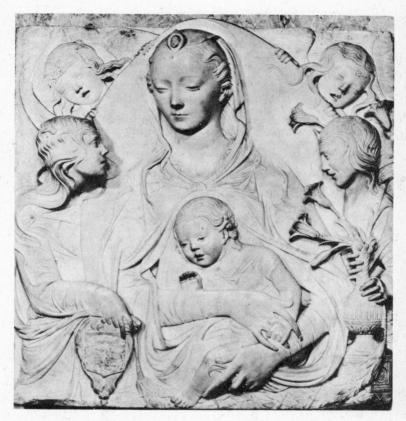

Agostino di Duccio, Virgin and Child with Four Angels, ca. 1460. Marble, $35'' \times 30^{1/4}''$. The Louvre, Paris.

anything supernatural about Agostino's relief, it is a supernatural prettiness and sweetness.

The differences between the two works may be brought out more clearly if we compare a few details. Consider the treatment of the hair. In Desiderio's relief it is rendered as a vaguely unified plastic mass in which curls are merely hinted at by irregular incised lines. The hair of Desiderio's Child has a soft, downy appearance and merges with the form of the forehead without any clear line of demarcation. Agostino, on the other hand, has treated the hair as a highly stylized

pattern of regular lines. These fall into graceful waves, and on the Child they twist round to form elegant tight little spiral curls. A similar difference pervades the drapery of the two reliefs. Desiderio's treatment is spare, full of irregularities, crumpled passages, and straightness. There are no lines which seem to be there purely for their own sake. Agostino's lines on the other hand are mostly decorative and are intended to be enjoyed for their own sake. They are full of graceful curves and elegant rhythms and counter-rhythms. Their linear design is confidently, even exuberantly, lyrical.

A comparison of the similarly positioned right forearms and hands of the two Virgins is most revealing. Agostino makes one continuous curve of the upper line of the forearm and the hand and carries the line right through to the ends of the extended first finger and thumb. But the line of Desiderio's arm and hand changes direction abruptly where the hand broadens out at the wrist. And although there is a connection through from the arm across the hand and into the extended finger, it is a straight line, not an elegant curve, and it is not continuous. Notice, too, the contrast in the lines of the fingers themselves in the two reliefs.

The outlines of the fleshy parts of Desiderio's figures—the head, arms, and shoulders of the Child, for example—are softer and more variable than those of Agostino's. This is true also of the modeling inside the contours. The lines down the left arms of both infants clearly show the difference. Finally, the lines of the facial features—the center line of the nose, the outlines of the lips and the eyes—are sharper in the Agostino than in the Desiderio, where their softness contributes to the "dewy" look of the faces.

It would be wrong to conclude from all this that Agostino's relief is more carefully designed and that Desiderio's merely describes the forms naturalistically. Desiderio's relief is in fact designed with extreme care and sensitivity. Indeed, according to John Pope-Hennessy, "in composition this is Desiderio's finest and most inventive Madonna relief."* Pope-Hennessy does complain, however, that its execution is "rather dry" and inferior to that of some of the sculptor's other works. The crux of the matter is that in this work of Desiderio's the design is less obtrusive than it is in the Agostino.

^{*} Italian Renaissance Sculpture (London: Phaidon, 1958), p. 303.

Brief marginal annotations have been added to the following essay in order to help you appreciate the writer's skill in presenting her ideas.

Rebecca Bedell

Title is focused, and, in "Development," implies the thesis John Singleton Copley's Early Development
From Mrs. Joseph Mann to
Mrs. Ezekial Goldthwait

Opening paragraph is unusually personal but engaging, and it implies the problem the writer will address

Several Sundays ago while I was wandering through the American painting section of the Museum of Fine Arts, a professorial bellow shook me. Around the corner strode a well-dressed mustachioed member of the art historical elite, a gaggle of note-taking students following in his wake. "And here," he said, "we have John Singleton Copley." He marshalled his group about the rotunda, explaining that, "as one can easily see from these paintings, Copley never really learned to paint until he went to England."

Thesis is clearly announced

A walk around the rotunda together with a quick leafing through a catalog of Copley's work should convince any viewer that Copley reached his artistic maturity years before he left for England in 1774. A comparison of two paintings at the Museum of Fine Arts, Mrs. Joseph Mann of 1753 and Mrs. Ezekial Goldthwait of ca. 1771, reveals that Copley had made huge advances in his style and technique even before he left America; by the time of his departure he was already a great portraitist. Both paintings are half-length por-

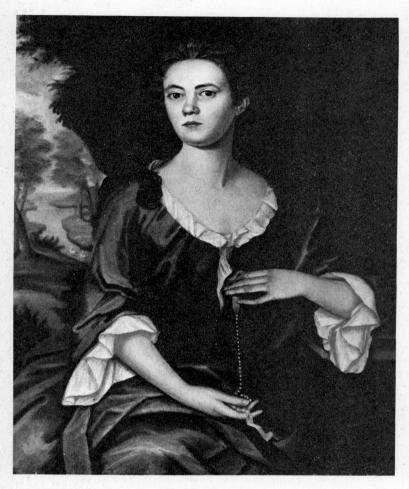

John Singleton Copley, Mrs. Joseph Mann, 1753. Oil on canvas, $36'' \times 28^{1/4}''$. Museum of Fine Arts, Boston. (Gift of Frederick H. and Holbrook E. Metcalf)

John Singleton Copley, Mrs. Ezekial Goldthwait, 1771. Oil on canvas, $50'' \times 40''$. Museum of Fine Arts, Boston. (Bequest of John T. Bowen in memory of Eliza M. Bowen)

traits of seated women, and both are accompanied by paired portraits of their husbands.

Brief description of first work

The portrait of Mrs. Joseph Mann, the twenty—two—year—old wife of a tavern keeper in Wrentham, Massachusetts, is signed and dated J. S. Copley 1753. One of Copley's earliest known works, painted when he was only fifteen years old, it depicts a robust young woman staring candidly at the viewer. Seated outdoors in front of a rock outcropping, she rests her left elbow on a classical pedestal and she dangles a string of pearls from her left hand.

Relation of the painting to its source

The painting suffers from being tied too closely to its mezzotint prototype. The composition is an almost exact mirror image of that used in Isaac Beckett's mezzotint after William Wissing's Princess Anne of ca. 1683.² Pose, props, and background are all lifted directly from the print. Certain changes, however, were necessary to acclimatize the image to its new American set—

¹Jules David Prown, <u>John Singleton Copley</u> (Cambridge, Mass.: Harvard University Press, 1966), I, 110.

²Charles Coleman Sellers, "Mezzotint Prototypes of Colonial Portraiture: A Survey Based on the Research of Waldon Phoenix Belknap, Jr.," <u>Art Quarterly</u>, 20 (1957), 407-68. See especially plate 16.

ting. Princess Anne is shown provocatively posed in a landscape setting. Her blouse slips from her shoulders to reveal an enticing amount of bare bosom. Her hair curls lasciviously over her shoulders and a pearl necklace slides suggestively through her fingers as though, having removed the pearls, she will proceed further to disrobe. But Copley reduces the sensual overtones. Mrs. Mann's bodice is decorously raised to insure sufficient coverage, and the alluring gaze of the princess is replaced by a cool stare. However, the suggestive pearls remain intact, producing an oddly discordant note.

First sentence of paragraph is both a transition and a topic sentence: the weakness of the painting

The picture has other problems as well. The young Copley obviously had not yet learned to handle his medium. The brush strokes are long and streaky. The shadows around the nose are a repellent greenish purple and the highlight on the bridge was placed too far to one side. The highlights in the hair were applied while the underlying brown layer was still wet so that instead of gleaming curls he produced dull gray smudges. In addition, textural differentiation is noticeably lacking. The texture of the rock is the same as the skin, which is the same as the satin and the grass and the pearls. The anatomy is laughable: There is no sense of underlying structure. The arms and neck are the inflated tubes so typical of provincial portraiture. The left earlobe is missing and the little finger on the left hand is dis-

Concrete details support the paragraph's opening assertion turbingly disjointed. Light too appears to have given Copley trouble. It seems, in general, to fall from the upper left, but the shadows are not consistently applied. And the light-dark contrasts are rather too sharp, probably due to an overreliance on the mezzotint source.

Transition ("Despite its faults") and statement of idea that unifies the paragraph Despite its faults, however, the painting still represents a remarkable achievement for a boy of fifteen. In the crisp linearity of the design, the sense of weight and bulk of the figure, the hint of a psychological presence, and especially in the rich vibrant color, Copley has already rivaled and even surpassed the colonial painters of the previous generation.

Transition ("about seventeen years later") and reassertion of central thesis In Mrs. Ezekial Goldthwait, about seventeen years later and about four years before Copley went to England, all the early ineptness had disappeared. Copley has arrived at a style that is both uniquely his own and uniquely American; and in this style he achieves a level of quality comparable to any of his English contemporaries.

Brief description of second picture

The substantial form of Mrs. Goldthwait dominates the canvas. She is seated at a round tilt—top table, one hand extended over a tempting plate of apples, oranges, and pears. A huge column rises in the right—hand corner to fill the void.

Biography, and (in rest of paragraph) its relevance to the work

The fifty-seven-year-old Mrs. Goldthwait, wife of a wealthy Boston merchant, was the mother of fourteen children; she was also a gardener

noted for her elaborate plantings.³ Copley uses this fertility theme as a unifying element in his composition. All the forms are plump and heavy, like Mrs. Goldthwait herself. The ripe, succulent fruit, the heavy, rotund mass of the column, the round top of the table—all are suggestive of the fecundity of the sitter.

The most obvious characteristic of the work

The painting is also marked by a painstaking realism. Each detail has been carefully and accurately rendered, from the wart on her forehead to the wood grain of the tabletop to the lustrous gleam of the pearl necklace. As a painter of fabrics Copley surpasses all his contemporaries. The sheen of the satin, the rough, crinkly surface of the black lace, the smooth, translucent material of the cuffs—all are exquisitely rendered.

"But" is transitional, taking us from the obvious (clothing) to the less obvious (character) But the figure is more than a mannequin modeling a delicious dress. She has weight and bulk,
which make her physical presence undeniable. Her
face radiates intelligence, and her open,
friendly personality is suggested by the slight
smile at the corner of her lips and by her warm,
candid gaze.

Brief reminder of the first work, to clarify our understanding of the second work The rubbery limbs of Copley's early period have been replaced by a more carefully studied anatomy (not completely convincing, but still a remarkable achievement given that he was unable

³Prown, p. 76.

to dissect or to draw from nude models). There is some sense for the underlying armature of bone and muscle, especially in the forehead and hands. And in her right hand it is even possible to see the veins running under her skin.

Further comparison, again with emphasis on second work

Light is also treated with far greater sophistication. The chiaroscuro is so strong and rich that it calls to mind Caravaggio's tenebroso. The light falls almost like a spotlight onto the face of Mrs. Goldthwait, drawing her forward from the deep shadows of the background, thereby enhancing the sense of a psychological presence.

Reassertion of thesis, supported by concrete details Copley's early promise as a colorist is fulfilled in mature works such as Mrs. Goldthwait. The rich, warm red-brown tones of the satin, the wood, and the column dominate the composition. But the painting is enlivened by a splash of color on either side—on the left by Copley's favorite aqua in the brocade of the chair, and on the right by the red and green punctuation marks of the fruit. The bright white of the cap, set off against the black background, draws attention to the face, while the white of the sleeves performs the same function for the hands.

Summary, but not mere rehash; new details Color, light, form, and line all work together to produce a pleasing composition. It is pleasing, above all, for the qualities that distinguish it from contemporary English works: for its insistence on fidelity to fact, for its forth right realism, for the lovingly delineated textures, for the crisp clarity of every line, for Mrs. Goldthwait's charming wart and her friendly double chin, for the very materialism that marks this painting as emerging from our pragmatic mercantile society. In these attributes lie the greatness of the American Copleys.

Further summary, again heightening thesis

Not that I want to say that Copley never produced a decent painting once he arrived in England. He did. But what distinguishes the best of his English works (see, for example, Mrs. John Montressor and Mrs. Daniel Denison Rogers)⁴ is not the facile, flowery brushwork or the fluttery drapery (which he picked up from current English practice) but the very qualities that also mark the best of his American works—the realism, the sense of personality, the almost touchable textures of the fabrics, and the direct way in which the sitter's gaze engages the viewer. Copley was a fine, competent painter in England, but it was not the trip to England that made him great.

⁴Prown, plates.

In Brief: How to Write an Effective Essay

All writers must work out their own procedures and rituals, but the following suggestions may provide some help.

- 1. Look at the work or works carefully.
- 2. Choose a worthwhile and compassable subject, something that interests you and is not so big that your handling of it must be superficial. As you work, shape your topic, narrowing it, for example, from "Egyptian Sculpture" to "Black Africans in Egyptian Sculpture," or from "Frank Lloyd Wright's Development" to "Wright's Johnson Wax Company as an Anticipation of His Guggenheim Museum."
- 3. **Keep your purpose in mind**. Although your instructor may ask you, perhaps as a preliminary writing assignment, to jot down your early responses—your initial experience of the work—it is more likely that he or she will ask you to write an analysis in which you will connect details and draw inferences. Another possibility is that your instructor will ask you to write an evaluation, perhaps in terms of cultural or esthetic values. The purpose of the paper will in large measure determine what is relevant.
- 4. **Keep looking at the art** you are writing about (or reproductions of it), jotting down notes on all relevant matters. You can generate ideas by asking yourself questions, such as those on pages 29–71. As you look and think, reflect on your observations and record them. (By the way, if you are writing about an object in a museum, it is a good idea to choose an object that is reproduced on a

postcard; the picture will help you to keep the object in mind when you are back in your room, writing.) If you have an idea, jot it down; don't assume that you will remember it when you get around to writing your essay. A sheet of paper is a good place for initial jottings, but many people find that in the long run it is easiest to use 4-by-6-inch cards, writing on one side only (notes on the reverse side usually get overlooked). Put only one point on each card, and put a brief caption on the card (e.g., Site of *David*); later you can easily rearrange the cards so that relevant notes are grouped together.

5. **Sort out your cards** into reasonable divisions, and reject cards irrelevant to your topic. As you work you may discover a better way to group your notes, and, of course, you may want to add to

your notes. If so, start reorganizing.

On the whole, it is usually best to devote the beginning of your paper to a statement of the problem. (Usually this means identifying the work[s] of art that you will discuss, and announcing your thesis.) Then go on, probably, to a discussion of how the object is structured artistically (e.g., composition, space, line, light), and then, finally, give a more general interpretation and evaluation. Such an organization takes the reader with you; the reader sees the evidence and thus is prepared to accept your conclusions.

In general, organize the material from the simple to the complex, in order to ensure intelligibility. If, for instance, you are discussing the composition of a painting, it probably will be best to begin with the most obvious points, and then to turn to the subtler but perhaps equally important ones. Similarly, if you are comparing two sculptures, it may be best to move from the most obvious contrasts to the least obvious. When you have arranged your notes into a meaningful sequence of packets, you have approximately divided your material into paragraphs.

6. **Get it down on paper**. Most essayists find it useful to jot down some sort of **outline**, indicating the main idea of each paragraph and, under each main idea, supporting details that give it substance. An outline—not necessarily anything highly formal with capital and lowercase letters and roman and arabic numerals but merely key phrases in some sort of order—will help you to overcome the paralysis called "writer's block" that commonly afflicts professionals as well as students.

A page of paper with ideas in some sort of sequence, however rough, ought to encourage you that you do have something to say.

And so, despite the temptation to sharpen another pencil or to put a new ribbon into the typewriter, the best thing to do at this point is to follow the advice of Isaac Asimov, author of 225 books: "Sit down and start writing."

If you don't feel that you can work from note cards and a rough outline, try another method: Get something down on paper, writing (preferably on a word processor) freely, sloppily, automatically, or whatever, but allow your ideas about what the work means to you and how it conveys its meaning—rough as your ideas may be—to begin to take visible form. If you are like most people, you can't do much precise thinking until you have committed to paper at least a rough sketch of your initial ideas. Later you can push and polish your ideas into shape, perhaps even deleting all of them and starting over, but it's a lot easier to improve your ideas once you see them in front of you than it is to do the job in your head. On paper one word leads to another; in your head one word often blocks another.

Just keep going; you may realize, as you near the end of a sentence, that you no longer believe it. O.K.; be glad that your first idea led you to a better one, and pick up your better one and keep going with it. What you are doing is, in a sense, by trial and error pushing your way not only toward clear expression but toward sharper ideas and richer responses.

- 7. **Keep looking and thinking**, asking yourself questions and providing tentative answers, searching for additional material that strengthens or weakens your main point; take account of it in your outline or draft.
- 8. With your outline or draft in front of you, write a more lucid version, checking your notes for fuller details. If, as you work, you find that some of the points in your earlier jottings are no longer relevant, eliminate them; but make sure that the argument flows from one point to the next. It is not enough to keep your thesis in mind; you must keep it in the reader's mind. As you write, your ideas will doubtless become clearer; some may prove to be poor ideas. (We rarely know exactly what our ideas are until we have them set down on paper. As the little girl said, replying to the suggestion that she should think before she spoke, "How do I know what I think until I see what I say?") Not until you have written a draft do you really have a strong sense of what you feel and know, and of how good your essay may be.

If you have not already made an outline, at this stage it is probably advisable to make one, thus ensuring that your draft is reasonably organized. Try to jot down, in sequence, each major point, and each subpoint. You may find that some points need amplification, or that a point made on page 3 really ought to go on page 1. Again, put yourself in the reader's shoes, and try to make sure that the paper not only has an organization, but that the organization will be clear to your reader.

9. After a suitable interval, preferably a few days, revise and edit the draft. To write a good essay you must be a good reader of the essay you are writing. We're not talking at this stage about proofreading or correcting spelling errors, though later of course you must engage also in those activities.

REVISING

In revising their work, writers ask themselves such questions as

Do I mean what I say?

Do I say what I mean? (Answering this question will cause you to ask yourself such questions as, Do I need to define my terms, add examples to clarify, reorganize the material so that a reader can grasp it?)

During this part of the process of writing, you do your best to read the draft in a skeptical frame of mind. In taking account of your doubts, you will probably unify, organize, clarify, and polish the draft.

- a. *Unity* is achieved partly by eliminating irrelevancies. These may be small (a sentence or two) or large (a paragraph or even a whole page or two). You wrote the material and now you are fond of it, but if it is irrelevant you must delete it.
- b. Organization is largely a matter of arranging material into a sequence that will assist the reader to grasp the point. If you reread your draft and jot down a paragraph outline—a series of sentences, one under the other, each sentence summarizing one paragraph—you can then see if the draft has a reasonable organization, a structure that will let the reader move easily from the beginning to the end.

- 112
 - c. Clarity is achieved largely by providing concrete details, examples, and quotations to support generalizations, and by providing helpful transitions ("for instance," "furthermore," "on the other hand," "however").
 - d. *Polish* is small-scale revision. For instance, one deletes unnecessary repetitions, combines choppy sentences into longer sentences, and breaks overly long sentences into shorter sentences.

After producing a draft that seems good enough to show to someone, writers engage in yet another activity. They edit. **Editing** includes such work as checking the accuracy of quotations by comparing them with the original, checking a dictionary for the spelling of doubtful words, and checking a handbook for doubtful punctuation—for instance whether a comma or a semicolon is needed in a particular sentence.

PEER REVIEW

Your instructor may encourage (or even require) you to discuss your draft with another student or with a small group of students. That is, you may be asked to get a review from your peers. Such a procedure is helpful in several ways. First, it gives the writer a real audience, readers who can point to what pleases or puzzles them, who make suggestions, who may often disagree (with the writer or with each other), and who frequently, though not intentionally, misread. Though writers don't necessarily like everything they hear (they seldom hear "This is perfect. Don't change a word!"), reading and discussing their work with others almost always gives them a fresh perspective on their work, and a fresh perspective may stimulate thoughtful revision. (Having your intentions misread, because your writing isn't clear enough, can be particularly stimulating.)

The writer whose work is being reviewed is not the sole beneficiary. When students regularly serve as readers for each other, they become better readers of their own work, and consequently better revisers. And, as you probably know, learning to write is in large measure learning to read.

If peer review is a part of the writing process in your course, the instructor may distribute a sheet with some suggestions and questions. Here is an example of such a sheet.

QUESTIONS FOR PEER REVIEW Fine Arts 10

Read each draft once, quickly. Then read it again, with the following questions in mind.

- 1. What is the essay's topic? Is it one of the assigned topics, or a variation of one of them? Is the title appropriate? Does the draft show promise of fulfilling the assignment?
- 2. Looking at the essay as a whole, what thesis (main idea) is stated or implied? If implied, try to state it in your own words.
- 3. Is the thesis plausible? How might it be strengthened?
- 4. Looking at each paragraph separately:
 - a. What is the basic point?
 - b. How does each paragraph relate to the essay's main idea or to the previous paragraph?
 - c. Should some paragraphs be deleted? Be divided into two or more paragraphs? Be combined? Be put elsewhere? (If you outline the essay by jotting down the gist of each paragraph, you will get help in answering these questions.)
 - d. Is each sentence clearly related to the sentence that precedes and to the sentence that follows?
 - e. Is each paragraph adequately developed? Are there sufficient details to support the generalizations?
 - f. Are the introductory and concluding paragraphs effective?
- 5. Are the necessary illustrations included, and are they adequately identified?
- 6. What are the paper's chief strengths?
- 7. Make at least two specific suggestions that you think will assist the author to improve the paper.

114

- 10. If you have received comments from a reader, consider them carefully. Even if you disagree with them, they may alert you to places in your essay that need revision, for example, clarification.
- 11. **Type or write a clean copy**, following the principles concerning margins, pagination, footnotes, and so on, set forth in Chapter 6. If you have borrowed any ideas, be sure to give credit, usually in footnotes, to your sources. Remember that plagiarism is not limited to the unacknowledged borrowing of words; a borrowed idea, even when put into your own words, requires acknowledgment. (On giving credit to sources, see pages 147–152.)

If you have received help from a friend or classmate, for instance a peer reviewer, acknowledge that help in a footnote or end-note. (If you look at almost any book or any article in *Art Bulletin* you will notice that the author acknowledges the help of friends and colleagues. In your own writing follow this practice.) Here are three sample acknowledgments from papers by students.

I wish to thank Jane Leslie for numerous valuable suggestions.

I wish to thank Judith Stubbs for calling my attention to passages that needed clarification, and Gary Smith for suggesting the comparison with Orozco's murals at Dartmouth College.

Carolyn Christensen pointed out my need to check the spelling of some words in a dictionary.

I am indebted to Louise Cort for explaining how Shigaraki ceramics were built and fired.

12. **Proofread and make corrections** as explained on pages 142–143.

In short.

- 1. is the writing true (do you have a point that you state accurately), and
- 2. is the writing good (do your words and your organization clearly and effectively convey your meaning)?

All of this adds up to Mrs. Beeton's famous recipe: "First catch your hare, then cook it."

5 Style in Writing

PRINCIPLES OF STYLE

Writing is hard work (Lewis Carroll's school in Alice's Adventures in Wonderland taught reeling and writhing), and there is no point in fooling ourselves into believing that it is all a matter of inspiration. Many of the books that seem, as we read them, to flow so effortlessly were in fact the product of innumerable revisions. "Hard labor for life" was Conrad's view of his career as a writer. This labor, for the most part, is not directed to prettifying language but to improving one's thoughts and then getting the words that communicate these thoughts exactly. There is no guarantee that effort will pay off, but failure to expend effort is sure to result in writing that will strike the reader as confused. It won't do to comfort yourself with the thought that you have been misunderstood. You may know what you meant to say, but your reader is the judge of what indeed you have said. Keep in mind Matisse's remark: "When my words were garbled by critics or colleagues, I considered it no fault of theirs but my own, because I had not been clear enough to be comprehended."

Many books have been written on the elements of good writing, but the best way to learn to write is to do your best, revise it a few days later, hand it in, and then study the annotations an experienced reader puts on your essay. In revising the annotated passages, you will learn what your weaknesses are. After drafting your next essay, put it aside for a day or so, and then reread it, preferably aloud. You may find much that bothers you. (If you read it aloud, you will probably catch choppy sentences, needless repetitions, and unpleasant combinations of words, such as "We see in the sea. . . . ") If the argument does not flow, check to see whether your organization is

reasonable and whether you have made adequate transitions. Do not hesitate to delete interesting but irrelevant material that obscures the argument. Make the necessary revisions again and again if there is time. Revision is indispensable if you wish to avoid (in Somerset Maugham's words) "the impression of writing with the stub of a blunt pencil."

Even though the best way to learn to write is by writing and by heeding the comments of your readers, a few principles can be briefly set forth here. These principles will not suppress your particular voice; rather, they will get rid of static, enabling your voice to come through effectively. You have something to say, but you can say it only after your throat is cleared of "Well, what I meant was" and "It's sort of, well, you know." Your readers do *not* know; they are reading in order to know. The paragraphs that follow are attempts to help you let your individuality speak clearly.

GET THE RIGHT WORD

Denotation

Be sure the word you choose has the right explicit meaning, or **denotation**. Don't say "tragic" when you mean "pathetic," "carving" when you mean "modeling," or "print" when you mean a photographic reproduction of a painting.

Connotation

Be sure the word you choose has the right association or implication—that is, the right **connotation**. Here is an example of a word with the wrong connotation for its context: "Close study will *expose* the strength of Klee's style." "Reveal" would be better than "expose" here; "expose" suggests that some weakness will be brought to light, as in "Close study will expose the flimsiness of the composition."

Concreteness

Catch the richness, complexity, and uniqueness of what you see. Do not write "His expression lacks emotion" if you really mean

the expression is icy, or indifferent, or whatever. But concreteness is not a matter only of getting the exact word—no easy job in itself. If your reader is (so to speak) to see what you are getting at, you have to provide some details. Instead of writing "The influence of photography on X is small," write "The influence of photography is evident in only six paintings."

Compare the rather boring statement, "Thirteenth-century sculpture was colored," or even "Thirteenth-century sculpture was brightly painted and sometimes adorned with colored glass," with

these sentences rich in concrete detail:

Color was an integral part of sculpture and its setting. Face and hands were given their natural colors; mouth, nose, and ears were slightly emphasized; the hair was gilded. Dresses were either covered in flowers or painted in vigorous colors: ornaments, buckles, and hems were highlighted by brilliant colors or even studded with polished stones or colored glass. The whole portal looked like a page from an illuminated manuscript, enlarged on a vast scale.

Marcel Aubert, *The Art of the High Gothic Era*, trans. Peter Gorge (New York: Crown, 1965), p. 60

Tone

Remember, when you are writing, you are the teacher. You are trying to help someone to see things as you see them, and it is unlikely that either solemnity or heartiness will help anyone see anything your way. There is rarely a need to write that Daumier was "incarcerated" or (at the other extreme) "thrown into the clink." "Imprisoned" or "put into prison" will probably do the job best. Be sure, also, to avoid shifts in tone. Consider this passage, from a book on modern sculpture:

We forget how tough it was to make a living as a sculptor in this period. Rare were supportive critics, dealers, and patrons.

Although "tough" is pretty casual ("difficult" might be better), "tough" probably would have been acceptable if it had not been followed, grotesquely, by the pomposity of "Rare were supportive critics." The unusual word order (versus the normal order, "Supportive critics were rare") shows a straining for high seriousness that is incompatible with "tough."

Nor will it do to "finagle" with an inappropriate expression by putting it in "quotes." As the previous sentence indicates, the apolo-

getic quotation marks do not make such expressions acceptable, only more obvious and more offensive. The quotation marks tell the reader that the writer knows he or she is using the wrong word but is unwilling to find the right word. If for some reason a relatively low word is the right one, use it and don't apologize with quotation marks.

Repetition

Although some repetitions—say, of words like "surely" or "it is noteworthy that"—reveal a tic that ought to be cured by revision, don't be afraid to repeat a word if it is the best word. Notice that in the following paragraph Meyer Schapiro does not hesitate to repeat "Impressionism," "Impressionist," "face," and "portrait" (three times each), and "portraiture" and "photography" (twice each).

We can follow the decline of portraiture within Impressionism, the art to which van Gogh assumed allegiance. The Impressionist vision of the world could hardly allow the portrait to survive; the human face was subjected to the same evanescent play of color as the sky and sea; for the eyes of the Impressionist it became increasingly a phenomenon of surface, with little or no interior life, at most a charming appearance vested in the quality of a smile or a carefree glance. As the Impressionist painter knew only the passing moment in nature, so he knew only the momentary face, without past or future; and of all its moments, he preferred the most passive and unconcerned, without trace of will or strain, the outdoor, summer holiday face. Modern writers have supposed that it was photography that killed portraiture, as it killed all realism. This view ignores the fact that Impressionism was passionately concerned with appearances, and was far more advanced than contemporary photography in catching precisely the elusive qualities of the visible world. If the portrait declines under Impressionism it is not because of the challenge of the photographer, but because of a new conception of the human being. Painted at this time, the portraits of van Gogh are an unexpected revelation. They are even more surprising if we remember that they were produced just as his drawing and color was becoming freer and more abstract, more independent of nature.

> Vincent van Gogh (New York: Abrams, 1952), pp. 16-17

When you repeat words or phrases, or when you provide clear substitutes (such as "he" for "van Gogh"), you are helping the reader to keep step with your developing thoughts. An ungrounded fear of repetition often produces a vice known as *elegant variation*. Having mentioned "painters," the writer then speaks of "artists," and then (more desperately) of "men of the brush." This use of synonyms is far worse than repetition; it strikes the reader as silly.

When it is not silly, it may be confusing. Consider:

Corot attracted the timid painters of his generation; bolder artists were attracted to Manet.

The shift from "painters" to "artists" makes us wonder (and no answer is given) if perhaps Manet's followers—but not Corot's—included etchers, sculptors, and so on.

Be especially careful not to use variations for important critical terms; if, for instance, you are talking about "nonobjective art," don't switch to "abstract art" or "nonrepresentational art" unless you tell the reader why you are switching.

The Sound of Sense, the Sense of Sound

Avoid jingles and other repetitions of sound, as in

The reason the season is autumn . . .

Circe certainly . . .

Michelangelo's Medici monument . . .

These irrelevant echoes call undue attention to the words and thus get in the way of the points you are making. But wordplay can be effective when it contributes to meaning. For example, in the sentence

The walls of Xian both defended and defined the city,

the echo of "defended" in "defined" nicely emphasizes the unity in this duality.

WRITE EFFECTIVE SENTENCES

Economy

Say everything relevant, but say it in the fewest words possible. The wordy sentence

There are a few vague parts in the picture that give it a mysterious quality

can be written more economically as

A few vaguely defined parts give the picture a mysterious quality. (Nothing has been lost by the deletion of "There are" and "that.") Even more economical is

A few vague parts add mystery to the picture.

The original version says nothing that the second version does not say and says nothing that the third version—nine words against fifteen—does not say. If you find the right nouns and verbs, you can often delete adjectives and adverbs. (Compare "a mysterious quality" with "mystery.")

Something is wrong with a sentence if you can delete words and not sense the loss. A chapter in a recent book begins:

One of the principal and most persistent sources of error that tends to bedevil a considerable proportion of contemporary analysis is the assumption that the artist's creative process is a wholly conscious and purposive type of activity.

Well, there is something of interest here, but it comes along with a lot of hot air. Why that weaseling ("tends to bedevil," "a considerable proportion"), and why "type of activity" instead of "activity"? Those spluttering p's ("principal and most persistent," "proportion," "process," "purposive") are a giveaway; the writer is gassing, not thinking. Pruned of the verbiage, what he says adds up to this:

One of the chief errors bedeviling much contemporary criticism is the assumption that the artist's creative process is wholly conscious and purposive.

If the author were to complain that this revision deprives him of his style, might we not fairly reply that what he calls his style is the display of insufficient thinking, a tangle of deadwood?

One especially common source of wordiness is "There is" or "There are" at the beginning of a sentence:

There are many aspects of Mayan art that have not been studied.

Better:

Many aspects of Mayan art have not been studied.

"There is," coupled with "a sense of," is almost always two steps in the wrong direction.

There is a strong sense of agitation in the drawing.

Better:

The drawing is agitated.

or

The lines seem agitated.

or

The drawing conveys agitation.

Of course we know that the drawing is not really agitated—it is only paper with marks on it—but when we say "The drawing is agitated" we mean, of course, that we *perceive* agitation, even though the drawing is literally inert. "There is a sense of" is unnecessary.

The **passive voice** (wherein the subject is the object of the action) is a common source of wordiness. In general, do not write "The sculpture was carved by Michelangelo"; instead, write "Michelangelo carved the sculpture." The revision is a third shorter, and it says everything that the longer version says. Another example (from an otherwise excellent catalog of an exhibition of Raphael and his circle):

Our knowledge of Raphael's later development is not so complete as to enable the possibility that this drawing is by him to be entirely excluded.

Here the passive ("to be entirely excluded") is accompanied by other kinds of wordiness (for instance, instead of writing "this drawing is by him," the author could have written "this drawing is his"), but one might begin by getting rid of the passive:

Our knowledge of Raphael's later development is not so complete as to enable us to exclude the possibility that the drawing is by him.

Parallels

Use parallels to clarify relationships. Few of us are likely to compose such deathless parallels as "I came, I saw, I conquered," or

"of the people, by the people, for the people," but we can see to it that coordinate expressions correspond in their grammatical form. A parallel such as "He liked to draw and to paint" (instead of "He liked drawing and to paint") neatly says what the writer means. Notice the clarity and the power of the following sentence on Henri de Toulouse-Lautrec:

The works in which he records what he saw and understood contain no hint of comment—no pity, no sentiment, no blame, no innuendo.

Peter and Linda Murray, A Dictionary of Art and Artists, 4th ed. (Harmondsworth, England: Penguin, 1976), p. 451

In the following wretched sentence the author seems to think that "people" and "California and Florida" can be coordinate:

The sedentary Pueblo people of the southwestern states of Arizona and New Mexico were not as severely affected by early Spanish occupation as were California and Florida.

This sort of fuzzy writing is acceptable in a first or even a second draft, but not in a finished essay.

Subordination

First, a word about short sentences. They can, of course, be effective ("Rembrandt died a poor man"), but unless what is being said is especially weighty, short sentences seem childish. They may seem choppy, too, because the periods keep slowing the reader down. Consider these sentences:

He was assured of government support. He then started to dissociate himself from any political aim. A long struggle with the public began.

There are three ideas here, but they probably are not worth three separate sentences. The choppiness can be reduced by combining them, subordinating some parts to others. In subordinating, make sure that the less important element is subordinate to the more important. In the following example the first clause ("As soon as he was assured of government support"), summarizing the writer's previous sentences, is a subordinate or dependent clause; the new

material is made emphatic by being put into two independent clauses:

As soon as he was assured of government support, he started to dissociate himself from any political aim, and the long struggle with the public began.

The second and third clauses in this sentence, linked by "and," are coordinate—that is, of equal importance.

We have already discussed parallels ("I came, I saw, I conquered") and pointed out that parallel or coordinate elements should appear so in the sentence. The following line gives van Gogh and his brother Theo equal treatment:

Van Gogh painted at Arles, and his brother Theo supported him.

The quotation is a **compound sentence**—composed of two or more clauses that can stand as independent sentences but that are connected with a coordinating conjunction such as *and*, *but*, *for*, *nor*, *yet*; or with a correlative conjunction such as *not only* . . . *but also*; or with a conjunctive adverb such as *also*, or *however* (these require a semicolon); or with a colon, semicolon, or (rarely) a comma.

A **complex sentence** (an independent clause and one or more subordinate clauses), however, does not give equal treatment to each clause; whatever is outside the independent clause is subordinate, less important. Consider this sentence:

Supported by Theo's money, van Gogh painted at Arles.

The writer puts van Gogh in the independent clause ("van Gogh painted at Arles"), subordinating the relatively unimportant Theo. Notice, by the way, that emphasis by subordination often works along with emphasis by position. Here the independent clause comes after the subordinate clause; the writer appropriately puts the more important material at the end, that is, in the more emphatic position.

Had the writer wished to give Theo more prominence, the passage might have run:

Theo provided money, and van Gogh painted at Arles.

Here Theo (as well as van Gogh) stands in an independent clause, linked to the next clause by "and." The two clauses, and the two people, are now of approximately equal importance.

If the writer had wanted to emphasize Theo and to deemphasize van Gogh, he might have written:

While van Gogh painted at Arles, Theo provided the money.

Here van Gogh is reduced to the subordinate clause ("while van Gogh painted at Arles"), and Theo is given the dignity of the only independent clause ("Theo provided the money"). (And again notice that the important point is also in the emphatic position, near the end of the sentence. A sentence is likely to sprawl if an independent clause comes first, preceding a long subordinate clause of lesser importance, such as the sentence you are now reading.)

In short, though simple sentences and compound sentences have their place, they make everything of equal importance. Since everything is not of equal importance, you must often write complex and compound-complex sentences, subordinating some ideas to other ideas.

But note: You need not, of course, worry about subtle matters of emphasis while you are drafting your essay. When you reread the draft, however, you may feel that certain sentences dilute your point, and it is at this stage that you should check to see if you have adequately emphasized what is important.

WRITE UNIFIED AND COHERENT PARAGRAPHS

Unity

A paragraph is one of the major tools for supporting your thesis. If your essay is some five hundred words long—about two double-spaced typewritten pages—you probably will not break it down into more than four or five parts or paragraphs. (But you should break your essay down into paragraphs, that is, coherent blocks that give the reader a rest between them. One page of typing is about as long as you can go before the reader needs a slight break.) A paper of five hundred words with a dozen paragraphs is probably faulty not because it has too many ideas but because it has too few developed ideas. A short paragraph—especially one consisting of a single sentence—is usually anemic; such a paragraph may be accept—

able when it summarizes a highly detailed previous paragraph or group of paragraphs, or when it serves as a transition between two complicated paragraphs, but usually summaries and transitions can

begin the next paragraph.

The unifying idea in a paragraph may be explicitly stated in a topic sentence. Most commonly, the topic sentence is the first sentence, forecasting what is to come in the rest of the paragraph; or it may be the second sentence, following a transitional sentence. Less commonly, it is the last sentence, summarizing the points that the paragraph's earlier sentences have made. Least commonly—but thoroughly acceptable—the paragraph may have no topic sentence, in which case it has a topic idea—an idea that holds the sentences together although it has not been explicitly stated. Whether explicit or implicit, an idea must unite the sentences of the paragraph. If your paragraph has only one or two sentences, the chances are that you have not adequately developed its idea.

A paragraph can make several points, but the points must be related, and the nature of the relationship must be indicated so that there is, in effect, a single unifying point. Here is a satisfactory paragraph about the first examples of Egyptian sculpture in the round. (The figures to which the author refers are not reproduced here.)

Sculpture in the round began with small, crude human figures of mud, clay, and ivory (Fig. 4). The faces are pinched out of the clay until they have a form like the beak of a bird. Arms and legs are long rolls attached to the slender bodies of men, while the hips of the women's figures are enormously exaggerated. A greater variety of attitudes and better workmanship are found in the ivory figurines which sometimes have the eye indicated by the insertion of a bead (Fig. 4). It is the carving of animals, however, such as the ivory hippopotamus from Mesaeed in Fig. 4, or the pottery figure (Fig. 6) which points the way toward the rapid advance which was to be made in the Hierakonpolis ivories and in the small carvings of Dynasty I.

William Stevenson Smith, Ancient Egypt, 4th ed. (Boston: Museum of Fine Arts, 1960), p. 20

Smith is talking about several kinds of objects, but his paragraph is held together by a unifying topic idea. The idea is this:

Although most of the early sculpture in the round is crude, some pieces anticipate the later, more skilled work.

Notice, by the way, that Smith builds his material to a climax, beginning with the weakest pieces (the human figures) and moving to the best pieces (the animals).

In the next example, from a book on Gothic art, we again get a paragraph that is unified even though it discusses two things.

In Book Five of his treatise *De consideratione*, completed in 1152, St. Bernard of Clairvaux contrasts the unity of the Three Persons of God with other lesser kinds of unity. First in his list is the unity which he calls "collective, as for example when many stones make one heap." And second is the unity which he calls "constitutive, as when many members make one body, or many parts constitute one whole." During the first half of the twelfth century the principle of collective unity as the basis of artistic composition was replaced by the principle of constitutive unity, and as a result the Gothic style was created.

The artistic style which dominated northwest Europe around the year 1100 is represented by a picture in a manuscript of the Life of St. Aubin written and illustrated in his monastery at Angers, and by the oldest parts of the priory church of La Charité-sur-Loire. The picture from the Saint's Life shows a party of Norman marauders sailing out to sea after their miraculous rout by the saint. The artist achieves compositional unity by the mere accumulation of aggressively distinct parts, the seven wavy bands which make up the mound of water, the four curved timbers of the hull of the boat, the eleven oval shields, the eleven brutally square faces of the soldiers, their thirtyfour vertical spear-shafts, their innumerable domed helmets. The artist's style is vehement, schematic, repetitive, and inhuman. His picture brings vividly to mind St. Bernard's example of collective unity, separate stones placed in a heap. The designer of the choir of La Charité shows this same tendency to think in distinct units which he accumulates but does not integrate, the massive semidome and barrel vault above, the firm chunky columns below, crowned by tight arches. These columns and these arches belong to the same visual world as the Norman pirates' cramped menacing array of spears.

George Henderson, Gothic (Harmondsworth, England: Penguin, 1967), p. 43

The topic sentence at the end of the first paragraph clearly indicates that the one idea in the paragraph is that there are two kinds of unity. The second paragraph is devoted to demonstrating the first kind of unity, the kind that dominated art in northwest Europe during the Romanesque period. It sets forth two examples; again, the

The Normans in Their Boat, shortly before 1100. Illumination on vellum, $11^5/8'' \times 8''$. In a manuscript of the Life of St. Aubin, Bibliothèque Nationale, Paris.

Apse of the priory church of La Charité-sur-Loire, consecrated 1107. Photograph by Martin-Sabon. (Permission © Arch. Phot. Paris/S.P.A.D.E.M., Paris/ARS, New York)

two can be set forth in a single paragraph because they are part of a single idea. Notice, by the way, that the final sentence of the paragraph neatly binds together the two examples and summarizes the point. One other comment: If the writer had discussed each example at greater length, he might have given each example in a separate paragraph, in order to give the reader a moment of rest after the first example; but because the second example is set forth briefly, in a single sentence, it shares a paragraph with the first example. In fact, if it were put, unamplified, into a separate paragraph, it would seem skimpy.

The beginning and especially the end of a paragraph are usually the most emphatic parts. A beginning may offer a generalization that the rest of the paragraph supports. Or the early part may offer details, preparing for the generalization in the later part. Or the paragraph may move from cause to effect. Although no rule can cover all paragraphs (except that all must make a point in an orderly way), one can hardly go wrong in making the first sentence either a transition from the previous paragraph or a statement of the paragraph's topic. Here is a sentence that makes a transition and also states the topic:

Not only representational paintings but also abstract paintings have a kind of subject matter.

This sentence gets the reader from subject matter in representational paintings (which the writer has been talking about) to subject matter in abstract paintings (which the writer goes on to talk about).

Consider the following two effective paragraphs on Anthony Van Dyck's portrait of Charles I.

Rather than begin with an analysis of Van Dyck's finished painting of Charles I, let us consider the problem of representation as it might have been posed in the artist's mind. Charles I saw himself as a cavalier or perfect gentleman, a patron of the arts as well as the embodiment of the state's power and king by divine right. He prided himself more on his dress than on robust and bloody physical feats. Van Dyck had available to him precedents for depicting the ruler on horseback or in the midst of a strenuous hunt, but he set these aside. How then could he show the regal qualities and sportsmanship of a dismounted monarch in a landscape? Compounding the artist's problem was the King's short stature, just about 5 feet, 5 inches. To have placed him next to his horse, scaled accurately, could have presented an ungainly problem of their relative heights. Van Dyck found a

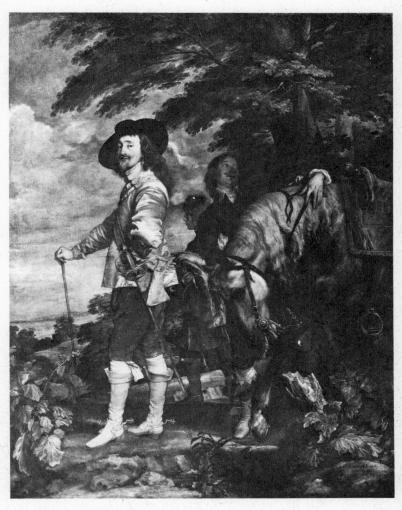

Anthony Van Dyck, *Charles I*, ca. 1635. Oil on canvas, $8'11'' \times 6'11^{1/2}''$. The Louvre, Paris. (Alinari/Art Resource)

solution to this last problem in a painting by Titian, in which a horse stood with neck bowed, a natural gesture that in the presence of the King would have appropriate connotations. Placing the royal pages behind the horse and farther from the viewer than the King reduced their height and obtrusiveness, yet furnished some evidence of the ruler's authority over men. Nature also is made to support and suitably frame the King. Van Dyck stations the monarch on a small rise and paints branches of a tree overhead to resemble a royal canopy. The low horizon line and our point of view, which allows the King to look down on us, subtly increase the King's stature. The restful stance yet inaccessibility of Charles depends largely upon his pose, which is itself a work of art, derived from art, notably that of Rubens. Its casualness is deceptive; while seemingly at rest in an informal moment, the King is every inch the perfect gentleman and chief of state. The cane was a royal prerogative in European courts of the time, and its presence along with the sword symbolized the gentleman-king.

Just as the subtle pose depicts majesty, Van Dyck's color, with its regal silver and gold, does much to impart grandeur to the painting and to achieve a sophisticated focus on the King. The red, silver, gold, and black of his costume are the most saturate and intense of the painting's colors and contrast with the darker or less intense coloring of adjacent areas. Largely from Rubens, Van Dyck had learned the painterly tricks by which materials and textures could be vividly simulated, so that the eye moves with pleasure from the silvery silken sheen of the coat to the golden leather sword harness and then on to the coarser surface of the horse, with a similar but darker combination of colors in its coat and mane. Van Dyck's portrait is evidence that, whatever one's sympathy for the message, the artist's virtuosity and

aesthetic can still be enjoyed.

Albert E. Elsen, *Purposes of Art* (New York: Holt, Rinehart and Winston, 1972), pp. 221-222

Let's pause to look at the structure of these two paragraphs. The first begins in effect by posing a question (What were the problems Van Dyck faced?) and then goes on to discuss Van Dyck's solutions. This paragraph could have been divided into two, the second beginning "Nature also"; that is, if Elsen had felt that the reader needed a break he could have provided it after the discussion of the king's position and before the discussion of nature and the king's pose within nature. But in fact a reader can take in all of the material without a break, and so the topic idea is "Van Dyck's solutions to the problem."

The second paragraph grows nicely out of the first, largely because Elsen begins the second paragraph with a helpful transition, "Just as." The topic idea here is the relevance of the picture's appeal through color; the argument is supported with concrete details, and the paragraph ends by pushing the point a bit further: The colors in the painting not only are relevant to the character portrayed but also have a hold on us.

Coherence

If a paragraph has not only unity but also a structure, then it has coherence; its parts fit together. Make sure that each sentence is properly related to the preceding and the following sentences. Nothing is wrong with such obvious **transitions** as *moreover*, *however*, *but*, *for example*, *this tendency*, *in the next chapter*, and so on; but, of course (1) these transitions should not start every sentence (they can be buried thus: "Degas, moreover, . . ."), and (2) they need not appear anywhere in the sentence. The point is not that transitions must be explicit but that the argument must proceed clearly. The gist of a paragraph might run thus: "Speaking broadly, there were in the Renaissance two traditions of portraiture. . . . The first. . . . The second. . . . The chief difference. . . . But both traditions. . . ."

Consider the following lucid paragraph from an essay on Auguste Rodin's Walking Man:

L'Homme qui marche is not really walking. He is staking his claim on as much ground as his great wheeling stride will encompass. Though his body's axis leans forward, his rearward left heel refuses to lift. In fact, to hold both feet down on the ground, Rodin made the left thigh (measured from groin to patella) one-fifth as long again as its right counterpart.

Leo Steinberg, Other Criteria (New York: Oxford University Press, 1972), p. 349

Notice how easily we move through the paragraph: The figure "is not. . . . He is. . . . Though. . . . In fact. . . . " These little words take us neatly from point to point.

It may be instructive to contrast the orderliness of the paragraph about Rodin's *Walking Man* with a paragraph (or, rather, the first part of a paragraph) that is a mess. The passage comes from a

Auguste Rodin, L'Homme qui marche, 1900. Bronze, 7'113/4". Rodin Museum, Paris. (Art Resource, New York)

discussion of Navajo blankets. (The plates referred to are not reproduced here.)

Anglo-American tastes differed markedly from those of the Indians and Spanish settlers. Plains and Pueblo Indian buyers preferred simple arrangements of horizontal stripes embellished with small areas of design (see Pl. VI); the Spanish preferred red-background serapes with large central diamonds (see Pl. VII); but white men wanted more colors and more designs, believing that color variation and design complexity translated into greater value. Navajo weavers anticipated the white man's tastes, and by the late 1850's, the direct, restrained compositions of classic Navajo blankets began to give way to a more ornate, more decorative style.

Antiques 111 (October 1991):584

What's wrong here? First, the sequence. Since the first sentence of the paragraph begins by saying that "Anglo-American tastes" differed from Indian and Spanish tastes, a reader expects the paragraph to continue the sequence, telling us first about Anglo-American taste, then about Indian taste, and then about Spanish taste. Instead, the second sentence begins unexpectedly by discussing Indian taste.

Actually, the sequence that we get in the second sentence (Indian, Spanish) makes sense, chronologically. So the trouble begins with the first sentence, which should have gone something like this:

Indian taste differed markedly from Spanish and Anglo-American tastes. Plains and Pueblo Indian buyers. . . .

The Spanish, however, . . . The Anglo-Americans wanted even more color and more complex designs. . . .

There is, however, an even more serious fault than the muddled sequence of the original version, a fault that makes readers stop and wonder if they are understanding the writer's point. The original paragraph begins by mentioning three kinds of people: Anglo-Americans, Indians, and Spaniards. It then goes on to discuss "Plains and Pueblo Indians," "Spanish settlers," and (believe it or not) "white men"—as though the Spanish settlers were not white men. In short, the writer is not paying any attention to what he is saying, with the result that the reader is at first puzzled (on encountering

"white men" instead of "Anglo-Americans") and then probably annoyed.

Introductory Paragraphs

Vasari, in *Lives of the Painters*, tells us that Fra Angelico "would never take his pencil in his hand till he had first uttered a prayer." One can easily understand his hope for divine assistance. Beginning a long poem, Lord Byron aptly wrote, "Nothing so difficult as a beginning." Of course, your job is made easier if your instructor has told you to begin your analysis with some basic facts: identification of the object (title, museum, museum number), subject matter (e.g., mythological, biblical, portrait), and technical information (material, size, condition). Even if your instructor has not told you to begin thus, you may find it helpful to start along these lines. The mere act of writing *anything* will probably help you to get going.

Still, almost all writers—professionals as well as amateurs—find that the beginning paragraphs of their drafts are false starts. In your finished paper the opening cannot be mere throat clearing. It should be interesting and informative. Don't take your title ("Space in Manet's A Bar at the Folies-Bergère") and merely paraphrase it in your first sentence: "This essay will study space in Manet's A Bar at the Folies-Bergère." There is no information about the topic here, at least none beyond what the title already gave, and there is no information about you either, that is, no sense of your response to the topic, such as might be present in, say,

The space in A Bar at the Folies-Bergère is puzzling; one at first wonders where the viewer is supposed to be standing.

In your effort to find your voice and to say something interesting, however, don't yield to irrelevancy or to grandiloquence ("Space, Shakespeare says, . . . ").

One surefire way to begin is this: Identify the artwork(s) you will discuss, and then suggest your thesis in your opening paragraph, moving from a generalization ("the space in the picture is puzzling") to some supporting details ("where is the man standing, whose reflection do we see in the upper right?"). Such an introduction quickly and effectively gets down to business; especially in a short paper there is no need (or room) for a long-winded introduction.

Notice in the following example, the opening paragraph in an essay on Buddhist art in Japan, how the writer moves from a "baffling diversity" to "one major thread of continuity."

Amid the often baffling diversity which appears in so much of the history of Japanese art, one major thread of continuity may be traced throughout the evolution of religious painting and sculpture. This tradition was based on the great international style of East Asian Buddhist imagery, which reached its maturity during the early eighth century in T'ang China and remained a strong influence in Japan through the thirteenth century.

John Rosenfield, Japanese Arts of the Heian Period: 794-1185 (New York: Asia Society, 1967), p. 23

Similarly, in the next example we move from a general comment about skin-clinging garments to an assertion of the thesis (the convention is exaggerated in English Neoclassical art), and this thesis is then supported with concrete details.

The pictorial and sculptural custom of clothing the nude in skinclinging dress has many and often-copied Classical precedents, but the erotic emphasis of this convention seems exaggerated in English art of the Neoclassic period more than at other times and places. The shadowy meeting of thighs, the smooth domes of bosom and backside, are all insisted on more pruriently through the lines of the dress than they were by contemporary French artists or by Botticelli and Mantegna and Desiderio da Settignano, who were attempting the same thing in the Renaissance—or, indeed, than by the Greek sculptors. The popular artists Rowlandson and Gillray naturally show this impulse most blatantly in erotic cartoons and satirical illustrations, in which women have enormous bubbly hemispheres fore and aft, outlined by the emphatically sketched lines of their dress.

Anne Hollander, Seeing Through Clothes (New York: Viking, 1978), p. 118

Concluding Paragraphs

The preceding discussion of opening paragraphs quoted Lord Byron: "Nothing so difficult as a beginning." But he went on to add, "Unless perhaps the end."

In conclusions, as in introductions, try to say something interesting. It is not of the slightest interest to say "Thus we see . . . ," and then go on to echo the title and the first paragraph. There is some

justification for a summary at the end of a long paper because the reader may have half forgotten some of the ideas presented thirty pages earlier, but a paper that can easily be held in the mind needs something different. A good concluding paragraph does more than provide an echo of what the writer has already said. It may round out the previous discussion, normally with a few sentences that summarize (without the obviousness of "We may now summarize"), but usually it also draws an inference that has not previously been expressed, thus setting the previous material in a fresh perspective. A good concluding paragraph closes the issue while enriching it.

Notice how the example that follows wraps things up and, at the same time, opens outward by suggesting a larger frame of reference. The writer is ending his discussion of Bernini's piazza of St. Peter's.

As happens with most new and vital ideas, after initial sharp attacks the colonnades became of immense consequence for the further history of architecture. Examples of their influence from Naples to Greenwich and Leningrad need not be enumerated. The aftermath can be followed up for more than two and a half centuries.

Rudolf Wittkower, Art and Architecture in Italy: 1600-1750, 3rd ed. (Harmondsworth, England: Penguin, 1973), p. 196

Pretty much the same technique is used at the end of Elsen's second paragraph on Van Dyck's *Charles I* (p. 132), where he moves from his detailed discussion of the picture to the assertion that the picture continues to attract us.

Finally, don't feel that you must always offer a conclusion in your last paragraph. When you have finished your analysis, it may be enough to stop—especially if your paper is fairly short, let's say fewer than five pages. If, for example, you have throughout your paper argued that a certain Japanese print shows a Western influence in its treatment of space, you need scarcely reaffirm the overall thesis in your last paragraph. Probably it will be conclusion enough if you just offer your final evidence, in a well-written sentence, and then stop.

Manuscript Form

BASIC MANUSCRIPT FORM

Much of what follows is nothing more than common sense. Unless your instructor specifies something different, you can adopt these principles as a guide.

- 1. Use 8½-by-11-inch paper of good weight. Do not use paper torn out of a spiral notebook; ragged edges distract a reader. If you have written your essay on a computer and have printed it on a continuous roll of paper, remove the strips from each side of the sheets and separate the sheets before you hand in the essay.
- 2. Write on one side of the page only. If you typewrite, double-space, typing with a reasonably fresh ribbon. If you submit a handwritten copy, use lined paper and write, in black or dark blue ink, on every other line if the lines are closely spaced. A word to the wise: Instructors strongly prefer typed papers.
- 3. Put your name, instructor's name, class or course number, and the date in the upper right-hand corner of the first page. It is a good idea to put your name in the upper right corner of each subsequent page, so the instructor can easily reassemble your essay if somehow a page gets detached and mixed with other papers.
- 4. Center the title of your essay about two inches from the top of the first page. Capitalize the first letter of the first and last words of your title, the first word after a semicolon or colon if you use either one, and the first letter of all the other words except articles (a, an,

the), conjunctions (and, but, or, etc.), and prepositions (about, in, on, of, with, etc.), thus:

The Renaissance and Modern Sources of Manet's Olympia

Some handbooks advise that prepositions of five or more letters (*about*, *beyond*) be capitalized. Notice that your title is neither underlined nor enclosed in quotation marks, though of course if, as here, your title includes the title of a work of art (other than architecture), that title is underlined to indicate italics.

- 5. Begin the essay an inch or two below the title. If your instructor prefers a title page, do not number it, but begin the essay on the next page.
- 6. Leave an adequate margin—an inch or an inch and a half—at top, bottom, and sides, so that your instructor can annotate the paper.
- 7. Number the pages consecutively, using arabic numerals in the upper right-hand corner. If you give the title on a separate page, do not number that page; the page that follows it is page 1.
- 8. Indent the first word of each paragraph five spaces from the left margin.
- 9. When you refer to a work illustrated in your essay, include helpful identifying details in parentheses, thus:

Vermeer's <u>The Studio</u> (Vienna, Kunsthistorisches Museum, Figure 6) is now widely agreed to be an allegorical painting.

But if in the course of the essay itself you have already mentioned where the picture is, do not repeat such information in the parenthetic material.

10. If possible, insert photocopies of the illustrations at the appropriate places in the paper, unless your instructor has told you to put all of the illustrations at the rear of the paper. Number the illustrations (each illustration is called a Figure) and give captions that include, if possible, artist (or, for anonymous works, the culture), title (underlined), date, medium, dimensions (height precedes width), and present location. Examples:

Figure 1. Japanese, Flying Angel, second half of the eleventh century. Wood with traces of gesso and gold, $33^{1/2}$ " \times 15". Museum of Fine Arts, Boston.

Figure 2. Diego Velázquez, Venus and Cupid, ca. 1644-1648. Oil on canvas, 3' $11^7/8'' \times 5'$ $9^1/4''$. National Gallery, London.

Note that in the second example the abbreviation ca. stands for circa, Latin for "about."

If there is some uncertainty about whether or not the artist created the work, precede the artist's name with *Attributed to*. If the artist had an active studio, and there is uncertainty about the degree of the artist's involvement in the work, put *Studio of* before the artist's name.

Four other points about captions for illustrations:

- 1. if you use the abbreviations B.C. or A.D., do not put a space between the letters;
- 2. B.C. follows a numeral (7 B.C.) but A.D. precedes a numeral (A.D. 10);
- 3. the abbreviations B.C. and A.D. are falling out of favor, and are being replaced with B.C.E. (Before the Common Era) and C.E. (Common Era);
- 4. some instructors may ask you to cite also your source for the illustration, thus:

Figure 3. Japanese, Head of a Monk's Staff, late twelfth century. Bronze, 91/4". Peabody Museum, Salem, Massa-chusetts. Illustrated in John Rosenfield, Japanese Arts of the Heian Period: 794-1185 (New York: Asia Society, 1967), p. 91.

If, in your source, the pages with plates are unnumbered, give the plate number where you would ordinarily give the page number.

11. If a reproduction is not available, be sure when you refer to a work to tell your reader where the work is. If it is in a museum, give

the acquisition number, if possible. This information is important for works that are not otherwise immediately recognizable. A reader needs to be told more than that a Japanese tea bowl is in the Freer Gallery. The Freer has hundreds of bowls, and, in the absence of an illustration, only the acquisition number will enable a visitor to locate the bowl you are writing about.

- 12. Make a photocopy of your essay, or print a second copy from the computer, so that if the instructor misplaces the original you need not write the paper again. It's a good idea to keep notes and drafts, too, until the instructor returns the original. Such material may prove helpful if you are asked to revise a paper, substantiate a point, or supply a source that you inadvertently omitted.
- 13. Fasten the pages of your paper with a staple or paper clip in the upper left-hand corner. (Find out which sort of fastener your instructor prefers.) Stiff binders are unnecessary; indeed they are a nuisance to the instructor, for they add bulk and they make it awkward to write annotations.

CORRECTIONS IN THE FINAL COPY

Your extensive revisions should have been made in your drafts, but minor last-minute revisions may be made on the finished copy. In proofreading you may catch some typographical errors, and you may notice some minor weaknesses. (It's not a bad idea to read the paper aloud to someone, or to yourself. Your tongue will trip over phrases in which a word is omitted, or sentences that are poorly punctuated. Some people who have difficulty spotting errors report that they find they are helped when they glide a pencil at a moderate speed letter by letter over the page. Without a cursor, they say, their minds and eyes read in patterns and they miss typos.

Let's say that in the final copy you notice an error in agreement between subject and verb: "The weaknesses in the draftsmanship is evident." The subject is "weaknesses" (not "draftsmanship") and so the verb should be "are," not "is." You need not retype the page, or even erase. You can make corrections with the following proof-reader's symbols.

Changes in wording may be made by crossing through words and rewriting just above them, either on the typewriter or by hand in pen:

The weaknesses in the draftsmanship is evident.

Additions should be made above the line, with a caret (A) below the line at the appropriate place:

The weaknesses in the draftsmanship evident.

Transpositions of letters may be made thus:

The weaknesses in Inte draftsmanship are evident.

Deletions are indicated by a horizontal line through the word or words to be deleted. Delete a single letter by drawing a vertical or diagonal line through it.

The weaknesses in in the draftsmanship are evident.

Separation of words accidentally run together is indicated by a vertical line, closure by a curved line connecting the things to be closed up:

The weaknesses in the draftsmanship are evident.

Paragraphing may be indicated by the symbol \mathcal{G} before the word that is to begin the new paragraph.

The weaknesses are evident. \mathcal{H} For instance, the drafts-manship is hesitant, and the use of color is. . . .

QUOTATIONS AND QUOTATION MARKS

If you are writing a research paper, you will, of course, include quotations, almost surely from scholars who have worked on the topic, and possibly also from documents such as letters or treatises written by the artist or by the artist's contemporaries. But even in a short analysis, based chiefly on looking steadily at the object, you may want to quote a source or two—for example, your textbook. The following guidelines tell you how to give quotations and how to cite your sources—but remember, a paper is not a bundle of quotations.

- 1. Be sparing in your use of quotations. Use quotations as evidence, not as padding. If the exact wording of the original is crucial, or especially effective, quote it directly, but if it is not, don't bore the reader with material that can be effectively reduced either by summarizing or by cutting. If you cut, indicate ellipses as explained later, under point 5.
- 2. Identify the speaker or writer of the quotation, so that readers are not left with a sense of uncertainty. Usually this identification precedes the quoted material (e.g., you write something like "Kenneth Clark says" or "Kenneth Clark long ago pointed out"), in accordance with the principle of letting readers know where they are going. But occasionally the identification may follow the quotation, especially if it will prove something of a pleasant surprise. For example, in a discussion of Jackson Pollock's art, you might quote a hostile comment on one of the paintings and then reveal that Pollock himself was the speaker. (Further suggestions about leading into quotations are given on page 191.)
- 3. Distinguish between short and long quotations, and treat each appropriately. Short quotations (usually defined as fewer than five lines of prose) are enclosed within quotation marks and run into the text (rather than set off, without quotation marks).

Michael Levey points out that "Alexander singled out Lysippus to be his favorite sculptor, because he liked the character given him in Lysippus' busts." In making this point, Levey is not taking the familiar view that. . . .

A long quotation (usually five or more lines of typewritten prose) is not enclosed within quotation marks. To set it off, the usual practice is to triple-space before and after the quotation and single-space the quotation, indenting five spaces—ten spaces for the first line if the quotation begins with the opening of a paragraph. (Note: The suggestion that you single-space longer quotations seems reasonable but is at odds with various manuals that tell how to prepare a manuscript for publication. Such manuals usually say that material that is set off should be indented ten spaces and double-spaced. Find out if your instructor has a preference.)

4. An embedded quotation (i.e., a quotation embedded in a sentence of your own) must fit grammatically into the sentence of which it is a part. For example, suppose you want to use Zadkine's comment, "I do not believe that art must develop on national lines."

Incorrect

Zadkine says that he "do not believe that art must develop on national lines."

Correct

Zadkine says that he does "not believe that art must develop on national lines."

Correct

Zadkine says, "I do not believe that art must develop on national lines."

Don't try to introduce a long quotation (say, more than a complete sentence) into the middle of one of your own sentences. It is almost impossible for the reader to come out of the quotation and to pick up the thread of your own sentence. It is better to lead into the long quotation with "Jones says": and then, after the quotation, to begin a new sentence of your own.

5. The quotation must be exact. Any material that you add must be in square brackets (not parentheses), thus:

Pissarro, in a letter, expressed his belief that "the Japanese practiced this art [of using color to express ideas] as did the Chinese."

If you wish to omit material from within a quotation, indicate the ellipsis by three spaced periods. If a sentence ends in an omission, add a closed-up period and then three spaced periods to indicate the omission. The following example is based on a quotation from the sentences immediately before this one:

The manual says that "if you . . . omit material from within a quotation, [you must] indicate the

ellipsis. . . . If a sentence ends in an omission, add a closed-up period and then three periods. . . ."

Notice that although material preceded "if you," periods are not needed to indicate the omission because "if you" began a sentence in the original. (Notice, too, that although in the original if was capitalized, in the quotation it is reduced to lowercase in order to fit into the sentence grammatically.) Customarily initial and terminal omissions are indicated only when they are part of the sentence you are quoting. Even such omissions need not be indicated when the quoted material is obviously incomplete—when, for instance, it is a word or phrase.

- 6. Punctuation is a bit tricky. Commas and periods go inside the quotation marks; semicolons and colons go outside. Question marks, exclamation points, and dashes go inside if they are part of the quotation, outside if they are your own.
- 7. Use single quotation marks for material contained within a quotation that itself is within quotation marks. In the following example, a student quotes William Jordy (the quotation from Jordy is enclosed within double quotation marks), who himself quoted Frank Lloyd Wright (the quotation within Jordy's quotation is enclosed within single quotation marks):

William H. Jordy believes that to appreciate Wright's Guggenheim Museum one must climb up it, but he recognizes that "Wright . . . recommended that one take the elevator and circle downward. 'The elevator is doing the lifting,' as he put it, 'the visitor the drifting from alcove to alcove.'"

8. Use quotation marks around titles of short works, that is, for titles of chapters in books and for stories, essays, short poems, songs, lectures, and speeches. Titles of unpublished works, even booklength dissertations, are also enclosed in quotation marks. But underline—to indicate *italics*—titles of pamphlets, periodicals, and books. Underline also titles of films, radio and television programs, ballets and operas, and works of art except architecture. Thus: Mi-

chelangelo's David, Picasso's Guernica, Frank Lloyd Wright's Guggenheim Museum.

Exception: Titles of sacred writings (e.g., the Old Testament, the Bible, Genesis, Acts, the Gospels, the Koran) are neither underlined nor enclosed within quotation marks. To cite a book of the Bible with chapter and verse, give the name of the book, then a space, then an arabic numeral for the chapter, a period, and an arabic numeral (not preceded by a space) for the verse, thus: Exodus 20.14–15. (The older method of citation, with a small roman numeral for the chapter and an arabic numeral for the verse, is no longer common.) Standard abbreviations for the books of the Bible (for example, 2 Cor. for 2 Corinthians) are permissible in citations.

ACKNOWLEDGING SOURCES

Borrowing Without Plagiarizing

You must acknowledge your indebtedness for material when

- 1. you quote directly from a work;
- 2. you paraphrase or summarize someone's words (the words of the paraphrase or summary are your own, but the points are not, and neither, probably, is the structure of the sentences); or
- 3. you appropriate an idea that is not common knowledge.

Let's suppose you are going to make use of William Bascom's comment on the earliest responses of Europeans to African art:

The first examples of African art to gain public attention were the bronzes and ivories which were brought back to Europe after the sack of Benin by a British military expedition in 1897. The superb technology of the Benin bronzes won the praise of experts like Felix von Luschan who wrote in 1899, "Cellini himself could not have made better casts, nor anyone else before or since to the present day." Moreover, their relatively realistic treatment of human features conformed to the prevailing European aesthetic standards. Because of their naturalism and technical excellence, it was at first maintained that they had been produced by Europeans—a view that was still current when the even more realistic bronze heads were discovered at Ife in 1912. The subsequent discovery of new evidence has caused the

complete abandonment of this theory of European origins of the bronzes of Benin and Ife, both of which are cities in Nigeria. William Bascom, African Art in Cultural Perspective (New York: Norton, 1973), p. 4

1. Acknowledging a direct quotation. You may want to use some or all of Bascom's words, in which case you will write something like this:

As William Bascom says, when Europeans first encountered Benin and Ife works of art in the late nineteenth century, they thought that Europeans had produced them, but the discovery of new evidence "caused the complete abandon—ment of this theory of European origins of the bronzes of Benin and Ife, both of which are cities in Nigeria."

Notice that the digit, indicating a footnote, is raised, and that it follows the period and the quotation mark. (The form of footnotes is specified on pages 153–160.) And, of course, in a relatively informal paper it may be enough merely to mention, in the body of the paper, the author, title, and page number, without using a footnote specifying place of publication, publisher, and date. The point here is not that you must use detailed footnotes but that you must give credit. Not to give credit is to plagiarize, which is a serious breach of the rules governing academic work.

2. Acknowledging a paraphrase or summary. Summaries (abridgments) are usually superior to paraphrases (rewordings, of approximately the same length as the original) because summaries are briefer, but occasionally you may find that you cannot abridge a passage in your source and yet you don't want to quote it word for word—perhaps because it is too technical or because it is poorly written. Even though you are changing some or all of the words, you must give credit to the source because the idea is not yours, nor, probably, is the sequence of the presentation.

Here is an example of a summary:

William Bascom, in <u>African Art</u>, points out that the first examples of African art—Benin bronzes and ivories—brought to Europe were thought by Europeans to be of Euro—

pean origin, because of their naturalism and their technical excellence, but evidence was later discovered that caused this theory to be abandoned.

Not to give Bascom credit is to plagiarize, even though the words are yours. The offense is just as serious as not acknowledging a direct quotation. And, of course, if you say something like this and do not give credit, you are also plagiarizing, even though almost all of the words are your own:

The earliest examples of African art to become widely known in Europe were bronzes and ivories that were brought to Europe in 1897. These works were thought to be of European origin, and one expert said that Cellini could not have done better work. Their technical excellence, as well as their realism, fulfilled the European standards of the day. The later discovery of new evidence at Benin and Ife, both in Nigeria, refuted this belief.

It is pointless to offer this sort of rewording: If there is a point, it is to conceal the source and to take credit for thinking that is not your own.

3. Acknowledging an idea. Let us say that you have read an essay in which Seymour Slive argues that many Dutch still lifes have a moral significance. If this strikes you as a new idea and you adopt it in an essay—even though you set it forth entirely in your own words and with examples not offered by Slive—you should acknowledge your debt to Slive. Not to acknowledge such borrowing is plagiarism. Your readers will not think the less of you for naming your source; rather, they will be grateful to you for telling them about an interesting writer.

In short, acknowledge your source (1) if you quote directly, and put the quoted words in quotation marks; (2) if you summarize or paraphrase someone's material, even though not one word of your source is retained; and (3) if you borrow a distinctive idea even though the words and the concrete application are your own.

Fair Use of Common Knowledge

If in doubt as to whether or not to give credit (either in a footnote or merely in an introductory phrase such as "William Bascom says"), give credit. But as you begin to read widely in your field or subject, you will develop a sense of what is considered common knowledge. Unsurprising definitions in a dictionary can be considered common knowledge, and so there is no need to say "According to Webster, a mural is a picture or decoration applied to a wall or ceiling." (That's weak in three ways: It's unnecessary, it's uninteresting, and it's unclear, since "Webster" appears in the titles of several dictionaries, some good and some bad.)

Similarly, the date of Picasso's death can be considered common knowledge. Few can give it when asked, but it can be found in many sources, and no one need get the credit for providing you with the date. Again, if you simply *know*, from your reading of Freud, that Freud was interested in art, you need not cite a specific source for an assertion to that effect, but if you know only because some commentator on Freud said so, and you have no idea whether the fact is well known or not, you should give credit to the source that gave you the information. Not to give credit—for ideas as well as for quoted words—is to plagiarize.

With matters of interpretation the line is less clear. For instance, almost all persons who have published discussions of van Gogh's The Potato Eaters have commented on its religious implications or resonance. In 1950, for example, Meyer Schapiro wrote. "The table is their altar . . . and the food a sacrament. . . . " In 1971 Linda Nochlin wrote that the picture is an "overtly expressive embodiment of the sacred," and in 1984 Robert Rosenblum commented on the "almost ritualistic sobriety that seems inherited from sacred prototypes." Of course if you got this idea from one source, you should cite the source, but if in your research you encountered it in several places, it will be enough if you say something like, "The sacramental quality of the picture has been widely noted." You need not cite half a dozen references—though you may wish to add, "first by," or "most recently by," or some such thing, in order to lend a bit of authority to your paper.

"But How Else Can I Put It?"

If you have just learned—say, from an encyclopedia—something that you sense is common knowledge, you may wonder, How can I change into my own words the simple, clear words that this source uses in setting forth this simple fact? For example, if before writing about Rosa Bonheur's painting of Buffalo Bill (he took his Wild West show to France), you look him up in the Encyclopaedia Britannica, you will find this statement about Buffalo Bill (William F. Cody): "In 1883 Cody organized his first Wild West exhibition." You cannot use this statement as your own, word for word, without feeling uneasy. But to put in quotation marks such a routine statement of what can be considered common knowledge, and to cite a source for it, seems pretentious. After all, the Encyclopedia Americana says much the same thing in the same routine way: "In 1883, . . . Cody organized Buffalo Bill's Wild West." It may be that the word "organized" is simply the most obvious and the best word. and perhaps you will end up using it. Certainly to change "Cody organized" into "Cody presided over the organization of" or "Cody assembled" or some such thing, in an effort to avoid plagiarizing, would be to make a change for the worse and still to be guilty of plagiarism. But you won't get yourself into this mess of wondering whether to change clear, simple wording into awkward wording if in the first place, when you take notes, you summarize your sources, thus: "1883: organized Wild West," or "first Wild West: 1883." Later (even if only thirty minutes later), when drafting your paper, if you turn this nugget-probably combined with others-into the best sentence you can, you will not be in danger of plagiarizing, even if the word "organized" turns up in your sentence.

Notice that *taking notes* is part of the trick; this is not the same thing as copying or photocopying. Photocopying machines are great conveniences but they also make it easy for us not to think; we later may confuse a photocopy of an article with a thoughtful response to an article. The copy is at hand, a few words underlined, and we use the underlined material with the mistaken belief that we have absorbed it.

If you take notes thoughtfully, rather than make copies mindlessly, you will probably be safe. Of course, you may want to say somewhere that all your facts are drawn from such-and-such a source, but you offer this statement not to avoid charges of plagiarism but for three other reasons: to add authority to your paper, to give respectful credit to those who have helped you, and to protect yourself in case your source contains errors of fact.

FOOTNOTES AND ENDNOTES

Kinds of Notes

In speaking of kinds of notes, this paragraph is not distinguishing between footnotes, which appear at the bottom of the page, and endnotes, which appear at the end of the essay; for simplicity footnote will cover both terms. Rather, a distinction is being made between (1) notes that give the sources of quotations, facts, and opinions used and (2) notes that give additional comment that would interrupt the flow of the argument in the body of the paper.

This second type perhaps requires a comment. You may wish to indicate that you are familiar with an opinion contrary to the one you are offering, but you may not wish to digress upon it during the course of your argument. A footnote lets you refer to it and indicate why you are not considering it. Or a footnote may contain full statistical data that support your point but that would seem unnecessarily detailed and even tedious in the body of the paper. This kind of footnote, giving additional commentary, may have its place in research papers and senior theses, but even in such essays it should be used sparingly, and it rarely has a place in a short analytical essay. There are times when supporting details may be appropriately relegated to a footnote, but if the thing is worth saying, it is usually worth saying in the body of the paper. Don't get into the habit of affixing either trivia or miniature essays to the bottom of each page of an essay.

Footnote Numbers and Positions

Number the notes consecutively through the essay or chapter. Although some instructors allow students to group all the notes at the rear of the essay, most instructors—and surely all readers—believe that the best place for a note is at the foot of the appropriate page. If you type all your notes in your draft, when typing your final copy you can easily gauge how much space the footnotes for any given page will require. If you use a word processor, your software may do the job for you.

Footnote Style

At the bottom of the page double-space twice (i.e., skip three lines) before giving the first footnote. Then indent five spaces, raise the typewriter carriage—if you are not using a computer—half a line, and type the arabic numeral (without a period). Lower the carriage to the regular position, skip one space, and type the footnote, single-spacing it. (Some manuals suggest double-spacing footnotes that run more than one line. Ask your instructors if they have a preference.) If the note runs more than one line, the subsequent lines are flush with the left margin, but each new note begins with an indentation of five spaces. Each note begins with an indented, raised numeral, then a capital letter, and ends with a period or other terminal punctuation. Double-space between footnotes.

FIRST REFERENCE TO A BOOK

Here is a typical first reference to a book:*

¹Michael Levey, <u>Painting at a Court</u> (New York: New York University Press, 1971), p. 134.

^{*} Different publishers and different periodicals have different styles. Some, for examples, do not require that the name of the publisher of a book be given in a footnote or endnote. The College Art Association does not use the same style even in two of its own publications, Art Bulletin and Art Journal, and most university presses use a style different from the styles of these two journals. The style set forth here is used by most university presses and by many journals in the humanities. (For the style used by Art Bulletin, see "Notes for Contributors," in the June 1990 issue. Art Journal will, on request, provide "Guidelines for Contributors.")

Notice that you give the author's name as it appears on the title page, first name first. You need not give the subtitle, but if you do give it, put a colon between the title and the subtitle and underline the subtitle. The name of the city (without the state or country) is usually enough; but if the city is not well known, or may be confused with another city of the same name (Cambridge, England, and Cambridge, Massachusetts), the state or country is added. The name of the publisher (here New York University Press) may be shortened. (Thus, Little, Brown and Company may be shortened to Little, Brown.) If the date is not given, in place of it put "n.d." The conventional abbreviation for page is "p." and for pages is "pp." (not "pg." and "pgs."). If you give the author's name in the body of the page—for example, in such a phrase as "Levey says that Rubens"—do not repeat the name in the footnote. Merely begin with the title:

But do not get carried away by the principle of not repeating in the note any material already given in the body of the paper. If the author and the title are given, convention nevertheless requires you to repeat the title—though not the author's name—in the first note citing the source.

For a book in one volume, by one author, revised edition:

For a book in one volume, by one author, later reprint:

¹Painting at Court (New York: New York University Press, 1971), p. 134.

Rudolf Wittkower, Art and Architecture in Italy, 1600-1750, 3rd ed. rev. (Harmondsworth, England: Penguin, 1973), p. 187.

³Erwin Panofsky, <u>Studies in Iconology</u> (1939; rpt. New York: Harper & Row, 1962), pp. 126-27.

For a book in more than one volume (notice that the volume number is given in roman numerals, the page number in arabic

155

numerals, and abbreviations such as "vol." and "p." are not used):

⁴Ronald Paulson, <u>Hogarth: His Life, Art, and Times</u> (New Haven, Conn.: Yale University Press, 1971), II, 161.

For a book by more than one author (if there are more than three authors, give the full name of the first author and add et al., the Latin abbreviation for "and others"):

⁵John M. Rosenfield and Shujiro Shimada, <u>Traditions of</u>

<u>Japanese Art</u> (Cambridge, Mass.: Fogg Museum, 1970),
pp. 280-281.

The name of the second author, like that of the first, is given first name first.

For an edited or translated book:

⁶The Letters of Peter Paul Rubens, trans. and ed. Ruth Magurn (Cambridge, Mass.: Harvard University Press, 1955), p. 238.

⁷Dietrich Seckel, The Art of Buddhism, trans. Ann E. Keep (New York: Crown, 1964), p. 208.

8Charles Pellet, "Jewelers with Words," in <u>Islam and the Arab World</u>, ed. Bernard Lewis (New York: Knopf, 1976), p. 151.

As note 8 indicates, when you are quoting from an essay in an edited book, you begin with the essayist (first name first) and the essay, then go on to give the title of the book and the name of the editor, first name first.

For an article in an encyclopedia, publisher and place of publication need not be given. If the article is signed, begin with the author's

name (first name first); if it is unsigned, simply begin with the title of the article, in quotation marks. The first example is for a signed article on Picasso:

⁹Thomas M. Messer, "Picasso, Pablo," <u>Encyclopedia</u>
Americana, 1979, XXII, 67.

Some manuals say that references to alphabetically arranged articles (signed or unsigned) need not include the volume and page number, but if you do include them, as here, use roman numerals for the volume (but do *not* write "vol.") and arabic numerals for the page (but do *not* write "p.").

The most recent edition of the Encyclopaedia Britannica comprises three groups of books, called Propaedia, Micropaedia, and Macropaedia, so you must specify which of the three groups you are referring to. The following example cites an unsigned article on Picasso:

10 "Picasso, Pablo (Ruiz y)," Encyclopaedia Britannica: Micropaedia, 1974, VII, 987.

REFERENCES TO INTRODUCTIONS AND TO REPRINTED ESSAYS

You may need to footnote a quotation from someone's introduction (say, Kenneth Clark's) to someone else's book (say, James Hall's). If, for example, in your text you say, "As Kenneth Clark points out," the footnote will look like this:

If you want to quote from, say, an essay or an extract from a book that has been reprinted in a book of essays, begin with the writer's name (if you have not given it in your lead-in), then give the title of the essay or original book, then, if possible, the place where this material originally appeared (you can usually find this informa-

ll Introduction to James Hall, <u>Dictionary of Subjects</u>
and Symbols in Art, 2nd ed. (New York: Harper & Row, 1979),
p. viii.

tion on the acknowledgment page of the book in hand or on the first page of the reprinted material), then the name of the title of the book you have in hand, and then the editor, place of publication, publisher, date, and page. The monstrous but accurate footnote might run like this:

12 Albert E. Elsen, Rodin (New York: Museum of Modern Art, 1963); in Readings in Art History, 2nd ed., ed. Harold Spencer (New York: Scribner's, 1976), II, 291.

You have read a selection from Elsen's Rodin, but you did not actually read it in Elsen's book; rather, you read it in the second volume of Spencer's anthology entitled Readings in Art History. You learned the name of Elsen's book, and the data about publication, from Spencer, so you print them, but your page reference is of course to the book that you are holding in your hand, page 291 in the second volume of Spencer's collection.

FIRST REFERENCE TO A JOURNAL

Footnote 13 is for a journal (here, volume 29) paginated consecutively throughout the year; footnote 14, specifying the month, is for a journal that paginates each issue separately. For a journal paginated separately you must list the issue number or month or week or day as well as the year because if it is, for example, a monthly, there will be twelve page 10's in any given year. Current practice favors omitting the volume number for popular weeklies (see footnote 15) and for newspapers, in which case the full date is given without parentheses.

¹³Anne H. van Buren, "Madame Cézanne's Fashions and the Dates of Her Portraits," <u>Art Quarterly</u> 29 (1966), 119.

¹⁴Linda Nochlin, "Why Have There Been No Great Women Artists?" Art News 69 (January 1971), 38.

¹⁵ Henry Fairlie, "The Real Life of Women," New Republic Aug. 26, 1978, p. 18.

The author's name and the title of the article are given as they appear in the journal (*first name first*), the title of the article in quotation marks, and the title of the journal underlined (to indicate italics). Until recently the volume number, before the date, was given with capital roman numerals, but current practice uses arabic numerals for both the volume and the page or pages. Notice that when a volume number is given, as in notes 13 and 14, the page number is *not* preceded by "p." or "pp."

The sample notes cite the specific page that the student is drawing on. If the article as a whole is being cited, instead of, say,

page 119, we would get 117-122.

If a book review has a title, the review may be treated as an article. If, however, the title is merely that of the book reviewed, or even if the review has a title but for clarity you wish to indicate that it is a review, the following form is commonly used:

FIRST REFERENCE TO A NEWSPAPER

The first example is for a *signed article*, the second for an unsigned one:

UNPAGINATED MATERIAL

If a pamphlet is unpaginated, simply put "unpaginated" where you would ordinarily put the page number. If plates in an article or book are unpaginated, put "Plate 1" (or whatever the number) where you would ordinarily put the page number.

¹⁶ Pepe Karmel, review of Calvin Tomkins, Off the Wall:
Robert Rauschenberg and the Art World of Our Time (Garden
City, N.Y.: Doubleday, 1980), New Republic, June 21, 1980,
p. 38.

¹⁷ Bertha Brody, "Illegal Immigrant Sculptor Allowed to Stay," The New York Times, July 4, 1990, Sec. B, p. 12, col. 2.

^{18&}quot;Portraits Stolen Again," <u>Washington Post</u>, June 30, 1990, p. 7, col. 3.

SECONDHAND REFERENCES

If you are quoting from, say, Frank Lloyd Wright, but you have not derived the quotation directly from Wright but from a book or article that quotes him, your footnote should indicate both the original source, if possible (i.e., not only Wright's name but his book, place of publication, etc.), and then full information about the place where you have found the material that you are using.

19 Frank Lloyd Wright, The Solomon R. Guggenheim Museum (New York: Museum of Modern Art, 1960), p. 20; quoted in William H. Jordy, American Buildings and Their Architects (Garden City, N.Y.: Anchor, 1976), IV, 348.

If Jordy had merely cited Wright's name, without any further bibliographic information, of course, you would be able to give only Wright's name and then the details about Jordy's book.

SUBSEQUENT REFERENCES

If you quote a second or third or fourth time from a work, use a short form in your footnote. The most versatile short form is simply the author's last name and the page number, thus:

You can even dispense with the author's name if you have mentioned it in the sentence to which the footnote is keyed. That is, if you have said "Panofsky goes on to say," the footnote need only be

If, however, you have made reference to more than one work by the author, you must indicate by a short title which work you are referring to, thus:

²⁰Levey, p. 155.

²¹p. 108.

²² Panofsky, Studies, p. 108.

Or if your sentence mentions that you are quoting Panofsky, the footnote may be

23 Studies, p. 108.

If you have said something like "Panofsky, in Studies in Iconology," the reference may be merely

²⁴p. 108.

In short, a subsequent reference should be as brief as clarity allows. The form "ibid." (for *ibidem*, "in the same place"), indicating that the material being footnoted comes from the same place as the material of the previous footnote, is no longer preferred for second references. "Op cit." (for *opere citato*, "in the work cited") and "loc. cit." (for *loco citato*, "in the place cited") have almost disappeared. Identification by author—or by author and short title, if necessary—is preferable.

FOOTNOTING INTERVIEWS, LECTURES, LETTERS

BIBLIOGRAPHY

A bibliography is a list of the works cited or, less often, a list of all the relevant sources. (There is rarely much point in the second sort; if you haven't made use of a particular book or article, why list it?) Normally a bibliography is given only in a long manuscript such as a research paper or a book, but instructors may require a bibliogra-

²⁵Interview with Alan Shestack, Director, Museum of Fine Arts, Boston, July 12, 1988.

²⁶Howard Saretta, "Masterpieces from Africa," Tufts University, May 13, 1988.

²⁷Information in a letter to the author, from James Cahill, University of California, Berkeley, Mar. 17, 1988.

phy even for a short paper if they wish to see at a glance the material that the student has used. In this case a heading such as "Works Cited" is less pretentious than "Bibliography."

If the bibliography is extensive, it may be advisable to divide it into two parts, Primary Materials and Secondary Materials (see p. 177), or even into several parts, such as Theological Background, Iconographic Studies, Marxist Interpretations, Feminist Interpretations, and so forth.

Because a bibliography (or each part of a bibliography) is arranged alphabetically by author, the author's *last name is given first*. If a work is by more than one author, it is given under the first author's name; this author's last name is given first, but the other author's or authors' names follow the normal order of first name first. (See the entry under Rosenfield, page 162.)

Anonymous works are sometimes grouped at the beginning, arranged alphabetically under the first word of the title (or the second word, if the first word is A, An, or The), but the recent tendency has been to list them at the appropriate alphabetical place, giving the initial article, if any, but alphabetizing under the next word. Thus an anonymous essay entitled "A View of Leonardo" would retain the "A" but would be alphabetized under V.

In addition to giving the last name first, a bibliographic entry differs from a footnote in several other ways. For example, a bibliographic entry does not put parentheses around the place of publication, the publisher, and the date. In typing an entry, begin flush with the left-hand margin; if the entry runs over the line, indent the subsequent lines of the entry five spaces. Double-space between entries. (Caution: Some manuals suggest double-spacing throughout; check with your instructor.)

A book by one author:

Caviness, Madeline Harrison. The Early Stained Glass of

Canterbury Cathedral. Princeton: Princeton University Press, 1977.

Note: Princeton needs no further identification, but if the city is obscure, or may be confused with another city of the same name (e.g., Cambridge, Massachusetts, and Cambridge, England), add the necessary additional information.

A book by more than one author:

Rosenfield, John M., and Elizabeth ten Grotenhuis. <u>Journey of the Three Jewels: Japanese Buddhist Paintings from Western Collections</u>. New York: Asia Society, 1979.

Notice in this entry that although the book is alphabetized under the *last name* of the *first* author, the name of the second author is given in the ordinary way, first name first.

A collection or anthology:

Goldwater, Robert, and Marco Treves, eds. Artists on Art.

New York: Pantheon, 1945.

This entry lists the collection alphabetically under the first editor's last name. Notice that the second editor's name is given first name first. A collection may be entered either under the editor's name or under the first word of the title.

An essay in a collection or anthology:

Livingstone, Jane, and John Beardsley. "The Poetics and Politics of Hispanic Art: A New Perspective." Exhibiting Cultures: The Poetics and Politics of Museum Display. Eds. Ivan Karp and Steven D. Lavine. Washington, D.C.: Smithsonian, 1991. 104-120.

This entry lists an article by Livingstone and Beardsley (notice that the first author's name is given with the last name first, but the second author's name is given in the usual order) in a book called *Exhibiting Cultures*, edited by Karp and Lavine. The essay appears on pages 104–120.

Two or more works by the same author:

Cahill, James. Chinese Painting. Geneva: Skira, 1960.

---. Scholar Painters of Japan: The Nanga School. New York: Asia House, 1972.

The horizontal line (three hyphens, followed by a period and then two spaces) indicates that the author (in this case James Cahill) is the same as in the previous item; multiple titles by one author are arranged alphabetically, as here where the title beginning *Chinese* precedes *Scholar*.

Encyclopedia articles:

"Baroque." The New Columbia Encyclopedia. 4th ed.

Jones, Henry Stuart. "Roman Art." Encyclopaedia Britannica. 11th ed.

"Picasso, Pablo (Ruiz y)." Encyclopaedia Britannica: Micropaedia. 1978 ed.

The first and third of these three encyclopedia articles are unsigned, so the articles are listed under their titles. The second is signed, so it is listed under its author. Notice that an encyclopedia does not require volume or page, or place or date of publication; the edition, however, must be identified somehow, and usually the date is the best identification.

An introduction to a book by another author:

Clark, Kenneth. Intro. to James Hall, Dictionary of Subjects and Symbols in Art. 2nd ed. New York: Harper & Row, 1979. vii-viii.

The last entry suggests that the student made use of the introduction, rather than the main body, of the book; if the body of the book were used, the book would be alphabetized under H for Hall, and the title would be followed by: Intro. Kenneth Clark.

An edition:

Rossetti, Dante Gabriel. Letters of Dante Gabriel

Rossetti. Ed. Oswald Doughty and J. R. Wahl. 4 vols.

Oxford: Clarendon, 1965.

A periodical:

Mitchell, Dolores. "The 'New Woman' as Prometheus: Women
Artists Depict Women Smoking." Woman's Art Journal
12 (Spring/Summer 1991):2-9.

Because this journal paginates each issue separately, the season or month must be given. For a journal that paginates issues continuously, give the year without the season or month.

A newspaper:

"Museum Discovers Fake." The New York Times January 21, 1980. Sec. D, p. 29, col. 2.

Romero, Maria. "New Sculpture Unveiled." Washington Post
March 18, 1980, p. 6, col. 4.

Because the first of these newspaper articles is unsigned, it is alphabetized under the first word of the title; because the second is signed, it is alphabetized under the author's last name.

A book review:

Gevisser, Mark. Rev. of Art of the South African Townships by Gavin Younger. Art in America 77 (July 1989):35-39.

This journal paginates each issue separately, so the month must be given as well as the year.

SOME CONVENTIONS OF LANGUAGE USAGE

The Apostrophe

1. To form the possessive of a name, the simplest (and perhaps the best) thing to do is to add 's, even if the name already ends with a sibilant (-s, -cks, -x, -z). Thus:

El Greco's colors Rubens's models Veláquez's subjects Augustus John's sketches (his last name is *John*) Jasper Johns's recent work (his last name is *Johns*)

But some authorities say that to make the possessive for names ending in a sibilant, only an apostrophe is added (without the additional s)—Velázquez would become Velázquez', and Moses would become Moses'—unless (1) the name is a monosyllable (e.g., Jasper Johns would still become Johns's) or (2) the sibilant is followed by a final e (Horace would still become Horace's). Note that despite the final s in Degas and the final x in Delacroix, these names do not end in a sibilant (the letters are not pronounced), and so the possessive must be made by adding 's.

2. Don't add's to the title of a work to make a possessive; the addition can't be italicized (underlined), since it is not part of the title, and it looks odd attached to an italicized word. So, not "The Sower's

colors"; rather, "the colors of The Sower."

3. Don't confuse *its* and *it's*. The first is a possessive pronoun ("Its colors have faded"); the second is a contraction of *it is* ("It's important to realize that most early landscapes were painted indoors"). You'll have no trouble if you remember that *its*, like other possessive pronouns such as ours, his, hers, theirs, does *not* use an apostrophe.

Capitalization

Although some writers do not capitalize renaissance, middle ages, romanesque, and so on, most do, even when, for example, Renaissance is used as an adjective ("Most Renaissance portraits"). But do not capitalize medieval. Most writers do not capitalize classic and romantic—but even if you do capitalize Romantic when it refers to a movement ("Delacroix was a Romantic painter"), note that you should not capitalize it when it is used in other senses ("There is something romantic about ruined temples"). Many writers capitalize the chief events of the Bible, such as the Creation, the Fall, the Annunciation, and the Crucifixion, and also mythological events, such as the Rape of Ganymede and the Judgment of Paris. Again, be consistent.

On capitalization in titles, see pages 139-140 and 169-170.

The Dash

Type a dash by typing two hyphens without hitting the space bar before, between, or after. Do not confuse the dash with the hyphen. Here is an example of the dash:

New York—not Paris—is the center of the art world today.

Foreign Words and Quotations in Foreign Languages

- 1. Underline (to indicate italics) foreign words that are not part of the English language. Examples: *sfumato* (an Italian word for a blurred outline), *pai-miao* (Chinese for fine-line work). But such words as chiaroscuro and Ming are not italicized because, as their presence in English dictionaries indicates, they have been accepted into English vocabulary. Foreign names are discussed below.
- 2. Do not underline a quotation (whether in quotation marks or set off) in a foreign language. A word about foreign quotations: If your paper is frankly aimed at specialists, you need not translate quotations from languages that your readers might be expected to know, but if it is aimed at a general audience, translate foreign quotations, either immediately below the original or in a footnote.
- 3. On translating the titles of works of art, and on capitalizing the titles of foreign books, see "Titles," pages 169–170.

The Hyphen

- 1. Use a hyphen to divide a word at the end of a line. Because words may be divided only as indicated by a dictionary, it is easier to end the line with the last complete word you can type than to keep reaching for a dictionary. But here are some principles governing the division of words at the end of a line:
 - a. Never hyphenate words of one syllable, such as called, doubt, through.
 - b. Never hyphenate so that a single letter stands alone: a-lone, hair-y.
 - c. If a word already has a hyphen, divide it at the hyphen: antiintellectual.
 - d. Divide prefixes and suffixes from the root: pro-vide; paint-ing.
 - e. Divide between syllables. If you aren't sure of the proper syllabification, check a dictionary.

Notice that when hyphenating, you do not hit the space bar before or after hitting the hyphen.

2. Use a hyphen to compound adjectives into a single visual unit: twentieth-century architects (but "She was born in the twentieth century").

Names

- 1. Dutch van, as in Vincent van Gogh, is never capitalized by the Dutch except when it begins a sentence; in American usage, however, it is acceptable (but not necessary) to capitalize it when it appears without the first name, as in "The paintings of Van Gogh." But: "Vincent van Gogh's paintings." Names with van are commonly alphabetized under the last name, for example, under G for Gogh.
- 2. French de is not used (De Gaulle was an exception) when the first name is not given. Thus, the last name of Georges de La Tour is La Tour, not de La Tour. But when de is combined with the definite article, into des or du, it is given even without the first name. La and Le are used even when the first name is not given, as in Le Nain.
- 3. Spanish de is not used without the first name, but if it is combined with el into del, it is given even without the first name.
- 4. Names of deceased persons are never prefaced with Mr., Miss, Mrs., or Ms.—even in an attempt at humor.
- 5. Names of women used to be prefaced by a polite Miss or Mrs., but the convention today is to treat them like men's names, that is, to give them no title.
- 6. First names are used for many writers and artists of the Middle Ages and Renaissance (examples: Dante, for Dante Alighieri; Michelangelo, for Michelangelo Buonarroti; Piero, for Piero della Francesca; Rogier, for Rogier van der Wyeden), and usually these are even alphabetized under the first name. But do not adopt a chatty familiarity with later people: Picasso, not Pablo. Exception: Because van Gogh often signed his pictures "Vincent," some writers call him Vincent.

Sexist Language

1. It is awkward to write "he or she" (or "she or he") or "his or her" (or "her or his") but the implicit male chauvinism in the generic use of the male pronoun ("An architect should maintain his independence") is more offensive than the awkwardness of "he or she," and the like. Do what you can to avoid the dilemma. Sometimes you can

use the plural *their* ("Architects should maintain their independence"). Or eliminate the possessive: "An architect should be independent."

- 2. Because man and mankind strike many readers as sexist when used in such expressions as "man's art" or "the greatness of mankind," consider using such words as human being, person, people, humanity, and we. (Example: "Human beings need art," or "We need art," instead of "Man needs art.")
- 3. Layman, craftsman, and similar words offend some readers. Try to use substitutes, such as layperson or unspecialized people, and (for craftsman) craftsperson, or, probably better, artisan or such a term as fabric artist.
- 4. Avoid such expressions as "woman painter" or "female sculptor," unless the context requires them. These terms imply that there is something freakish in a woman who paints or sculpts.

Spelling

If you are a weak speller, ask a friend to take a look at your paper. If you have written the paper on a word processor, use the spelling checker if there is one, but remember that the spelling checker tells you only if a word is not in its dictionary. It does *not* tell you that you erred in using *their* where *there* is called for.

Experience has shown that the following words are commonly misspelled in papers on art. If the spelling of one of these words strikes you as odd, memorize it.

altar (noun)	dimension	shepherd
alter (verb)	dominant	silhouette
background	exaggerate	spatial
connoisseur	independent	subtly
contrapposto	parallel	symmetry
Crucifixion	prominent	vertical (not verticle)
deity (not diety)	recede	

Be careful to distinguish the following:

affect, **effect** Affect is usually a verb, meaning (1) "to influence, to produce an effect, to impress," as in "These pictures

greatly affected the history of painting," or (2) "to pretend, to put on," as in "He affected to enjoy the exhibition." Psychologists use it as a noun for "feeling" ("The patient experienced no affect"), but leave this word to psychologists. *Effect*, as a verb, means "to bring about" ("The workers effected the rescue in less than an hour"). As a noun, *effect* means "result" ("The effect of his work was negligible").

capital, capitol A *capital* is the uppermost member of a column or pilaster; it also refers to accumulated wealth, or to a city serving as a seat of government. A *capitol* is a building in which legislators meet, or a group of buildings in which the functions of government are performed.

eminent, immanent, imminent Eminent, "noted, famous"; immanent, "remaining within, intrinsic"; imminent, "likely to occur soon, impending."

its, it's Its is a possessive ("Its origin is unknown"); it's is short for it is ("It's an early portrait").

lay, lie To *lay* means "to put, to set, to cause to rest" ("Lay the glass on the print"). To *lie* means "to recline" ("Venus lies on a couch").

loose, **lose** Loose is an adjective ("The nails in the frame are loose"); lose is a verb ("Don't lose the nails").

precede, **proceed** To *precede* is to come before in time; to *proceed* is to go onward.

principal, principle *Principal* as an adjective means "leading," "chief"; as a noun it means a leader (and, in finance, wealth). *Principle* is only a noun, "a basic truth," "a rule," "an assumption."

Titles

- 1. On the form of the title of a manuscript essay, see pages 139–140.
- 2. On underlining titles of works of art, see the next section, "Underlining."
- 3. Some works of art are regularly given with their titles in foreign languages (Goya's Los Caprichos, the Limbourg Brothers' Les

Très Riches Heures du Duc de Berry, Picasso's Les Demoiselles d'Avignon), and some works are given in a curious mixture of tongues (Cézanne's Mont Sainte-Victoire Seen from Bibémus Quarry), but the vast majority are given with English titles: Picasso's The Old Guitarist, Cézanne's Bathers, Millet's The Gleaners. In most cases, then, it seems pretentious to use the original title.

4. Capitalization in foreign languages is not the same as in English.

French: If you give a title—of a book, essay, or work of art—in French, capitalize the first word and all proper nouns. If the first word is an article, capitalize also the first noun and any adjective that precedes it. Examples: Le Dejeuner sur l'herbe; Les Très Riches Heures du Duc de Berry.

German: Follow German usage; for example, capitalize the pronoun *Sie* ("you"), but do not capitalize words that are not normally capitalized in German.

Italian, capitalize only the first word and names of people and places.

Underlining

Underline (to indicate italics) titles of works of art, other than architecture: Michelangelo's *David*, van Gogh's *Sunflowers*, but the Empire State Building, the Brooklyn Bridge, the Palazzo Vecchio.

Underline titles of books other than holy works: Art and Illusion, The Odyssey, Genesis, the Bible, the Koran. For further details about biblical citations, see page 147.

Underline foreign words, but do not underline quotations from foreign languages (see p. 166).

7 The Research Paper

A NOTE ON ART-HISTORICAL RESEARCH AND ART CRITICISM

It is sometimes argued that there is a clear distinction between scholarship (or art-historical research) and criticism (or appreciation). In this view, scholarship gives us information about works of art and it uses works of art to enable us to understand the thought of a period; criticism gives us information about the critic's feelings, especially the critic's evaluation of the work of art. Art history, it has been said, is chiefly fact finding, whereas art criticism is chiefly fault finding. And there is some debate about which activity is the more worthwhile. The historical scholar may deprecate evaluation criticism as mere talk about feelings, and the art critic may deprecate scholarly art-historical writing as mere irrelevant information. We should look further, then, at historical scholarship and criticism, and at the relation between them.*

*This simple polarity is called into doubt by a third kind of activity, connoisseurship, for the connoisseur identifies and evaluates works of art. Erwin Panofsky, in *Meaning in the Visual Arts* (Garden City, N.Y.: Doubleday, 1955), suggests that the connoisseur differs from the art historian not so much in principle as in emphasis; the connoisseur's opinions (e.g., "Rembrandt around 1650"), like the historian's, are verifiable. The difference is this: "The connoisseur might be defined as a laconic art historian, and the art historian as a loquacious connoisseur" (p. 20). But elsewhere (p. 322) in his book Panofsky distinguishes between art history on the one hand and, on the other, "aesthetics, criticism, connoisseurship, and 'appreciation.'" Perhaps we

The art historian is sometimes viewed as a sort of social scientist, reconstructing the conditions and attitudes of the past through documents. (The documents, of course, include works of art as well as writings.) In studying Cubism, for example, the supposedly dispassionate art historian does not prefer one work by Braque to another by Braque, or Picasso to Braque, or the other way around. The historian's job, according to this view, is to explain how and why Cubism came into being, and value judgments are considered irrelevant.

The art critic, on the other hand, is supposedly concerned not with verifiable facts but with value judgments. Sometimes these judgments can be reduced to statements such as "This work by Braque is better than that work by Picasso," or "Picasso's late works show a falling-off," and so on, but even when critics are not so crudely awarding A's and B's and C's, acts of evaluation lie behind their choice of works to discuss. Intrigued by a work, they usefully call our attention to qualities in it that evoke a response, helping us to see what the work has to offer us. As they do so, they are usually also calling our attention to the degree to which the work corresponds to certain standards or values, for instance, complexity or unity or sincerity or innovativeness. Critics often claim, or assume, that like historians—they are impartial; their judgments, they may say, are based on external standards such as those just specified. The distinction, then, between objectivity (supposedly the property of the historian) and subjectivity (supposedly the property of the critic) is thus called into doubt.

It is probably true, of course, that the root of criticism is a feeling, even a passion, which is then made acceptable by being set forth in a carefully reasoned account. But it must then be added that the root of much historical writing is also a feeling or intuition—a hunch perhaps that a stained-glass window in a medieval cathedral may be a late replacement, or that photography did not influence the

can retain Panofsky's definition of the connoisseur as a "laconic art historian," and say that the connoisseur's specialty is a sensitivity to artistic traits, and that the art historian possesses the knowledge of the connoisseur, that is, a knowledge of what is genuine and of when it was made, and then goes on (by analyzing forms and by relating them chronologically) to explain the changes that have occurred in the ways that artists have seen.

paintings of Degas as greatly as is usually thought. The historian then follows up the hunch by scrutinizing the documents and by setting forth—like the critic—a reasoned account.

It is doubtful, then, that historical scholarship and esthetic criticism are indeed two separate activities; or, to put it a little differently, we can ask if scholarship is really concerned exclusively with verifiable facts, and, on the other hand, if criticism is really concerned exclusively with unverifiable responses, that is, only with opinions. If scholarship limited itself to verifiable facts, it would have little to deal with; the verifiable facts usually don't go far enough.

Suppose that a historian who is compiling a catalog of Rembrandt's work, or who is writing a history of Rembrandt's development, is confronted by a drawing attributed to Rembrandt. External documentation is lacking: No letter describes the drawing, gives a date, or tells us that the writer saw Rembrandt produce it. The historian must decide whether the drawing is by Rembrandt, by a member of Rembrandt's studio, by a pupil but with a few touches added by the master, or is perhaps an old copy or even a modern forgery. Scholarship (e.g., a knowledge of paper and ink) may reveal that the drawing is undoubtedly old, but questions still remain: Is it by the master or by the pupil or by both? (The problem is extremely complex, because Rembrandt apparently was a great teacher, one who could inspire his students to produce works of exceptional beauty. Still, there is much to be said for holding to the axiom that great works of art are produced only by great masters. It is hard to believe that a mediocrity occasionally rises to the heights of genius, no matter how exceptional his or her teacher. But on the other hand, it seems certain that a master can have an off-day.)

Even the most scrupulous historians must bring their critical sense into play, and offer conclusions that go beyond the verifiable facts—conclusions that are ultimately based on an evaluation of the work's quality, a feeling that the work is or is not by Rembrandt. Art historians try to work with scientific objectivity, but because the facts are often inconclusive, much in their writing is inevitably (and properly) an articulation of a response, a rational explanation of feeling that is based on a vast accumulation of experience. Another example: A writer's decision to include in a textbook a discussion of a given artist or school of art is probably a judgment based ultimately

on the feeling that the matter is or is not worth discussing, is or is not something of importance or value. And the decision to give Vermeer more space than Casper Netscher is an esthetic decision, for Netscher was, in his day, more influential than Vermeer. Indeed, art history has worked along these lines from its beginnings in *Lives of the Most Excellent Painters, Sculptors and Architects* by Giorgio Vasari (1511–1574). Vasari says that he disdained to write a "mere catalog," and that he did not hesitate to "include [his] own opinion" everywhere and to distinguish among the good, the better, and the best.

And, on the other hand, even critics who claim that they are concerned only with evaluation, and who dismiss all other writing on art as sociology or psychology or gossip, bring some historical sense to their work. The exhibitions that they see have usually been organized by scholars, and the accompanying catalogs are often significant scholarly works; it is virtually impossible for a serious museum goer not to be influenced, perhaps unconsciously, by art historians. When, for example, critics praise the Cubists for continuing the explorations of Cézanne, and damn John Singer Sargent for contributing nothing to the development of art, they are doing much more than expressing opinions; they are drawing on their knowledge of art history, and they are also echoing the fashionable view that a work of art is good if it marks an advance in the direction that art happens to have taken.

Probably it is best, then, not to insist on the distinction between scholarship and criticism, but to recognize that most writing about art is a blend of both. True, sometimes a piece of writing emphasizes the facts that surround the work (e.g., sources, or the demands of the market), showing us how to understand what people once thought or felt; and sometimes it emphasizes the reasons why the writer especially values a particular work, showing the work's beauty and significance for us. But on the whole the best writers on art do both things, and they often do them simultaneously.

Consider, as an example, Julius S. Held's article, "The Case Against the Cardiff 'Rubens' Cartoons," published in *The Burlington Magazine*, March 1983. Four full-scale cartoons (large drawings) for tapestries were acquired in 1979 by the National Museum of Wales as works by Rubens, but their attribution has been doubted. In the second paragraph of his article, Professor Held comments.

When I first saw the photographs of the cartoons, and even more so after I had seen them in their setting in Cardiff (27th July 1980), I failed to notice anything that would justify the extraordinary claims made for them. That they were Flemish paintings of the seventeenth century no one could deny. They could also be of special interest as cartoons painted on paper, a category of works that must have existed in great quantity, though few have survived. Yet an attribution to Rubens, as the author of their design as well as the actual executant seemed to me highly questionable and certainly not at all self-evident.

Obviously Held is suggesting that the works do not look like works by Rubens, and in the words "the extraordinary claims made for them" we hear a strong implication that they are not good enough to be by Rubens. So we begin with evaluation, taste, perhaps subjective judgment, but judgment made by a trained eye.

Held goes on to buttress this judgment with other criteria, of a more objective kind. Technically, the cartoons are unprecedented in Rubens's oeuvre. They are done in watercolor on paper, a medium he never used on this scale; even in small drawings watercolor alone is rarely employed. The attribution, hence, of the disputed cartoons to Rubens is unlikely on this ground alone. Held proceeds to ask himself on what basis these cartoons were attributed to Rubens in the first place. The main argument in favor was based on the existence of two modelli, painted in oil and depicting actions similar to those of the two cartoons. These modelli are indeed by Rubens, but they cannot be used in support of the attribution of the cartoons. Why? Because in composition these modelli differ radically from the cartoons, whereas in all the instances in which we know Rubens's modelli for tapestry cartoons, the modelli and the cartoons agree with each other in all essential respects. In disengaging the modelli from the cartoons, Held also uses an iconographic argument: The cartoons depict incidents from the life of Aeneas, but the modelli illustrate scenes from the life of Romulus.

In short, during the course of his argument, Held introduces historical data in support of critical judgments. His final words make this clear: "The purpose of my paper is served . . . if it succeeds to remove Rubens's name from four paintings that are not worthy to carry it."

WHAT RESEARCH IS

Because a research paper requires its writer to collect the available evidence—usually including the opinions of earlier investigators—one sometimes hears that a research paper, unlike a critical essay, is not the expression of personal opinion. But such a view is unjust both to criticism and to research. A critical essay is not a mere expression of personal opinion; to be any good it must offer evidence that supports the opinions, thus persuading the reader of their objective rightness. And a research paper is largely personal, because the author continuously uses his or her own judgment to evaluate the evidence, deciding what is relevant and convincing. A research paper is not merely an elaborately footnoted presentation of what a dozen scholars have already said about a topic; it is a thoughtful evaluation of the available evidence, and so it is, finally, an expression of what the author thinks the evidence adds up to.*

You may want to do some research even for a paper that is primarily critical. Consider the difference between a paper on the history of Rodin's reputation and a paper offering a formal analysis of a single work by Rodin. The first of these, necessarily a research paper, will require you to dig into books and magazines and newspapers to find out about the early response to his work; but even if you are writing a formal analysis of a single piece, you may want to do a little research into, for example, the source of the pose. The point is that writers must learn to use source material thoughtfully, whether they expect to work with few sources or with many.

Though research sometimes requires one to read tedious material, or material that, however interesting, proves to be irrelevant, those who engage in research feel, at least at times, an exhilaration, a sense of triumph at having studied a problem thoroughly and at having arrived at conclusions that at least for the moment seem objective and irrefutable. Later, perhaps, new evidence will turn up that will require a new conclusion, but until that time, one may reasonably feel that one knows *something*.

^{*}Because footnotes may be useful or necessary in a piece of writing that is not a research paper (such as this chapter), and because I want to emphasize the fact that a thoughtful research paper requires more than footnotes, I have put the discussion of footnotes in Chapter 6 on pages 152–160.

PRIMARY AND SECONDARY MATERIALS

The materials of most research are conventionally divided into two sorts, primary and secondary. The primary materials or sources are the subject of study, the secondary materials are critical and historical accounts already written about these primary materials. For example, if you want to know whether or not Rodin was influenced by Michelangelo, you will look at works by both sculptors, and you will read what Rodin said about his work as a sculptor. In addition to studying these primary sources, you will also read secondary material such as modern books on Rodin. There is also material in a sort of middle ground: what Rodin's friends and assistants said about him. If these remarks are thought to be of compelling value, especially because they were made during Rodin's lifetime or soon after his death, they can probably be considered primary materials. And, of course, for a work such as Rodin's Monument to Balzac (1897), the novels of Balzac can be considered primary materials.

If possible, draw as heavily as you can on primary sources. If in a secondary source you encounter a quotation from Leonardo or Mary Cassatt or whomever-many artists wrote a good deal about their work—do not be satisfied with this quotation. Check the original source (it will probably be cited in the secondary source that quotes the passage) and study the quotation in its original context. You may learn, for instance, that the comment was made so many

years after the art work that its relevance is minimal.

FROM SUBJECT TO THESIS

First, a subject. No subject is undesirable. As G. K. Chesterton said, "There is no such thing on earth as an uninteresting subject; the only thing that can exist is an uninterested person." Research can be done on almost anything that interests you, though you should keep in mind two limitations. First, materials for research on recent works may be extremely difficult to get hold of, since crucial documents may not yet be in print and you may not have access to the people involved. And, second, materials on some subjects may be unavailable to you because they are in languages you can't read or in publications that no nearby library has. So you probably won't try to work on the stuff of today's news—for example, the legal disposition of the works of a sculptor whose will is now being contested; and (because almost nothing in English has been written on it) you won't try to work on the date of the introduction into Japan of the image of the Buddha at birth. But no subject is too trivial for study: Newton, according to legend, wondered why an apple fell to the ground.

You cannot, however, write a research paper on subjects as broad as Buddhist art, or Michelangelo, or the Asian influence on Western art. You have to focus on a much smaller area within such a subject. Let's talk about the Asian influence on Western art. You might narrow your topic, so that you concentrate on the influence of Japanese prints on van Gogh (or on Toulouse-Lautrec, or on Mary Cassatt), or on the influence of calligraphy on Mark Tobey, or on the influence of Buddhist sculpture on Jo Davidson. Your own interests will guide you to the topic—the part of the broad subject—that you wish to explore, and you won't know what you wish to explore until you start exploring. Picasso has a relevant comment: "To know what you want to draw, you have to begin drawing. If it turns out to be a man, I draw a man."

But, of course, even though you find you are developing an interest in an appropriately narrow topic, you don't know a great deal about it; that's one of the reasons you are going to do research on it. Let's say that you happen to have a Japanese print at home, and your instructor's brief reference to van Gogh's debt to Japanese prints has piqued your interest. You may want to study some pictures and do some reading now. As an art historian (at least for a few hours each day for the next few weeks), at this stage you think you want to understand why van Gogh turned to Japanese art (the explanation will probably include some relatively remote causes as well as what historians have called "releasers" or "triggers"), and what the effect of Japanese art was on his own work. Possibly your interest will shift to the influence of Japan on van Gogh's friend, Gauguin, or even to the influence of Japanese prints on David Hockney in the 1970s. That's all right; follow your interests. Exactly what you will focus on, and exactly what your thesis, or point of view, will be, you may not know until you do some more reading. But how do you find the relevant material?

FINDING THE MATERIAL

You may already happen to know of some relevant material that you have been intending to read—perhaps titles listed on a bibliography distributed by your instructor—or you can find the titles of some of the chief books by looking at the bibliography in such texts as H. W. Janson's *History of Art* or Spiro Kostof's *History of Architecture*, but if these do not prove useful and you are at a loss about where to begin, consult the card or on-line catalog of your library, the appropriate guides to articles in journals, and certain reference books listed here subsequently.

The Library Catalog: Card or Computerized

The card catalog has cards arranged alphabetically not only by author and title but also by subject. If your library has an on-line catalog, the principle is the same but alphabetization won't matter. The catalog won't have a heading for "The Influence of Japanese Prints on van Gogh," of course, but it will have one for "Art: Japanese" (this will then be broken down into periods), and there will also be a subject heading for "Prints, Japanese," after which will be a card (or an entry in the on-line catalog) for each title that is in the library's collection. And, of course, you will look up van Gogh (who, it will probably turn out, will be listed under Gogh), where you will find cards listing books by him (e.g., collections of his letters) and about him. Often it is useful and sometimes necessary, even for computerized catalogs, to look up your subject in the Library of Congress Subject Headings, the three big red books that libraries keep near their catalogs.

Scanning Encyclopedias, Books, and Book Reviews

Having checked the catalog and written down the relevant data (author, title, call number), you can begin to scan the books, or you can postpone looking at the books until you have found some relevant articles in periodicals. For the moment, let's postpone the periodicals.

If you know almost nothing about your topic, you may want to begin by reading the relevant articles in *Encyclopedia of World Art*, originally a fifteen-volume work published by McGraw-Hill in 1959–1968, but now with two supplementary volumes (1983 and 1987) updating the bibliographies. (Don't confuse this seventeen-volume work with *McGraw-Hill Dictionary of Art* [1969], a five-volume set containing about 15,000 entries, emphasizing biographies of artists.) *Encyclopedia of World Art* includes articles on nations, schools, artists, iconographic themes, genres, and techniques. An article such as "Genre and Secular Subjects" provides an excellent overview. Be sure to check the index (volume 15) in order to find all of the relevant material in the *Encyclopedia*, and be sure to check the two supplementary volumes, volumes 16 and 17.

General encyclopedias, such as Encyclopedia Americana and Encyclopaedia Britannica, can be useful at the beginning. For certain topics, such as early Christian symbolism, New Catholic Encyclopedia (fifteen volumes) is especially valuable.

Let's assume that you have glanced at some entries in an encyclopedia, or perhaps have decided that you already know as much as would be included in such an introductory work, and you now want to investigate the subject more deeply. Put a bunch of books in front of you, and choose one as an introduction. How do you choose one from half a dozen? Partly by its size—choose a fairly thin one—and partly by its quality. Roughly speaking, it should be among the more recent publications, or you should have seen it referred to (perhaps in the textbook used in your course) as a standard work on the subject. The name of the publisher is at least a rough indication of quality: A book or catalog published by a major museum, or by a major university press, ought to be fairly good.

When you have found the book that you think may serve as your introductory study, read the preface in order to get an idea of the author's purpose and outlook, scan the table of contents in order to get an idea of the organization and the coverage, and scan the final chapter or, if the book is a catalog of an exhibition, the last few pages of the introduction, where you may be lucky enough to find a summary. The index, too, may let you know if the book will suit your purpose by showing you what topics are covered

and how much coverage they get. If the book still seems suitable, scan it.

At this stage it is acceptable to trust one's hunches—you are only going to scan the book, not buy it or even read it—but you may want to look up some book reviews to assure yourself that the book has merit, and to be aware of other points of view. There are four especially useful indexes to book reviews:

Book Review Digest (published from 1905 onward)
Book Review Index (1965–)
Art Index (1929–)
Humanities Index (1974–)

Book Review Digest includes brief extracts from the reviews, chiefly in relatively popular (as opposed to scholarly) journals. Thus if an art book was reviewed in the New York Times Book Review, or in Time magazine, you will probably find something (listed under the author of the book) in Book Review Digest. Look in the volume for the year in which the book was published, or in the next year. But specialized books on art will probably be reviewed only in specialized journals on art, and these are not covered by Book Review Digest.

You can locate reviews by consulting *Book Review Index* (look under the name of the author of the book) or by consulting *Art Index*. (In the early volumes of *Art Index*, reviews were listed, alphabetically by the author of the review, throughout the volumes, but since 1973–1974 reviews have been listed at the rear of each issue, alphabetically by the author of the book or by the title if the book has no author.) Scholarly reviews sometimes appear two or even three years after the publication of the book, so for a book published in 1985 you probably will want to consult issues of *Book Review Index* and *Art Index* for as late as 1988. *Humanities Index* works the same way as *Art Index* but indexes different journals for an interdisciplinary approach.

When you have located some reviews, read them and then decide whether you want to scan the book. Of course, you cannot assume that every review is fair, but a book that on the whole gets good reviews is probably at least good enough for a start.

By quickly reading such a book (take few or no notes at this stage), you will probably get an overview of your topic, and you will see exactly what part of the topic you wish to pursue.

Indexes to Published Material

An enormous amount is published in books, magazines, and scholarly journals; you cannot start looking at random, but fortunately there are indexes. The most widely used indexes are these:

Readers' Guide to Periodical Literature (1900–) Art Index (1929–) BHA: Bibliography of the History of Art (1991–) Répertoire d'art et d'archéologie (1910–1990) RILA (1975–1989) ARTbibliographies MODERN (1969–)

Readers' Guide indexes more than a hundred of the more familiar magazines—such as Atlantic, Nation, Scientific American, Time. Probably there won't be much for you in these magazines unless your topic is something like "Van Gogh's Reputation Today," or "Popular Attitudes toward Surrealism, 1930–1940," or "Jackson Pollock as a Counter-Culture Hero of Fifties America," or some such thing that necessarily draws on relatively popular writing. Readers' Guide is available since 1984 through WILSONLINE and WILSONDISC (CD-ROM).

Art Index, Répertoire d'art, RILA, and ARTbibliographies MOD-ERN are indexes to many of the less popular, more scholarly periodicals—for example, periodicals published by learned societies—and bulletins issued by museums.

Art Index lists material in about 250 periodicals, bulletins, and yearbooks; it does not list books but it does list, at the rear, book reviews under the name of the author of the book. Art Index covers not only painting, drawing, sculpture, and architecture, but also photography, decorative arts, city planning, and interior design—and it covers Africa and Asia as well as Western cultures. A computerized version of Art Index since October 1984 is available through WILSONLINE, and, on CD-ROM, through WILSONDISC.

BHA: Bibliography of the History of Art (1991–) represents a merger of the next two bibliographies that are discussed, Répertoire d'art and RILA, but you will still need to consult these two for material published before 1989. BHA covers visual arts in all media but it is limited to Western art from Late Antiquity to the present. Thus, it excludes not only ancient Western art, but also Asian,

Indian, Islamic, African, and Oceanic art, and American art before the arrival of Europeans. In addition to including citations of books, periodical articles, exhibition catalogs, and doctoral dissertations, it includes abstracts (*not* evaluations) in English or French. *BHA* is available online from DIALOG.

Répertoire d'art lists books as well as articles in some 1750 periodicals (many of them European), but, like its successor BHA it excludes non-Western art, and since 1965 it has excluded art before the early Christian period. It also excludes artists born after 1920.

RILA: International Repertory of the Literature of Art lists books as well as articles in some 300 journals. It is especially useful because it includes abstracts, but it covers only post-Classical European art (it begins with the fourth century) and post-Columbian American art. It thus excludes (again, like its successor BHA) prehistoric, ancient, Asian, Indian, Islamic, African, Oceanic, and Native American art. Several volumes of RILA can be searched at one time by using its Cumulative Indexes: volumes 1–5, 6–10, 11–15. (Likewise, one art magazine, Burlington Magazine, has cumulative indexes: 1903–1962, 1963–1972, 1973–1982.)

ARTbibliographies MODERN used to cover art from 1800, but beginning in 1989 it limited its coverage to art from 1900. It now provides abstracts or brief annotations not only of periodical articles concerned with art of the twentieth century, but also of exhibition catalogs and books. Entries since 1974 can be searched through DIALOG.

Major newspapers also cover art topics, for example, exhibitions and books, and some have indexes: The New York Times (1851–) and Times of London (1790–).

Whichever indexes you use, begin with the most recent years and work your way back. If you collect titles of materials published in the last five years, you will probably have as much as you can read. These articles will probably incorporate the significant points of earlier writings. But, of course, it depends on the topic; you may have to—and want to—go back fifty or more years before you find a useful body of material.

Note, too, that if the museum that owns an object also issues publications, the object may be discussed in a publication issued about the time the object was acquired. Thus, if the Cleveland Museum of Art acquired an object in 1950 (the date of acquisition is

given on the label next to the work), an issue of *The Bulletin of the Cleveland Museum of Art* in 1950 or 1951 may discuss it.

Caution: Indexes drastically abbreviate the titles of periodicals. Before you put the indexes back on the shelf, be sure to check the key to the abbreviations, so that you know the full titles of the periodicals you are looking for.

Other Guides

There are a great many reference books-not only general dictionaries and encyclopedias but dictionaries of technical words (e.g., Adeline's Art Dictionary, reissued as Adeline Art Dictionary), and of motifs (e.g., James Hall's Dictionary of Subjects and Symbols in Art), and encyclopedias of special fields, such as Encyclopedia of World Art, already mentioned on page 180. Adeline's Art Dictionary, for example, defines terms used in painting, sculpture, architecture, etching, and engraving. Hall's Dictionary is devoted chiefly to classical and biblical themes in Western art: If you look up the Last Supper, you will find two detailed pages on the topic, explaining its significance and the various ways in which it has been depicted since the sixth century. For instance, in the earliest depictions Christ is at one end of the table, but later Christ is at the center. A dog may sit at the feet of Judas, or Judas may sit alone on one side of the table; if the disciples have haloes, Judas's halo may be black. Again, if in Hall's Dictionary you look up cube, you will find that in art it is "a symbol of stability on which Faith personified rests her foot; . . . Its shape contrasts with the unstable globe of Fortune." James Smith Pierce's From Abacus to Zeus, a similar dictionary, includes fewer symbols and shorter discussions (half of one page for the Last Supper), but, unlike Hall's Dictionary, it includes definitions of terms used in art, such as ground line.

For definitions of the chief terms and for brief biographies, see Peter and Linda Murray's little Dictionary of Art and Artists, or The Oxford Companion to Art, edited by Harold Osborne. The Larousse Dictionary of Painters accompanies its biographies with illustrations. U. Thieme and F. Becker's Allgemeines Lexikon der bildenden Künstler, von der Antike bis zur Gegenwart, a thirty-seven-volume compilation (six-volume supplement by H. Vollmer), is the chief biographical dictionary; it covers painters and sculptors from ancient times to the early twentieth century, but to use it one must be able to read

German. Thieme-Becker and Vollmer are now being updated and supplemented with some 300,000 new entries in Allgemeines Künstlerlexikon, a sixty-volume work scheduled to be published over a period of thirty years. For artists of the twentieth century, the best general reference works are The Oxford Companion to Twentieth-Century Art, edited by Harold Osborne, and Contemporary Artists.

There are also subject bibliographies—books that are entirely devoted to listing (sometimes with comment) publications on specific topics. Thus, Yvonne M. L. Weisberg and Gabriel P. Weisberg's *Japonisme* lists and comments on almost 700 books, articles, exhibition catalogs, and unpublished dissertations concerning the Japanese influence on Western art from 1854 to 1910. Similarly, Nancy J. Parezo, Ruth M. Perry, and Rebecca S. Allen's *Southwest Native American Arts and Material Culture* lists more than 8,000 references, including books, journals, exhibition catalogs, and dissertations.

How do you find such books? Perhaps the best guide, partly because it is the most recent and therefore includes many titles not found in older books, is

Lois Swan Jones, Art Information: Research Methods and Resources, 3rd ed. (1990)

Among other useful guides to the numerous books on art are these:

Bernard Goldman, Reading and Writing in the Arts: A Handbook, rev. ed. (1978)

Gerd Muehsam, Guide to Basic Information Sources in the Visual Arts (1978)

Donald L. Ehresmann, Fine Arts: A Bibliographic Guide to Basic Reference Works, Histories, and Handbooks, 3rd ed. (1990)

Etta Arntzen and Robert Rainwater, Guide to the Literature of Art History (1980)

W. Eugene Kleinbauer and Thomas P. Slavens, Research Guide to the History of Western Art (1982)

What about reference books in other fields? The best guide to reference books in all sorts of fields is *Guide to Reference Books*, tenth edition (1986), compiled by Eugene P. Sheehy and others.

There are guides to all of these guides: reference librarians. If you don't know where to turn to find something, turn to the librarian.

READING AND TAKING NOTES

As you read, you will, of course, find references to other publications, and you will jot these down so that you can look at them later. It may turn out, for example, that a major article was published 20 years ago and that the most recent writing about your topic is a series of footnotes to this piece. You will have to look at it, of course, even though common sense had initially suggested (incorrectly, it seems) that the article would be out of date.

In reading an article or a chapter of a book, read it through but do not take notes while reading it. By the time you reach the end, you may find it isn't noteworthy. Or you may find a useful summary near the end that will contain most of what you can get from the piece. Or you will find that, having a sense of the whole, you can now quickly reread the piece and take notes on the chief points.

When you take notes, if you don't use a word processor use four-by-six-inch cards, and write on one side only; material on the back of a card is usually neglected when you come to write the paper. If your notes from a source, on a particular point, run to more than one card (say to three), number each card thus: 1 of 3, 2 of 3, 3 of 3. Use four-by-six cards because the smaller cards (three-by-five) are too small for summaries of useful material, and the larger cards (five-by-seven) invite you to put too much material on one card.

Here is a guide to note taking:

- 1. Write summaries rather than paraphrases; write abridgments rather than restatements, because restatements may turn out to be as long as or longer than the original. There is rarely any point to paraphrasing; generally speaking, either quote exactly (and put the passage in quotation marks, with a notation of the source, including the page number or numbers) or summarize, reducing a page or even an entire article or chapter of a book to a single four-by-six card. Even when you summarize, indicate your source (including the page numbers) on the card, so that you can give appropriate credit in your paper.
- 2. Of course, in your summary you will sometimes quote a phrase or a sentence—putting it in quotation marks—but quote

sparingly. You are not doing stenography; rather, you are assimilating knowledge and you are thinking, and so for the most part your source should be digested rather than engorged whole. Thinking now, while taking notes, will also help you later to avoid plagiarism. If, on the other hand, when you take notes you mindlessly copy material at length, later when you are writing the paper you may be tempted to copy it yet again, perhaps without giving credit. Similarly, if you photocopy pages from articles or books, and then merely underline some passages, you probably will not be thinking; you will just be underlining. But if you make a terse summary on the word processor or on a note card, you will be forced to think and to find your own words for the idea.

Most of the direct quotations that you copy should be effectively stated passages or crucial passages or both. In your finished paper these quotations will provide authority and emphasis. Be sure not to let your paper degenerate into a string of quotations.

- 3. If you quote but omit some material within the quotation, be sure to indicate the omission by three spaced periods, as explained on page 145. Check the quotation for accuracy, and check the page number you have recorded on your card.
- 4. Never copy a passage by changing an occasional word, under the impression that you are thereby putting it into your own words. Notes of this sort may find their way into your paper, your reader will sense a style other than your own, and suspicions of plagiarism may follow. It is worth saying yet again that you should either quote exactly, and enclose the words within quotation marks, or summarize drastically. In both cases, be sure to give credit to your source. (For a detailed discussion of plagiarism, see pages 147–152.)
- 5. Feel free to jot down your own responses to the note. For example, you may want to say, "Baker made same point 5 yr earlier"; but make certain that later you will be able to distinguish between these comments and the notes summarizing or quoting your source. A suggestion: Surround all comments recording your responses with double parentheses, thus: ((. . .)).
- 6. In the upper corner of each note card, write a brief key—for example, "Van G on color of prints"—so that later you can tell at a glance what is on the card.

WRITING THE PAPER

There remains the difficult job of writing up your findings, usually in 2000–3000 words (eight to twelve double-spaced typed pages). Here is some advice.

1. Reread your note cards, sorting them into packets by topic, or moving blocks if your notes are on a word processor. Put together what belongs together. Don't hesitate to reject material that—however interesting—now seems redundant or irrelevant. In doing your research you quite properly took many notes (as William Blake said, "You never know what is enough unless you know what is more than enough"), but now, in looking your material over, you see that some is unnecessary and so you reject it. Your finished paper should not sandbag the reader; keep in mind the Yiddish proverb, "Where there is too much, something is missing."

After sorting and resorting, you will have a kind of first draft without writing a draft. This business of settling on the structure of your work—the composition of your work, one might say—is often frustrating. Where to begin? Should this go before that? But remember that great artists have gone through greater struggles. If we look at a leaf from one of Raphael's sketchbooks, we find him trying, and trying again, to work out the composition of, say, the Virgin and Child. Nicolas Poussin used a miniature stage, on which he arranged and rearranged the figures in his composition. An x-ray of Rembrandt's The Syndics of the Cloth Drapers Guild reveals that he placed the servant in no fewer than four positions (twice at the extreme right, once between the two syndics at the right, and finally in the center) before he found a satisfactory arrangement. You can hardly expect, at the outset, to have a better grasp of your material than Raphael, Poussin, and Rembrandt had of theirs. What Degas said of a picture is true of a research paper: "A good picture requires as much planning as a crime."

2. From your packets of cards or your rearranged notes you can make a first outline. In arranging the packets into a sequence, and then in sketching an outline (see p. 109), you will be guided by your *thesis*, your point. Without a thesis you will have only a lot of note cards, not an essay. This outline will indicate not only the major parts of the essay but also the subdivisions within these parts.

Do not confuse this outline with a paragraph outline (i.e., with an outline made by jotting down the topic idea of each paragraph); when you come to write your essay, a single heading in your outline may require two or three or more paragraphs.

Don't scorn the commonest organization:

- a. introduction of the works to be studied, and of the thesis
- b. presentation of evidence, with interpretation relating it to the thesis
- c. presentation of counterevidence, and rebuttal
- d. conclusion

You may find that this organization doesn't suit your topic or you. Fine, but remember that your reader will need to be guided by some sort of organization that you will have to adopt and make clear.

3. When you write your first draft, you may find it helpful to leave lots of space at the top and bottom of each page so that you can add material, which will be circled and connected by arrows to the proper place. On reading your draft you may find that a quotation near the bottom of page 6 will be more appropriate if it is near the top of page 6. Circle it, and with an arrow indicate where it should go. If it should go on page 4, scissor it out and paste it on page 4. This process is a bit messy, but you will get a strong sense of what your paper sounds like only if you can read a draft with all of the material in the proper place. (The great advantage of using a word processor, of course, is that you can move passages of text without cutting and pasting.) If you move some material in your draft, also move your note cards containing the material, so that if for some reason you later have to double-check your notes, you can find your source easily.

Your opening paragraph—in which you usually will define the problem and indicate your approach—may well be the last thing that you write, for you may not be able to enunciate these ideas clearly until you have learned from drafting the rest of your essay. (On opening paragraphs, see pages 136–137.)

4. Write or type your quotations, even in the first draft, exactly as you want them to appear in the final version. (If you took notes on a word processor, just move the quotations from your notes into the paper.) Short quotations (fewer than five lines of prose) are enclosed within quotation marks but are not otherwise set off;

longer quotations, however, are set off (triple-space before them and after them), slightly indented, and are *not* enclosed in quotation marks. For more on quotations, see pages 143–147.

- 5. Include, right in the body of the draft, all of the relevant citations (later these will become footnotes), so that when you come to revise, you don't have to start hunting through your notes to find who said what and where. You can, for the moment, enclose these citations within diagonal lines, or within double parentheses—anything at all to remind you that they will be your footnotes.
- 6. Be sure to **identify works of art as precisely as possible**. Not "Rembrandt's *Self-Portrait*" (he did more than sixty), or even "Rembrandt's *Self-Portrait* in the Kunsthistorisches Museum, Vienna" (they own at least two), but "Rembrandt's *Self-Portrait of 1655*, in the Kunsthistorisches Museum, Vienna," or, more usually, "Rembrandt's *Self-Portrait* (1655, Kunsthistorisches Museum, Vienna)." If the exact date is unknown, preface the approximate date with ca., the abbreviation for *circa*, Latin for "about." Example: ca. 1700. Be sure to identify all illustrations with a caption, giving, if possible, artist, title, date, medium, size, and present location. (See pp. 140–141.)
- 7. Beware of the compulsion to include all of your notes in your essay. You have taken all these notes, and there is a strong temptation to use them all. But, truth to tell, in hindsight many are useless. Conversely, you will probably find as you write your draft that here and there you need to check a quotation or to collect additional examples. Probably it is best to continue writing your draft, if possible; but remember to insert the necessary material after you get it.
- 8. As you revise your draft, make sure that you do not merely tell the reader "A says . . . B says . . . C says . . . ". When you write a research paper, you are not merely setting the table with other people's dinnerware; you are cooking the meal. You must have a point, an opinion, a thesis; you are working toward a conclusion, and your readers should always feel they are moving toward that conclusion (by means of your thoughtful evaluation of the evidence) rather than reading an anthology of commentary on the topic.

Thus, because you have a focus, you should say such things as "There are three common views on. . . . The first two are represented by A and B; the third, and by far the most reasonable, is C's view that . . . " or "A argues . . . but . . . " or "Although the third view, C's, is not conclusive, still . . . " or "Moreover, C's point can be strengthened when we consider a piece of evidence that this author does not make use of." You cannot merely say, "A says . . . , B says . . . , C says . . . ," because your job is not to report what everyone says but to establish the truth of a thesis.

When you introduce a quotation, then, try to let the reader see the use to which you are putting it. "A says" is of little help; giving the quotation and then following it with "thus says A" is even worse. You need a lead-in such as "A concisely states the common view," "B calls attention to a fatal weakness," "Without offering any proof, C claims that," "D admits," "E rejects the idea that. . ". In short, it is usually advisable to let the reader know why you are quoting or, to put it a little differently, how the quotation fits into your argument. After giving a quotation, you'll almost surely want to develop (or take issue with) the point made in the quotation.

It is almost always desirable in your lead-in to name the author of the quotation, rather than to say something like "One scholar has said," or "Another critic claims that. . . . " In all probability the authors whom you are quoting are known in the field and your reader should not have to turn to the footnotes to find out whose words he or she has been reading.

While you were doing your research you may have noticed that the more interesting writers persuade the reader of the validity of their opinions by

- a. letting the reader see that they know what of significance had been written on the topic;
- b. letting the reader hear the best representatives of the chief current opinions, whom they correct or confirm; and
- c. advancing their opinions, by offering generalizations supported by concrete details.

Adopt these techniques in your own writing.

Your overall argument, then, is fleshed out with careful summaries and with effective quotations and with judicious analyses of

your own, so that by the end of the paper the readers not only have read a neatly typed paper, but they also are persuaded that under your guidance they have seen the evidence, heard the arguments justly summarized, and reached a sound conclusion. They may not become better persons but they are better informed.

- 9. Make sure that in your final version you state your thesis early, perhaps even in the title (not "Van Gogh and Japanese Prints" but "Van Gogh's Use of Japanese Prints"), but if not in the title, almost certainly in your first paragraph.
- 10. When you have finished your paper **prepare a final copy** that will be easy to read. Type the paper (see pp. 139–140), or print a copy from the word processor, putting the footnotes into the forms given on pages 156–160.

A bibliography or list of works consulted (see pp. 160–164) is usually appended to the research paper, partly to add authority to your paper, partly to give credit to the writers who have helped you, and partly to enable readers to look further into the primary and secondary material if they wish. But if you have done your job well, the reader will be content to leave things where you left them, grateful that you have set things straight.

In brief: After you have written a draft and have revised it at least once (better, twice or more), reread it with the following questions in mind. If possible, ask a friend also to read the draft, along with the questions, or with the peer review chart on page 112. If your answers or your friend's are unsatisfactory, revise.

- 1. Exactly what topic are you examining, and exactly what thesis are you arguing?
- 2. Does the paper fulfill all of the promises that it makes or implies?
- 3. Are the early paragraphs interesting, and do they give the reader a fairly good idea of what will follow?
- 4. Is evidence offered to support arguable assertions?
- 5. Has all irrelevant material—however interesting—been deleted?
- 6. Are quotations introduced with helpful lead-ins? Are all quotations instructive and are they no longer than they need to be?

- 7. Is the organization clear, reasonable, and effective?
- 8. Is the final paragraph merely an unnecessary restatement of what by now, at the end of the paper, is obvious?
- 9. Does the title (if you have settled on one) give the reader an idea of what the paper is concerned with?

Essay Examinations

WHAT EXAMINATIONS ARE

The first two chapters of this book assume that writing an essay requires knowledge of the subject as well as skill with language. Here a few pages will be devoted to discussing the nature of examinations; perhaps one can write better essay answers when one knows what examinations are.

A well-constructed examination not only measures learning and thinking but also stimulates them. Even so humble an examination as a short-answer quiz is a sort of push designed to move students forward by coercing them to do the assigned looking or reading. Of course, internal motivation is far superior to external, but even such crude external motivation as a quiz can have a beneficial effect. Students know this; indeed, they often seek external compulsion, choosing a particular course "because I want to know something about . . . and I know that I won't do the work on my own." (Teachers often teach a new course for the same reason; we want to become knowledgeable about, say, the Symbolists, and we know that despite our lofty intentions we may not seriously confront the subject unless we are under the pressure of facing a class.)

In short, however ignoble it sounds, examinations force students to acquire knowledge and then to convert knowledge into thinking. Sometimes it is not until preparing for the final examination that students—returning to museums, studying photographs of works of art, rereading the chief texts and classroom notes—see what the course was really about; until this late stage the trees obscure the forest, but now, reviewing and sorting things out—thinking about

"I think you know everybody."

Drawing by Chas. Addams; © 1979 The New Yorker Magazine, Inc.

the facts, the data, and the ideas of others—they see a pattern emerge. The experience of reviewing and then of writing an examination, though fretful, can be highly exciting, as connections are made and ideas take on life. Such discoveries about the whole subject matter of a course can almost never be made by writing critical essays on topics of one's own construction, for such topics rarely require a view of the whole. Further, we are more likely to make imaginative leaps when trying to answer questions that other people pose to us than when trying to answer questions we pose to ourselves. (Again, every teacher knows that students in the classroom ask questions that stimulate the teacher to see things and to think thoughts that would otherwise have been neglected.) And although a teacher's question

may cause anxiety, when students confront and respond to it on an examination they often make yet another discovery—a selfdiscovery, a sudden and satisfying awareness of powers they didn't know they had.

WRITING ESSAY ANSWERS

Let's assume that before the examination you have read the assigned material, marked the margins of your books (but not of the library's books), made summaries of the longer readings and of the classroom comments, visited the museums, reviewed all this material, and had a decent night's sleep. Now you are facing the examination sheet.

Here are seven obvious but important practical suggestions:

- 1. Take a moment to jot down, as a sort of outline or source of further inspiration, a few ideas that strike you after you have thought a little about the question. You may at the outset realize there are, say, three points you want to make, and unless you jot these down—three key words will do—you may spend all the allotted time on one point.
- 2. Answer the question: If you are asked to compare two pictures, compare them; don't write two paragraphs on the lives of each painter. Take seriously such words as *compare*, *summarize*, and especially *evaluate*.
- 3. You can often get a good start merely by turning the question into an affirmation—for example, by turning "In what ways is the painting of Manet influenced by Goya?" into "Manet's painting is influenced by Goya in at least . . . ways."
- 4. Don't waste time summarizing at length what you have read unless asked to do so—but, of course, you may have to give a brief summary in order to support a point. The instructor wants to see that you can *use* your reading, not merely that you have done the reading.
- 5. Budget your time. Do not spend more time on a question than the allotted time.

- 6. Be concrete. Illustrate your argument with facts—names of painters or sculptors or architects, titles of works, dates, and brief but concrete descriptions.
- 7. Leave space for last-minute additions. Either skip a page between essays, or write only on the right-hand pages so that on rereading you can add material at the appropriate place on the left-hand pages.

Beyond these general suggestions, it is best to talk about essay examinations by looking at the four most common sorts of questions:

- 1. a work to analyze
- 2. a historical question (e.g., "Trace the influence of Japanese art on two European painters of the later nineteenth century"; "Trace the development of Picasso's representations of the Minotaur")
- 3. a critical quotation to be evaluated
- 4. a comparison (e.g., "Compare the representation of space in the late works of van Gogh and Gauguin)

A few remarks on each of these types may be helpful.

- 1. On analysis, see Chapter 2. As a short rule, look carefully at subject matter, line, color (if any), composition, and medium.
- 2. A good essay on a historical question, like a good lawyer's argument, will offer a nice combination of argument and evidence; that is, the thesis will be supported by concrete details (names of painters and paintings, dates, possibly even brief quotations). A discussion cannot be convincing if it does not specify certain works as representative—or atypical—of certain years. Lawyerlike, you must demonstrate (not merely assert) your point.
- 3. If you are asked to evaluate a critical quotation, read the quotation carefully and in your answer take account of *all* of the quotation. If, for example, the critic has said, "Goya in his etchings always . . . but in his paintings rarely . . . ," you will have to write about etchings and paintings (unless, of course, the instructions on the examination ask you to take only as much of the quotation as you wish). Watch especially for words like *always*, *for the most part*, *never*; that is, although the passage may on the whole approach the truth,

you may feel that some important qualifications are needed. This is not being picky; true evaluation calls for making subtle distinctions, yielding assent only so far and no further. Another example of a quotation to evaluate: "Picasso's Les Demoiselles d'Avignon [illustrated on p. 22] draws on several traditions, and the result is stylistic incoherence." A good answer not only will specify the traditions or sources (e.g., Cézanne's bathers, Rubens's The Judgment of Paris, Renaissance and Hellenistic nudes, pre-Christian Iberian sculptures, Egyptian painting, African art), calling attention to the passages in the painting where each is apparent, but also will evaluate the judgment that the work is incoherent. It might argue, for example, that the lack of traditional stylistic unity is entirely consistent with the newness of the treatment of figures and with the violent eroticism of the subject.

4. On comparisons, see Chapter 3. Because lucid comparisons are especially difficult to write, be sure to take a few moments to jot down a sort of outline so that you know where you will be going. You can often make a good start by beginning with the similarities of the two objects. As you jot these down, you will probably find that your perception of the *differences* will begin to be heightened.

In organizing a comparison of two pictures by van Gogh and two by Gauguin, you might devote the first and third paragraphs to van Gogh, the second and fourth to Gauguin. Or you might first treat one painter's two pictures and then turn to the second painter. Your essay will not break into two parts if you announce at the outset that you will treat one artist first, then the other, and if you remind your reader during your treatment of the first artist that certain points will be picked up when you get to the second, and, finally, if during your treatment of the second artist you occasionally glance back to the first.

LAST WORDS

Chance favors the prepared mind.

Louis Pasteur

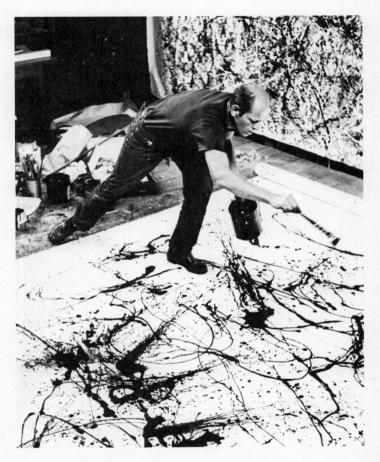

Hans Namuth, Jackson Pollock Painting, 1951.

Acknowledgments

"Millet's *The Gleaners*" (pp. 6–7) by Robert Herbert, reproduced from the exhibition catalogue *Man and His World: International Fine Arts Exhibition*. © The National Gallery of Canada for the Corporation of the National Museums of Canada. Reprinted by permission of The National Gallery of Canada and Robert L. Herbert.

"Gay and Lesbian Art Criticism" (pp. 14–16) by James Saslow was written for this book and used by permission of the author.

Excerpt from "The Carvers of the Northeast" (p. 19) by John Pemberton III in Yoruba: Nine Centuries of African Art and Thought, edited by Allen Wardwell (New York: Center for African Art, 1989) page 206, reprinted by permission of John Pemberton III.

Quotation and drawing (pp. 25–26) from Rudolf Arnheim, Art and Visual Perception (1974). Reprinted by permission of the University of California Press.

Quote by Eugene J. Johnson (p. 53) in *International Handbook of Contemporary Developments in Architecture*, edited by Warren Sanderson. Copyright © 1981 by Warren Sanderson. Reprinted by permission of Greenwood Press, Westport, CT.

Excerpt from "The Assignment I'll Never Forget" (p. 67) by Dorothea Lange in *Popular Photography* 46:2 (February 1960), page 43, reprinted by permission of *Popular Photography*.

Excerpt from text by Laurence B. Kanter (p. 87) in *Painting in Renaissance Siena* 1420–1500 by Keith Christiansen, Laurence B. Kanter, and Carl Brandon Strehlke. Copyright © 1988 by The Metropolitan Museum of Art. Reprinted by permission of The Metropolitan Museum of Art.

"Two Low Relief Carvings from the Fifteenth Century" (pp. 95–99) © Oxford University Press 1964. Reprinted from *Relief Sculpture* by L. R. Rogers (1964) by permission of Oxford University Press.

"Mrs. Mann and Mrs. Goldthwait" (pp. 99, 102–107) by Rebecca Bedell. Copyright © 1981 by Rebecca Bedell. Used by permission of the author.

Excerpt from *Purposes of Art* (pp. 130, 132) Third Edition, by Albert E. Elsen. Copyright © 1972 by Holt, Rinehart and Winston, Inc., by permission of the publisher.

Quotation from *Gothic* (p. 127) by George Henderson (Harmondsworth, England: Penguin Books Ltd., 1967), p. 43. Copyright © George Henderson, 1967. Reprinted by permission of Penguin Books Ltd.

constitutions in the

Index

A.D., 141 Abstract art, 28, 39 Acknowledgments of readers, 114-115 of sources, 147-52 Action painting, 29 Addams, Charles, 195 Aerial perspective, 38 Agostino di Duccio, Virgin and Child, 97 Allegory, 18 Analysis, 23-85, 86 Apostrophe, 164-165 Architecture, questions on, 52-59 Arnheim, Rudolf, 25-26 Atmospheric perspective, 38 Attribute, 17 Attribution, 86, 141 Aubert, Marcel, 118 Auden, W. H., 2-3 Audience, 2 Authenticity, 86, 141, 173

Bacon, Francis, 58
Bascom, William, 147–148
Base, of sculpture, 50
B.C., 141
B.C.E., 141
Bedell, Rebecca, 99–107
Beer, Stephen, 79–83
Berger, John, 3
Bible, references to, 147
Bibliographic guides, 181–185

Bibliography, form of, 160–164
Biographical writing, 13, 15, 16–17
Book reviews
indexes to, 181
reference to, 158, 164
Boston City Hall Plaza, 54, 56,
57–58
Brush strokes, 29, 34

Cambridge (Mass.) City Hall, 54, 55 Capitalization of foreign titles, 169-170 of title of essay, 139-140 Captions for illustrations, 140-141 Card catalog, 179 Cartier-Bresson, Henri, 62 Carving, 47 Catalog, library, 179 C.E., 141 Ceramics, 75 Charité-sur-Loire, La, 129 Chinese sculpture, Bodhisattva Kuan Yin, 92 City Hall Plaza (Boston), 56 Clarity, in essay, 112 Clark, Kenneth, 70 Closed silhouette, 47-50 Coherence, 133-136 Color in architecture, 58 in drawing and painting, 35-36 in sculpture, 50

Common knowledge, 150-151 Comparison, writing a, 86-107, 198 Complementary colors, 36 Complex sentences, 124-125 Composition, 37, 67 Compound sentences, 124 Concreteness, 117-118 Connoisseurship, 171n Connotation, 117 Constantine the Great, 77 Content, 27-28 Contour hatching, 38 Contour lines, 33-34 Copley, John Singleton Mrs. Ezekial Goldthwait, 101 Mrs. Joseph Mann, 100 Corrections in manuscript, 142-143 Criticism functions of, 2-3 kinds of, 9-21 scholarship and, 171-193 Crucifixion, 27

Danto, Arthur C., 54 Daremo, Joan, 83-85 Dash. 165-166 Date on caption, 140-141 and style, 87-89 Degas, Edgar, 157 Denotation, 117 Depth, 37-38 Description, 71 Desiderio da Settignano, Virgin and Child with Four Angels, 96 Dimensions, 140-141 Diocletian, Palace of, 76 Documentation, 152-164 Drapery, 46

Economy, 120–122 Editing, 112 Egyptian sculpture, 126 King Chefren, 48 Prince Khunera as a Scribe, 79–83

Drawing, questions on, 31-43

Dutch names, 167

Elegant variation, 120 Ellipsis, 145–146 Elsen, Albert E., 130–132 Emphasis, 124–125 Encyclopedias citations of, 155–156, 163 as sources, 180 Endnotes, 152–160 Evaluation, 7, 172, 173–175 Examinations, 194–198

Facture, 47
Feminist criticism, 11–14
Figures, 31
First person, use of, 21–22
Footnotes, 152–160
Foreign titles, 169–170
Foreign words, 166, 170
Foreshortening, 38
Form, 78
Formal analysis, 71–73
Frankenthaler, Helen, Mountains and Sea, color insert, xvii, 41–42
French names, 167
French titles, 170
Freudian criticism, 16

Garrard, Mary D., 11, 13
Gauguin, Paul, 36
Gaze, 13, 15–16, 31–32
Gay criticism, 14–16
Gentileschi, Artemisia, Judith Slaying
Holofemes, 12–13
Gender criticism, 14
German titles, 170
Giovanni da Bologna, Mercury, 49
Golding, John, 21
Gothic period, 78
Gottlieb, Adolph, 40

Held, Julius S., 174–175 Henderson, George, 127 Herbert, Robert, 5–7 Hierarchical scale, 38 Hollander, Anne, 137 Hue, 35 Hue-intensity, 36 Hughes, Robert, 41–42 Hyphen, 166

"I," use of, 21–22 Iconography, 17–19 Iconology, 18 Illustrations, captions for, 140–141 Impasto, 34 Impressionists, 119 Indexes to articles and books, 182–184 to book reviews, 181 Ink painting, 34–35 Intensity, 36 Intention, 70 Italian titles, 170

Japanese sculpture, Sakyamuni Buddha, 91 Johnson, Eugene J., 53, 68

Italics, 146-147, 170

Kahlo, Frida, 13 Kahn, Louis, 58 Kandinsky, Wassily, 28, 39–40 Kanter, Laurence B., 87 Klee, Paul, 27, 28

Labels, for works of art, 140–141
Landscape, questions on, 33
Lange, Dorothea, Migrant Mother, 64
Lesbian criticism, 14–16
Library catalog, 179
Light
in architecture, 58–59
in painting, 36–37
Lin, Maya, Vietnam Veterans
Memorial, 43–45
Line, 28–29, 33–34, 37
"Linear" versus "painterly," 34

Manet, Edouard, Woman Writing, 89 Manuscript form, 139–170 Margins, 140 Marxist criticism, 9 Matisse, Henri, 28, 29–30, 116 Matteo di Giovanni, Madonna and Child, 88

Medium, 34, 47

Michelangelo

Creation of Adam, 25–26

David, 23–24, 47, 50

Millet, Jean-François, The Gleaners, 5–9

Miró, Joan, 28

Modeling, 38, 47

Mondrian, Piet, 41

Munch, Edvard, The Scream, 83–85

Murray, Linda, 123

Murray, Peter, 123

Names foreign, 167 of works of art, 146–147 Nochlin, Linda, 10 Nonobjective art, 28, 39–43 Normans in Their Boat, 128 Notes, taking, 151, 186–187 Novak, Barbara, 27

Oil paint, 34
Olowe, Central Veranda Post, 19
Open silhouette, 47–50
Opinions, expressing, 21–22
Organization
of comparison, 90–95, 198
of essay, 8–9, 111, 188–189
of essay on architecture, 59
Ornament, 54
Outline, 109, 188–189

"Painterly" versus "linear," 34
Painting
questions on, 31–43
sample analyses of, 6–7, 83–85, 99–107
Panofsky, Erwin, 171n
Paragraphs, 125–138
coherence and unity, 125–136
concluding, 9, 137–138
introductory, 8, 136–137
transitions within, 133–136

Parallels, 122-123 Paraphrase, 148, 186 Passive voice, 122 Patronage, 10, 52 Peer reviewing, 88, 112-113 Pemberton, John, 19 Period style, 75-79 Personal style, 75 Perspective, 38 Persuasion, 8, 21 Pevsner, Nikolaus, 70 Photographs, of sculpture, 50-52 Photography, questions on, 59-68 Picasso, Pablo, 28, 30 Les Demoiselle d'Avignon, 11, 21-22, 198 Pictorialists, 59-61 Plagiarism, 147-152 Pollock, Jackson, 199 Pop art, 29 Portraiture questions on, 31-32, 45-46 van Gogh's, 119 Possessive, form of, 164-165 Primary material, 177 Proofreading, 142 Psychoanalytic criticism, 16-17

Questions, asking, 29–71 Quotation marks, 143–147 as apologies, 118–119 Quotations, 143–147 in foreign languages, 166 form of, 144–146 introductions to, 144, 191

Recession, 37–38
Reference books, 184–185
Reinhardt, Ad, 29
Rembrandt, 17
Self-Portrait with Saskia, 4–5
Repetition, 119–120
Reporters, 61–62
Research paper, 176–193
Response, 30
Revising, 111–114, 189–193

Rodin, Auguste, 46
L'Homme qui marche (Walking Man), 47, 134
Rogers, L. R., 95–99
Roman sculpture
Constantine the Great, 77
portrait sculpture, 45–46, 76
Rosenberg, Harold, xiv
Rosenblum, Robert, 42–43
Rosenfield, John, 137
Rothko, Mark, 40
Ruskin, John, 52

Saarinen, Eero, 68 Trans World Airlines Terminal, 54, 57 Saslow, James M., 14-16 Saturation, 36 Scale, 39, 54 hierarchical, 38 Schapiro, Meyer, 119 Scholarship, 171-193 Sculpture questions on, 43-52 Roman portrait, 45-46, 76 sample analyses of, 79-83, 90, 95-99 Secondary material, 177 Segal, George, The Bus Riders, 51 Sentences, 120-125 Sexist language, 167-168 Shading, 38 Silhouette, open versus closed, 47 - 50Site, 50, 55 Smith, William Stevenson, 126 Snapshot esthetic, 61 Social history, 9-11, 15 Sources, 147-152 Space, 37-38 Spanish names, 167 Spelling, 168-169 Steinberg, Leo, 133 Stella, Frank, 36 Tahkt-i-Sulayman I, 42-43 Still life, questions on, 32-33

Style
in art, 73–79
in writing, 116–138
Subject, of essay, 177–178
Subject matter, of work of art, 27–28
Subordination, 123–125
Sullivan, Louis, 52, 54
Summary, 148, 186
Symbols, 17, 50

Taylor, John F. A., 72
Tempera, 34
Thesis, 8, 25, 73, 79, 177–178, 188, 190
Title
of essay: choice of, 192; form of, 139–140
of work of art: in foreign language, 169–170; form of, 146–147; significance of, 30–31, 40
Tone, 108–109
Topic, 178
idea, 126, 132–133
sentence, 126–133

Transitions, 133-136 Trudeau, Gary, Doonesbury, 69

Underlining, 146–147, 170 Unity in essay, 111 in paragraphs, 125–133 Usage, 164–169

Value, 35–36
Van Dyck, Anthony, Charles I, 131
van Gogh, Vincent, 38n, 68, 70
capitalization of, 167
on color, 35
and portraiture, 119
Variation, 120
Vasari, Giorgio, 174
Vietnam Veterans Memorial, 43–45
Vitruvius, 52
Volume, 46–47

Warhol, Andy, 29 White, Minor, 62 Wittkower, Rudolf, 138 Wordiness, 120–122